Romantik

04

JOURNAL FOR THE STUDY OF ROMANTICISMS

Editors

Robert W. Rix (University of Copenhagen), Lis Møller (Aarhus University), Karina Lykke Grand (Aarhus University), Anna Lena Sandberg (University of Copenhagen), Cian Duffy (University of Copenhagen).

Nordic Advisor (fourth issue)

Paula Henrikson (University of Uppsala)

Editorial Board

Gunilla Hermansson (University of Gothenburg), Leena Eilittä (University of Helsinki), Knut Ljøgodt (Northern Norway Art Museum), Elisabeth Oxfeldt (University of Oslo)

Advisory Board

Charles Armstrong (University of Bergen), Jacob Bøggild (Aarhus University), David Fairer (University of Leeds), Karin Hoff (Georg-August-Universität Göttingen), David Jackson (University of Leeds), Stephan Michael Schröder (University of Cologne), Lauri Suurpää (Sibelius Academy, Helsinki)

Main editorial contact

Robert W. Rix [rjrix@hum.ku.dk]

Editorial Secretary

Kasper Rueskov Guldberg

Visit www.romantikstudier.dk or www.unipress.dk

Subscription services

Aarhus University Press [unipress@au.dk] or [+45 87 15 39 65]

Subscription price

Annual subscription price is DKK 150.00

Price per issue

DKK 199.95 per issue plus postage

Romantik is supported by the Nordic Board for Periodicals in the Humanities and Social Sciences NOP-HS and by AU Ideas

Contents

04

This fourth volume of *Romantik* marks a point in the journal's short history, where it can be said to have become established as both a regular and salient feature of the critical landscape. When one considers the attention the journal has received, the rising number of subscriptions and not least the large number of downloads of articles from the open access versions, the journal has made remarkable progress since its inaugural issue in 2012. When it comes to submissions, we are grateful that researchers worldwide now consider *Romantik* to be a significant channel for publishing frontier research.

When reflecting on romantic studies, which the journal aims to promote, it is clearly not a settled field. Taking stock of 'the state of the art' will show a series of different (and often contradictory) refractions of the discipline. There is an enduring interest in revising traditional and canonical romanticism, while others explore new spaces inhabited by the ignored or peripheral. Since the name 'Romanticism' was introduced as a denomination for literature and art produced in the decades around and after 1800, it has been a slippery term. The name partly postdates the movement it attempts to describe, and, in several countries, romantic works were produced long afterwards. For this reason, there has been an ongoing debate over what constitutes 'Romanticism', and whether this name could be with a capital letter and in the singular. In fact, some would argue, the 'romantic' in literature, arts, philosophy and science has been reworked and renegotiated so many times that the definition has been stretched to the point of breaking.

This is nothing new, of course. In 1924, the American historian Arthur O. Lovejoy observed in his 'On the Discrimination of Romanticisms' that the term had come to mean so much and so many different things that it had become virtually unusable as a singular definition. Thus, only a use of the term in the plural, *romanticisms,* would save it. The subtitle of the present journal shows agreement with Lovejoy's observations on plurality. We should remember that Lovejoy wrote several decades before the staggering proliferation of feminist, new historical, and minority studies, which have further expanded our sense of what qualifies as 'romantic'. To this must be added a now broader palette of national romanticisms (beyond the German, French, and English versions) which this journal has helped make available for critical view. Lovejoy foresaw the diversity of criticism that we accept as a condition of romantic studies today.

FOREWORD

Romantik sees an advantage in this diversity. We do not imagine a progression towards a final consensus. Instead, the journal aims to facilitate a dynamic vision of a widening horizon. That is to say, we need to better understand literary and artistic images already familiar, while also allow new images to appear before our sight perhaps for the first time. The research articles the editors have been able to accept for this issue are a good indication of how a challenging and multifaceted vision of romantic studies looks today. Not least, the geographies covered in this issue show a stimulating breadth: one article raises global issues (East vs. West), another trains the lens on the European network of romantic painting in Rome, yet another discusses the formation of a national tradition in the very periphery of Europe (Faroe Islands), and there is also a novel examination of the regional romanticism of Brighton. We are pleased to provide such a multiplicity of contexts, which also reach across the literature/art history divide. But, importantly, it is the aim of the journal to juxtapose the various local, national, and transnational romanticisms, because we believe that the connections and disconnections between them mean something. Our commitment is to an ongoing dialogue between romanticisms. This dialogue is our appeal to the tribunal of romantic studies. Welcome to *Romantik*.

The Editors

Byron's
Dis-Orienta

BYRON'S DIS-ORIENTATIONS:
THE GIAOUR, FOR EXAMPLE

CHRISTOPH BODE

[ABSTRACT]

This article examines the representation of 'the Orient' and the dichotomy between 'East' and 'West' in Byron's first 'Turkish Tale', *The Giaour* (1813). It argues that Byron's poem offers a more complex understanding of these relationships than has often been recognised by readings rooted to a greater extent in theoretical constructions of orientalism than in close attention to the narrative of *The Giaour*, its paratexts, and its engagement with contemporary historical events. Conversely, through a reading of the poem focused on these aspects, the article hopes to make clear that Byron stages not a simplistic dichotomy between 'East' and 'West', but rather the inevitable instability of borders and cultural identities.

KEYWORDS *Byron, British Romanticism, Orientalism, Cultural Identities, Hybridity*

Introduction

It is safe to say that in Lord Byron's oeuvre we find a radical dissolution of the dichotomy of identity and alterity, as well as of the dichotomies of authenticity and role-playing, of fiction and non-fiction, of fact and fake, since his epic and lyric poetry were read, in their own time, as revealingly autobiographical, while, curiously enough, at the same time the persona of Lord Byron can be shown to be a largely fictional construct that conforms to or follows the textual blueprint – all this in a drama that is supremely audience-related, because it is played out with the public (and not only with the reading public) as Lord Byron's sparring partner: it is a conspicuously public self-fabrication, or self-fashioning, to use Stephen Greenblatt's phrase.[1]

My theme in this essay is how that strategy to radically dismantle binary oppositions is also true, I would even say particularly true of Byron's *Oriental Tales*. They are a most pertinent example of how Byron generally processes alterity – and not surprisingly so, since, throughout the nineteenth century, the Orient is Europe's quintessential Other, the Other *per se*: 'we' define 'ourselves' against 'them' (no matter whether we denigrate or glorify the Orient, which is basically the same instrumentalization for purposes of self-constitution, only with the

Prof. Dr. Christoph Bode, professor of English Literature
at the Ludwig-Maximilians-Universität, Munich, Germany
Aarhus University Press, *Romantik*, 04, 2015, pages 9-25

values reversed).[2] For reasons of space, I will here restrict myself to one *Oriental Tale* only, to *The Giaour*.

A Matter of Perspectives

In his seminal study *British Romantic Writers and the East: Anxieties of Empire* Nigel Leask writes that Byron, in his *Eastern* or *Oriental* or *Turkish Tales*, reduces 'the imperialist Self to a level with its oriental Other; but in so doing he in effect perpetuates the prejudice of the 'East'/'West' binary opposition whilst attacking the ideology of empire which it empowers': 'he failed to break free of the sort of binary opposition constitutive of orientalism'.[3]

It seems to me that this surprising assessment is based on a curiously superficial reading of, for example, *The Giaour* (the first of Byron's *Turkish Tales*), a reading that is curiously content-oriented and does not really take into account the epic poem's perspectival structure, that is, its narratological mediation – which is all the more surprising since Leask himself says that *The Giaour* is 'the most structurally complex of all *Eastern Tales*'.[4] If that is so, and I believe it is, how can you talk about the What without having analyzed the How? How can you talk about the story without having analyzed the discourse?

I would like to show – taking *The Giaour* as but one example – that Leask's assessment, according to which Byron perpetuates simple binary oppositions, is deplorably mistaken, based as it is on a conspicuous under-reading of the text – an under-reading which may well be telling and symptomatic, because it is itself bound to a special agenda and a special perspective. By way of contrast, my take on Byron is that, from the very beginning – and that is why *The Giaour* as his first *Oriental Tale* is such a good example – he means to deconstruct and dis-assemble binary oppositions in a way that is both most skilful and most dis-orienting to the reader.

Presumably Byron wrote *The Giaour* between September 1812 and March 1813 – a first draft was circulated privately in that month. The first edition came out in June 1813. Meanwhile, his epic had grown from 453 to 684 lines, and that growth would continue until the 7th edition, published at the end of the same year. That final version sports the 1,334 lines we know today. In other words: the poem had grown threefold.[5]

Not only for Karl Kroeber was the result of all these additions 'confusion'.[6] After careful analysis, William Marshall opines 'that all the "fragments" in the poem . . . do not constitute a whole that we can piece together': 'he [Byron] badly weakened the poem'.[7]

But curiously enough – and this is even admitted by Byron's detractors – all these additions do not really affect the paraphrasable story of *The Giaour*, which is given away in the 'Advertisement' and then re-confirmed in Byron's longish note to the final line of the poem. Yet this very circumstance – that in a kind of framing, before the plot even begins, and then again, after it is over, we are told what the story will be, or what it was, retrospectively – is by no means accidental: *The*

Giaour itself (if by that title we only understand the verse) doesn't yield that story so easily. That is the reason why it is revealed before it begins and summarized when it is over. Between that beginning and that end we have Kroeber's 'confusion'. My contention is that even through that manoeuvre *The Giaour* cannot be closed and sealed and that its very openness is perfectly consistent.

Let us go into the text. At first, the 'Advertisement' as far as it summarizes the story:

The tale which these disjointed fragments present, is founded upon circumstances now less common in the East than formerly; either because the ladies are more circumspect than in the 'olden time'; or because the Christians have better fortune or less enterprise. The story, when entire, contained the adventures of a female slave, who was thrown, in the Mussulman manner, into the sea for infidelity, and avenged by a young Venetian, her lover[.][8]

The closing note for line 1334 reaffirms this with greater detail:

The circumstance to which the above story relates was not very uncommon in Turkey. A few years ago the wife of Muchtar Pacha complained to his father of his son's supposed infidelity; he asked with whom, and she had the barbarity to give in a list of the twelve handsomest women in Yanina. They were seized, fastened up in sacks, and drowned in the lake the same night! One of the guards who was present informed me, that not one of the victims uttered a cry, or shewed a symptom of terror at so sudden a 'wrench from all we know, from all we love'. The fate of Phrosine, the fairest of this sacrifice, is the subject of many a Romaic and Arnaout ditty. The story in the text is one told of a young Venetian many years ago, and now nearly forgotten. I heard it by accident recited by one of the coffee-house story-tellers who abound in the Levant, and sing or recite their narratives. The additions and interpolations by the translator will be easily distinguished from the rest by the want of Eastern imagery; and I regret that my memory has retained so few fragments of the original.[9]

Consequently, critics who are primarily interested in 'content' are prone to say that *The Giaour* is about how Leila, the most attractive slave in Hassan's harem, betrays him with an infidel. Upon finding out, Hassan kills her by drowning, but is in turn killed by her lover, who then flees.

But this very simple story – Kroeber says 'a silly story'[10] – is a constructed abstraction, like every *histoire* is bound to be, which, however, in this particular case, is incredibly complicated by two circumstances on the discourse level, which are mentioned in the 'Advertisement' and in the final note, namely: first, what we are given is said to be a heavily fragmented text, whose few surviving parts are 'disjointed', and, second, the text has more than one narrator – in fact, far more than one narrator: for I count two extradiegetic narrators (to wit, the 'coffee-house story-teller' and the 'translator' with all his 'additions and interpolations') and no fewer than three intradiegetic narrators (viz., the Muslim fisherman, the

Christian monk, and the Giaour himself), to which we may add (or not) two directly presented voices (Hassan's and his mother's; Plato's mimesis, as opposed to *haplê diêgêsis*),[11] voices that, it is true, are used dramatically without having a full blown story to tell, but that imply a perspective of their own nevertheless. That makes seven different narrators, seven different points of view, seven different perspectives, seven different takes on the story.

When I say 'I count', that is not an inappropriate personal intrusion, for others count differently and the assignment of certain passages to any of these narrators differs, for example: does the Muslim fisherman tell the greatest part of the story up until the Giaour flees or only those scenes that he witnessed himself? Is the dreadful curse against the Giaour hurled by the fisherman or by the extradiegetic 'coffee-house story-teller'? Our secondary literature is full of surprises, but this confusion is caused by the text itself: exactly because it consists of 'disjointed fragments', which are not always marked in an unequivocal way and analytically discrete (Kroeber complains 'all of [these changes], which occur with unnerving abruptness'),[12] and because we have to deal with up to seven narrators on different discursive levels, this assignment of individual fragments to distinct voices and perspectives is a *task* of interpretation – and it is a job at which a simple plot summary, not even Lord Byron's own, is of no great help. Like in a prism, the fragments of a purportedly 'original story' are displayed, which seem to reflect 'one and the same', which, however, since it is only given in this fragmentary and subjectively refracted way, is not 'one and the same'. Fragmentation and multiple narrations disperse what 'really' happened – because in the foreground, in this discourse, we have points of view, perspectives, evaluations. It is *between* these separate views that the space of possibilities of *The Giaour* unfolds, a multi-dimensional space that cannot be paraphrased in a uni-linear way, but that can only be disclosed and traced in its narrative technique and in its dynamism.

As Robert Gleckner once remarked (only to veer off into a completely different direction): 'Byron's main interest . . . was not in the plot . . . but rather in the conflicting points of view from which that plot could be viewed'.[13] *The Giaour* works with rapid cuts and radical changes of perspective. If you cannot follow swiftly or prefer to ignore that narrative *mediation* altogether, as if it did not matter, then you easily become an under-reader and you drown the text – death by drowning (and, of course, *this* reference is not to *The Waste Land*, but to Hassan's drowning of Leila).

The first change of perspective that the Christian, European reader must register is in the title: *Giaour* is, as we are told by the footnote, another expression for 'infidel', which means that from a Muslim point of view one of us is called an infidel, a pagan. This ascription remains. The Giaour will never acquire a proper name. He will remain (at first only from a Muslim perspective) an unbeliever. 'We' are 'they'. The title signals: this story will be told from the POV of the Other. This requires re-thinking: the true believers, that's the pagans; and the unbelievers, that's us.

But when the poem proper begins, we unmistakably read the discourse of a *European*, who complains that Greece has fallen victim to Oriental tyranny and despotism, though not without her fault:

> 'T were long to tell, and sad to trace,
> Each step from splendour to disgrace,
> Enough—no foreign foe could quell
> Thy soul, till from itself it fell,
> Yes! Self-abasement pav'd the way
> To villain-bonds and despot-sway.[14]

This continues to line 167. With line 168, the tale proper sets in, but 168 to 179 could be ascribed either to the 'coffee-house story-teller' or, with higher probability, to the 'translator', whose interpolation the passage could be. One still waits for the true, undeniable voice of the Orient. That begins with line 180, though we can only tell so from 190 onwards, retrospectively:

> And though to-morrow's tempest lower,
> 'T is calmer than thy heart, young Giaour!
> I know thee not, I loathe thy race,
> But in thy lineaments I trace
> What time shall strengthen, not efface;
> Though young and pale, that sallow front
> Is scathed by fiery passion's brunt,
> Though bent on earth thine evil eye
> As meteor-like thou glidest by,
> Right well I view and deem thee one
> Whom Othman's sons should slay or shun.[15]

The Giaour, fleeing at night, is called a member of a loathsome race, 'Whom Othman's sons should slay or shun'. But who's talking? Is it the fisherman, who, in a glimpse, sees the Giaour, whose life he had possibly crossed once before, and fatefully so, when he – the fisherman – lent his boat to an Emir to sink or drown 'some precious freight'.[16] (What exactly this might have been, we are never told, but is it possible, after the hint in the 'Advertisement' to take in that information in a neutral way?). Or is this, for the first time, the second extradiegetic narrator, the Muslim 'coffee-house story-teller', who, unrestrainedly, gives vent to his hatred of Christians? Much in the same way that before the European extradiegetic narrator had expressed his hatred of Oriental despotism?

Now, no matter how you read it and no matter how you identify the narrative levels here (extradiegetic narrator or intradiegetic narrator?):[17] here, just like in the speech of the Christian monk at the end, what is primarily displayed and accentuated is that these narrators are so imprisoned in their own belief systems that they cannot help but seeing the Other in such a way, as opposite in a di-

chotomy.[18] But 'multiple narration'[19] in Byron's *The Giaour* places these partial, but self-privileging views *against each other* in such a way that their deficits and their differences become obvious and manifest,[20] no less – and maybe more importantly so – than their deep affinities and similarities.

An ideology that cannot bear any ambiguities is exquisitely displayed in Hassan, when he recognizes *who* it is that ambushes him with a band of robbers:

> In fuller sight, more near and near,
> The lately ambush'd foes appear,
> And issuing from the grove advance
> Some who on battle charger prance. —
> Who leads them on with foreign brand,
> Far flashing in his red right hand?
> " 'T is he!—'t is he!—I know him now;
> I know him by his pallid brow;
> I know him by the evil eye
> That aids his envious treachery;
> I know him by his jet-black barb,
> Though now array'd in Arnaut garb,
> Apostate from his own vile faith,
> It shall not save him from the death;
> 'T is he! well met in any hour,
> Lost Leila's love—accursed Giaour!"[21]

Repeating his identification in a kind of staccato, Hassan insists that he can see through appearances and that he knows reality, the core of evil. Although 'array'd in Arnaut's garb', that is, in the clothes of a Muslim Albanian, it's *him*, the Christian! In a typical confusion that you find often in racists and fundamentalists alike, the stranger is charged both with adhering to his original faith and with having rejected his faith. The assimilated foreigner is only the most cunning of all strangers.

But if the Giaour once rejected his Christian faith – be it seriously or simply to conform – or if he now rejects his Christian faith (in order to deceive – though on his flight his 'Christian crest' can be seen again), his return to the bosom of the church is no less problematic, it is dubious and fishy.[22] For this is the way in which the friar, to whose monastery the Giaour fled some six years ago sees him:

> " 'T is twice three years at summer tide
> Since first among our freres he came;
> And here it soothes him to abide
> For some dark deed he will not name.
> But never at our vesper prayer,
> Nor e'er before confession chair
> Kneels he, nor recks he when arise

Incense or anthem to the skies,
But broods within his cell alone,
His faith and race alike unknown.
The sea from Paynim land he crost,
And here ascended from the coast,
Yet seems he not of Othman race,
But only Christian in his face:
I'd judge him some stray renegade,
Repentant of the change he made,
Save that he shuns our holy shrine,
Nor tastes the sacred bread and wine.
. . .
Saint Francis! keep him from the shrine!
Else may we dread the wrath divine
Made manifest by awful sign.—
If ever evil angel bore
The form of mortal, such he wore—
By all my hope of sins forgiven
Such looks are not of earth nor heaven!"[23]

Twice the Giaour has crossed the line that separates binary oppositions – that makes him a kind of hybrid, a doubtful candidate, he is unclassifiable: 'his faith and race alike unknown' – like any Own that returns as Other, he is uncanny. If he stands identified in a definite way (four times 'I know him'), he is subject to the logic of mutual assured destruction ('It shall not save him'); as religiously and ethnically un-identifiable, he lives in the isolation of him that never belongs anywhere ('For he declines the convent oath, / And leaves those locks' unhallowed growth, / But wears our garb in all beside[.]'[24]): 'The Giaour's status as between cultures, neither Christian nor Muslim, should complicate any reading that casts him and Hassan as binary opposites representing two perennially antagonistic civilizations'.[25]

But the Giaour is not the only character in *The Giaour* that can be read as a hybrid figure that questions easy dichotomy. Leila, the Giaour's great love and ideal woman – 'The bird that sings within the brake, / The swan that swims upon the lake, / One mate, and one alone, will take' – is sometimes read as a personified ideal or, allegorically, as Greece, as for example, McGann does in his early *Fiery Dust*:

She is deliberately associated with the natural paradise of the landscape (473-518) and represents that perfection toward which both Hassan and the Giaour are impelled. At the level of the political allegory she represents the land over which the Turks and the Venetians have been fighting for centuries, . . . [t]hus, if Leila's love for the Giaour seems horrifying to a Turkish sensibility . . ., her conduct is perfectly understandable at the level of the political allegory.[26]

Her attempt to be no longer the sex object of an Oriental tyrant ('A soulless toy for tyrant's lust') would then be the allegory of the Greek fight for independence. But such readings rob Leila of all ambiguity: after all, she is a Cherkessian, that is, a fair-skinned Caucasian of Muslim creed.[27] In the love triad of the Giaour, Hassan and Leila, she is the Third that is not 'naturally' assignable, because one aspect of hers points to one partner, another to the other. The fair-skinned Muslima, married to one, but having a love relationship with the other, cannot be related in an un-ambiguous, unequivocal way – she is no personification of purity or perfection, but an embodiment of blending and hybridity, as Alan Richardson spells out: 'In Orientalist discourse, Circassia is associated not only with luxuriousness (because of the fabled beauty of its women) but with hybridity as well, as a region of fair-skinned, blue-eyed Muslims'.[28]

The text plays around this undecideability with a mirror-like reflection of the binary concepts of 'true/untrue' and 'faithful/faithless', and 'fidelity/infidelity': if Leila is the Giaour's true love, then she was not untrue to him but true; and he would have sanctioned her fidelity as a wife – infidelity to him – in basically the same way that Hassan punished her for her unfaithfulness towards him. In the words of the Giaour:

> Still, ere thou dost condemn me—pause—
> Not mine the act, though I the cause;
> Yet did he but what I had done
> Had she been false to more than one;
> Faithless to him—he gave the blow,
> But true to me—I laid him low;
> Howe'er deserv'd her doom might be,
> Her treachery was truth to me;
> To me she gave her heart, that all
> Which tyranny can ne'er enthrall;
> And I, alas! too late to save!
> Yet all I then could give, I gave,—
> 'T was some relief,—our foe a grave.[29]

'Faithful' and 'faithless', 'fidelity' and 'infidelity' – that these are reciprocal assignments, mutual ascriptions we know since the very title of poem, *The Giaour*, points us to it. *Infidel* means Christian, believer. *Faithful* means pagan, Muslim. And then religious orthodoxy and marital fidelity, just like their opposites, are firmly associated with each other: 'The faithless slave that broke her bower, / And, worse than faithless, for a Giaour!–'.[30] But the logic of unfaithfulness and fidelity is only a sub-case of the clash of civilizations: 'Her treachery was truth to me'. True fidelity shows in being untrue to the Other.

There is, however, with regard to the triangle of gender relations, one basic, decisive difference to the pure reciprocity of semiotic ascriptions: primarily, Leila's assignation is undecidable because, in this sea of voices, *she* is not given a

voice of her own. Leila, hybrid object, is only the silent signifier that rules the relationship of the Giaour and Hassan. And this silence even translates to the undecidable pronunciation of her name: it *could* be Li:la, it *could* be Leila. Since, unlike 'Giaour', 'Leila' is never in the end position of one of *The Giaour's* couplets, its pronunciation is perfectly undecided; what is more: lines 1118–1119 suggest Leila, whereas 1210–1211 suggest Li:la.

But this relationship between the Giaour and Hassan is not strictly symmetrical: although the Giaour himself is hybrid, he can only perceive his Other in a strictly dichotomous way, exactly like Hassan sees him. The Giaour is hybrid, but this does not necessarily inform the way he looks at the world. In their unbridled hatred of the Other and in their will to totally annihilate the Other, they are uncannily similar to each other, if not identical.

Their deadly embrace is so graphically described as a sexual union of lovers that to identify a homosexual subtext doesn't seem far-fetched,[31] a sub-text whose covert message would read: the men can have intercourse in death as soon as the woman (only the *seeming* object of desire, which superficially acts as a go-between for the two of them) has been discarded – she was not really the object of desire, she was the obstacle of desire's fulfilment:

> Ah! fondly youthful hearts can press,
> To seize and share the dear caress;
> But Love itself could never pant
> For all that Beauty sighs to grant,
> With half the fervour Hate bestows
> Upon the last embrace of foes,
> When grappling in the fight they fold
> Those arms that ne'er shall lose their hold;
> Friends meet to part—Love laughs at faith;
> True foes, once met, are joined till death![32]

In the description of their fight, it is truly difficult to keep their identities apart, as disjointed pronouns and severed hands fly around:

> With sabre shiver'd to the hilt,
> Yet dripping with the blood he spilt;
> Yet strain'd within the sever'd hand
> Which quivers round that faithless brand;
> His turban far behind him roll'd
> And cleft in twain its firmest fold[.][33]

This resembles the deadly fight between Humbert Humbert and Clare Quilty at the end of Nabokov's *Lolita*.[34] As the two *doppelgänger* are rolling on the floor, the atmosphere heats up, gets steamy, and who is who is by no means clear – after all, both of them are in Oriental dress. (As John Lennon sang in 'I Am the Walrus': 'I

am he as you are he and you are me and we are all together'.) It is only in line 669 that we learn: Hassan is in the inferior position, he has lost.

But what on earth has happened to the Giaour? He, who could invariably be identified by the colour of his face ('I know him by that pallid brow' or 'young and pale, . . . sallow front'), now looks like Hassan: 'And O'er him bends that foe with brow / *As dark as his that bled below—'.*[35] There is an uncanny similarity between him and his deadly foe, in the hour of his triumph, he has turned into the spitting image of his Other.

> 'Yes, Leila sleeps beneath the wave,
> But his shall be a redder grave;
> Her spirit pointed well the steel
> Which taught that felon heart to feel.
> He call'd the Prophet, but his power
> Was vain against the vengeful Giaour:
> He call'd on Alla—but the word
> Arose unheeded or unheard.
> Thou Paynim fool!—could Leila's prayer
> Be pass'd, and thine accorded there?
> I watch'd my time, I leagu'd with these,
> The traitor in his turn to seize;
> My wrath is wreak'd, the deed is done,
> And now I go—but go alone.'[36]

The two have become interchangeable. When the Giaour says at the end, 'Yet did he but what I had done', he recognizes this reciprocity which includes functional interchangeability. Facing the dying Hassan, he encounters his own countenance:

> One cry to Mahomet for aid,
> One prayer to Alla—all he made:
> He knew and crossed me in the fray—
> I gazed upon him where he lay,
> And watched his spirit ebb away;
> Though pierced like Pard by hunters' steel,
> He felt not half that now I feel.
> I search'd, but vainly search'd to find,
> The workings of a wounded mind;
> Each feature of that sullen corse
> Betrayed his rage, but no remorse.[37]

As a character, the Giaour is definitely *not* an all-understanding, all-relativizing multi-cultural hero, quite the contrary: he is a rigidly categorizing automaton, which even denies himself any freedom of the will to repeat a quote:

> Still, ere thou dost condemn me—pause—
> Not mine the act, though I the cause;
> Yet did he but what I had done
> Had she been false to more than one;
> Faithless to him—he gave the blow,
> But true to me—I laid him low[.][38]

It is not his reflection, but his *deeds* that make him cross borderlines and turn him into an outlaw. In this narrative, he will be forever united with his most beloved and with his most hated: 'This broken tale was all we knew / Of her he lov'd, or him he slew'.[39] I the end, he is buried in a nameless grave: forever an infidel, *whichever way you look at it/him*: the *Giaour*. That is an acquired, an earned name. If it is true to say that the Giaour is an early Byronic hero (remember that this first *Turkish Tale* was published immediately after *Childe Harold I* and *II*), then it is also true to say: the Byronic hero is always the stranger,[40] because he was where he did not belong and, having returned, does not belong anywhere any more.

The Giaour, as a character, insists on the power of unconditional love, on fate, destiny and determination, he insists on how one thing led to another, inevitably. But that is nothing but a means of characterization, a way to show what makes him tick. The discourse of *The Giaour* itself tells a different story. It does *not* show how one thing led to another, how every effect became in turn the cause of another effect, and so on and so forth. Rather, it shows in momentary glimpses a totally broken and dispersed chronology: first a flight, then a mother bewailing her dead son, then the sinking or drowning of something in the sea, Hassan pursuing somebody, an ambush and the killing of Hassan . . . – it is evident (is it not?) that in order to make a story out of that, one would have to *tell* it first. It has to be constructed. And *The Giaour* shows that different narrators construct *different* stories. *That* is the story that is told in *The Giaour*. And that to dichotomize the world is self-defeating, because dichotomies (and less so binary oppositions) aim at the destruction and annihilation of what is identified as the Other, which, once this is achieved, makes you realize that the Other you killed was your spitting image, your uncanny *doppelgänger*. Thus, far from re-affirming well established binary oppositions and far from perpetuating dichotomies, Byron's is an entirely different ball game: 'Byron sets up dichotomies only to undermine them throughout the poem'.[41] He uses the Orient only to dis-orient his readers.

The Paratexts

But that is not only true for the *poem*, it is also true for the *paratexts*, viz. for the 'Advertisement' and the final note, which seemingly serve the function to close *The Giaour*, exactly because the fragments themselves do not form a coherent whole. In the final note it says about the drowning of 12 women who were accused of infidelity: 'The fate of Phrosine, the fairest of this sacrifice, is the subject of many a Romaic and Arnaout ditty'.[42] 'Many a Romaic and Arnaout ditty'? – as

Barbara Ravelhofer notes that is written 'with wicked imprecision', for Arnaouts are Muslim Albanians, especially such as would fight as legionaries in the Ottoman army.[43] But 'Romaic' means 'modern Greek' and, by implication, 'Greek-Orthodox'. That is not a blatant contradiction (as Ravelhofer thinks) if this is meant to say: one and the same *donnée*, or subject matter, is handed down *both* in Albanian *and* Greek songs, in *both* an Albanian *and* a Greek tradition, with *both* Muslim *and* Christian perspectives.

Taking into account the perspectival structure of Byron's *The Giaour*, his narrative long poem would be the dramatization of a polyphony, which, with regard to the *general* story had been there all along, but which is now presented in *one* narrative. The two extradiegetic narrators – the Muslim 'coffee-house story-teller' and the European 'translator' with all his 'additions and interpolations' – lend a bi-vocality to the text, which is then blown up by various intradiegetic narrators and dramatized voices to a fully-fledged polyphony. *The Giaour* is a heterogeneous text, a hybrid, 'Romaic *and* Arnaout'. Whoever expects full disclosure about (and *closure of*!) this discourse from the final note – this *or* that – will be informed: *both and*. As much as the final note tries to close the tale, it also signals in these three words 'Romaic *and* Arnaout' that this pure given can only ever be the starting point for all the different discourses that derive from that *donnée*. *The Giaour* is a dramatization of multi-perspectivity and of polyphony. And since this plurality of voices and perspectives is not terminally integrated, they perpetually relativize and undercut each other: perspectivism is the *theme* and the undercutting of binary oppositions is the *main operating mode* in this de-frosting of signs signifying Identity and Alterity, Own and Other. It is only if, like Nigel Leask, you underestimate or even totally ignore the importance of *narrative mediation* that you are bound to miss this point. Then, and only then, will you be satisfied with a summary or a paraphrase of the supposed 'content' of the poem. Any such summary, however, will miss the point of the text – the purpose for which it was written – to the degree that it ignores the How of the What. The meaning of *The Giaour* is definitely not that a woman is killed by drowning and that it shows Oriental despotism from a European perspective. The meaning of *The Giaour* is what you can do with this, for example, that this woman would have suffered the same fate if untrue to her Christian lover, which takes the question of despotism out of the confrontation of Orient vs. Occident and transposes it to the level of gender relations; or that over the silent dead, there reigns the patriarchal hegemony of Hassan *and* the Giaour, which, in turn, is set to relativize the Other it produces and to eventually dissolve it.

Therefore, I believe, it is not a frivolous analogy to say: if you think that *The Giaour* reaffirms Orientalist dichotomies, then you sink the meaning of the poem, like Leila, 'into the sea for infidelity'.[44] Fortunately, we now know what to make of such totalizing readings that ignore or negate Byron's disorientations.

Byron's 'Advertisement' is no less fertile, semiotically speaking, than the end-note. For after the rough summary it says about the point in time at which this story is supposed to have 'really' happened:

[A]t the time the Seven Islands were possessed by the Republic of Venice, and soon after the Arnauts were beaten back from the Morea, which they had ravaged for some time subsequent to the Russian invasion. The desertion of the Mainotes, on being refused the plunder of Misitra, led to the abandonment of that enterprise, and to the desolation of the Morea; during which the cruelty exercised on all sides was unparalleled even in the annals of the faithful.[45]

Not only the modern reader would benefit from having this explanation, as it were, 'explained' (which even the perfect editor Jerome McGann does not provide entirely): the 'Seven Islands' are the Ioanian Islands, also called *Eptannissa*; Arnaouts, we have heard, are Muslim Albanian serving the Ottomans; the Morea is the Peloponnes; Maina or Mani the 'middle finger', the peninsula of the peninsula, inhabited by the Mainotes. It helps to know that in 1770 a relatively small Russian expeditionary force had tried to occupy the Peloponnes. But why the insurgent Greek Mainotes should have had an interest to loot the Greek city of Misitra (Mistrás, near Sparta) and why, once they were denied this, they withdrew and did not want to rebel against Turkish repression remains a mystery, just like McGann's assessment that the story is set 'shortly after 1779, when Hassan Ghazi broke the forces of the Albanians (i.e. the Arnaouts) in the Morea' is only puzzling.[46] So, Greeks want to plunder Greek cities and they withdraw, in a huff, once they are denied this, and then the Ottoman army commander Hassan Ghazi drives the Muslim Albanians who fight for the Ottoman Empire out of the Turkish occupied Peloponnes. Is this madness?

It *is* confusing, but Byron doesn't create this confusion, he only makes use of it to dis-orient the reader once more. It is true that in 1770 the Russians, playing their power game, had sent 500 men to the Peloponnes to incite the Mainotes to rebellion, who, however, were disappointed by the smallness of the Russian contingent – as well as suspicious, since they were expected to swear an oath of allegiance to Catherine the Great. Small initial successes of the insurgents were quickly annihilated as the Sublime Porte sent in thousands of Albanians to repress the rebellion. Russians and Greeks were beaten:

The successes of the Albanians were marked by the greatest cruelty: the country was ravaged, the people massacred without mercy, often merely to find a pretext for carrying off the young women and children to be sold as slaves. The pasha of the Morea endeavoured in vain to arrest these atrocities. He proclaimed an amnesty; and, as far as his power extended, his humanity restored order and confidence; but over the greater part of the peninsula the Albanian irregular bands remained for some years masters and tyrants of the province.[47]

But although the Russians after that returned with a bigger fleet and won the battle of Tchesmé so that Constantinople now lay before them unprotected, they soon lost interest in the Greek theatre of war and in 1774, in the peace of Kainardji, abandoned the Greeks to their fate: 'The Greeks, who had been cajoled and

bribed to rebel, were abandoned to their fate as soon as their services were useless to Russian interest . . . [I]n this treaty the Greeks of the Morea and the islands were sacrificed by Russia'.[48] What remained, were the Albanians: 'The Albanians who had entered the Morea established themselves permanently in companies throughout the peninsula, and collected the taxes on their own account, besides extorting large sums by cruel exactions, under the pretence of obtaining arrears of pay due to them by the Porte'.[49] This terror was at first tolerated by the Turks, maybe because the cruelty of the Russians and the Mainotes against the Muslims living in the Peloponnes was not yet forgotten:

The peace with Russia could not make the Turks forget the cruelty with which their countrymen had been massacred in the Morea; and for several years the Greeks were everywhere subjected to constant supervision and increased oppression. The cruelties of the Albanians were tolerated even after their rapacity became so great that many Turks as well as Greeks were ruined by their exactions, and compelled to abandon their property, and escape to other parts of the empire.[50]

Only when the complaints of both Christians and Muslims alike could no longer be ignored did Constantinople send in Hassan Ghazi (in 1779) to evict the Albanians:

The reiterated complaints of the disorders perpetrated by the Albanians in the Morea, both by Mussulmans and Christians, at length determined him to restore tranquillity to that valuable province. Hassan, whose victory over the Russians at Lemnos had gained him the title of Ghazi (the Victorious), had been raised to the rank of capitan-pasha. In the year 1779 he was ordered to reduce the Albanians to obedience and re-establish order in the Morea. With his usual promptitude in action, he landed a considerable force at Nauplia, and marched with a body of four thousand chosen infantry, and the cavalry collected by the neighbouring pashas, to attack the Albanians, who had concentrated a large part of their troops at Tripolitza. The Albanians, confident in their numbers and valour, marched out to engage the little army of the capitan-pasha in the plain, and were completely defeated by the steady valour of the infantry, and by the fire of the artillery. After this victory Hassan hunted down the dispersed bands of the Albanians over the whole peninsula, and exterminated them without mercy. The heads of the chieftains were sent to Constantinople, and exposed before the gate of the Serai, while a pyramid was formed of those of the soldiers under the walls of Tripolitza, the remains of which were seen by travellers at the end of the last century.[51]

So it is true that the Ottomans fought the Muslims without mercy '[and] the Maniates [sic], who feared the Albanians more than the Turks, had deputed Zanet Koutouphari, one of their chiefs, to wait on Hassan at Rhodes in 1777 to solicit an amnesty for the part they had taken in the Russian war, to assure the capitan-pasha of their devotion to the sultan's government, and to claim his protection'.[52]

This, then, is the gist of this history: the Christian Mainotes eventually found

relative peace under the Ottoman Muslims after the terror regime of other Muslims and after they themselves had barbarously waged terror against infidels. That was only 34 years ago, when Byron wrote *The Giaour*. As confusing as it may have sounded, it is all true what Byron writes in his 'Advertisement'. *In real history*, these simple dichotomies are dissolved and Byron merely reminds his readers of these facts, or, if they did not know, he dis-orients them by dissolving their simplistic ideas of the Orient, of 'East' vs. 'West', of Christianity vs. Islam, and so on and so forth.

To quote once more from the 'Advertisement: '[T]he desolation of the Morea, during which the cruelty exercised *on all sides*', that is clear enough, but here comes the true stroke of genius: 'was unparalleled even in the annals *of the faithful*' (emphases added). Now who is that, after all that's been said? 'They' or 'us'? *Whose* annals, when it is conceded that cruelty was exercised on *all* sides, whose annals record unparalleled cruelty?

The Giaour knows an answer of Delphic wisdom: We – that is, the others. Ours – that is, theirs.

This has less of Arthur Rimbaud's 'Je est un autre', and more of Julia Kristeva's 'Nous sommes étrangers à nous-mêmes': We are strangers to ourselves.

Notes

1 This argument is made at greater length in Christoph Bode, *Selbst-Begründungen: Diskursive Konstruktion von Identität in der britischen Romantik, I: Subjektive Identität* (Trier: Wissenschaftlicher Verlag Trier, 2008), 117–43, and in Christoph Bode, *Fremd-Erfahrungen: Diskursive Konstruktion von Identität in der britischen Romantik, II: Identität auf Reisen* (Trier: Wissenschaftlicher Verlag Trier, 2009), 265–86.

2 The controversy over how well Byron knew the Orient is by no means over: in the pro camp we find Oueijan (Naji Oueijan, *A Compendium of Eastern Elements in Byron's Oriental Tales* [Frankfurt/ Washington, D.C.: Peter Lang, 1999]) and Sharafuddin (Mohammed Sharafuddin, *Islam and Romantic Orientalism: Literary Encounters with the Orient* [London/New York: Tauris, 1994]), but, particularly with regard to *The Giaour*, we see Marandi take up the opposite position (Seyed Mohammed Marandi, 'Byron's Infidel and the Muslim Fisherman', *Keats-Shelley Review* 20 [2006]: 133–55). Edward Said, in his *Orientalism: Western Conceptions of the Orient* (Harmondsworth: Penguin, 1991), by the way, seems to have totally ignored Byron's *Oriental Tales* – in *Orientalism*, the name of Byron appears only in enumerative lists; the only passage that mentions a work of Byron's – *The Giaour*, interestingly enough – reads like this: 'the Orient is a form of release, a place of original opportunity' (Said, *Orientalism*, 167). I find it difficult to relate this to anything in *The Giaour*.

3 Nigel Leask, *British Romantic Writers and the East: Anxieties of Empire* (Cambridge: Cambridge University Press, 1992), 4 and 24.

4 Ibid., 29.

5 Not only with regard to dating and the variants, Jerome McGann's 7-volume edition of Byron's *Complete Poetical Works* sets the benchmark (Oxford: Oxford University Press, 1980–1993); cf. here vol. 3, 406ff. In this essay, quotes refer to Jerome McGann, *Lord Byron: The Major Works*, Oxford World's Classics (Oxford: Oxford University Press, 2000), which is based on *The Complete Poetical Works*.

6 Karl Kroeber, *Romantic Narrative Art* (Madison/Milwaukee/London: University of Wisconsin Press, 1966), 140.

7 William H. Marshall, 'The Accretive Structure of Byron's *The Giaour*', *Modern Language Notes* 76 (1961): 502–9.

8 McGann, *Byron: The Major Works*, 207.

9 Ibid., 246.

10 Kroeber, *Romantic Narrative Art*, 139.

11 Cf. Christoph Bode, *The Novel: An Introduction* (Oxford: Wiley-Blackwell, 2011), 105.

12 Kroeber, *Romantic Narrative Art*, 140.

13 Robert F. Gleckner, *Byron and the Ruins of Paradise* (Baltimore, MD: Johns Hopkins, 1967), 97; cf. also David Seed, ' "Disjointed Fragments": Concealment and Revelation in *The Giaour*', *The Byron Journal* 18 (1990): 13–27, here 17 and 25.

14 McGann, *Byron: The Major Works*, 207ff., ll. 136–41.

15 Ibid., ll. 189–99.

16 Ibid., l. 362.

17 For example, Marilyn Butler, 'The Orientalism of Byron's *Giaour*', in *Byron and the Limits of Fiction*, eds. Bernard Beatty and Vincent Newey (Liverpool: Liverpool UP, 1988), 87, and Karl Kroeber, *Romantic Narrative Art* (p. 140), attribute this to the *fisherman*, but Jerome McGann to the extradiegetic narrator. Cf. Jerome McGann, *Fiery Dust: Byron's Poetic Devlopment* (Chicago: University of Chicago Press, 1968), 144–6.

18 On selective cognition in *The Giaour*, cf. Frederick W. Shilstone, 'Byron's *The Giaour*: Narrative Tradition and Romantic Cognitive Theory', *Research Studies of Washington State University* 48 (1980): 94–104; and, in a conspicuously negative assessment, Kroeber, *Romantic Narrative Art*, 140: 'Byron tries to charge the relatively simple sequence of incidents in *The Giaour* with fearful emotions by recounting it through different narrators, whose observation is limited or whose understanding of events is partial. The result, however, is bewilderment rather than suspense'.

19 McGann, *Fiery Dust*, 144.

20 Cf. Bernard Beatty, 'Calvin in Islam: A Reading of *Lara* and *The Giaour*', *Romanticism: The Journal of Romantic Culture and Criticism* 5 (1999): 70–86, here 73.

21 McGann, *Byron: The Major Works*, 207ff., ll. 604–19.

22 Ibid., l. 256.

23 Ibid., ll. 798–815 and 909–15.

24 Ibid., ll. 899–901.

25 Alan Richardson, 'Byron's *The Giaour*: Teaching Orientalism in the Wake of September 11', in *Interrogating Orientalism: Contextual Approaches and Pedagogical Practices*, eds. Diane Long Hoeveler and Jeffrey Cass (Columbus, OH: Ohio State UP, 2006), 213–23, here 220; see also Gleckner, *Byron*, 111: 'to the Muslim and Christian world, in neither of which the Giaour has a place, his end is fitting and proper'. Cf. Beatty, 'Calvin', 277).

26 McGann, *Fiery Dust*, 156. For the line 'The bird that sings . . .', cf. McGann, *Byron: The Major Works*, 207ff., ll. 1169-71.

27 The quoted line is from McGann, *Byron: The Major Works*, 207ff., l. 490.

28 Richardson, 'Byron's *The Giaour*', 221.

29 McGann, *Byron: The Major Works*, 207ff., ll. 1060-72.

30 Ibid., ll. 535-6.

31 Cf. Abigail F. Keegan, *Byron's Othered Self and Voice: Contextualizing the Homographic Signature* (New York: Peter Lang, 2003); Jeffrey L. Schneider, 'Secret Sins of the Orient: Creating a (homo)textual Context for Reading Byron's *The Giaour*', *College English* 65 (2002): 81-96; and Richardson, 'Byron's *The Giaour*', 220).

32 McGann, *Byron: The Major Works*, 207ff., ll. 645-54.

33 Ibid., ll. 655-60.

34 'We fell to wrestling again. We rolled all over the floor, in each other's arms, like two huge helpless children. He was naked and goatish under his robe, and I felt suffocated as he rolled over me. I rolled over him. We rolled over me. They rolled over him. We rolled over us'. Vladimir Nabokov, *Lolita* (Harmondsworth: Penguin, 1989), 297.

35 McGann, *Byron: The Major Works*, 207ff., ll. 194 and 673-4; emphasis added.

36 McGann, *Byron: The Major Works*, 207ff., ll. 675-88.

37 Ibid., ll. 1082-92.

38 Ibid., ll. 1060-5.

39 Ibid., ll. 1333-4.

40 Cf. Sharafuddin, *Islam*, 214.

41 Richardson, 'Byron's *The Giaour*', 219.

42 McGann, *Byron: The Major Works*, 246.

43 Barbara Ravelhofer, 'Oral Poetry and the Printing Press in Byron's *The Giaour* (1813)', *Romanticism* 11 (2005): 23-40, here 23.

44 McGann, *Byron: The Major Works*, 207.

45 Ibid.

46 Ibid., 1034.

47 George Finlay, *The History of Greece under Othoman and Venetian Domination* (Edinburgh/London: William Blackwood and Sons, 1856), 313-4.

48 Ibid., 321 and 322.

49 Ibid., 321-2.

50 Ibid., 323.

51 Ibid., 323-4.

52 Ibid., 324.

Friendships and Portraits

FRIENDSHIPS AND PORTRAITS IN THE AGE OF ROMANTICISM
REFLECTIONS ON EIGHT PORTRAITS BY C. A. JENSEN

SINE KROGH

[ABSTRACT]

Friendships play an important part in our lives, but few of us think about how the cultural convention of friendship makes us act. Studies of the nineteenth century show that during the period of German romanticism it became fashionable amongst poets, writers, and artists to celebrate and visualize friendships. In the 1810s, Rome seemed the perfect incubator for young artists forming friendships and cultivating artistic communities. The most remarkable output of the painter C. A. Jensen's Italian sojourn, starting in 1818, was eight small portraits of his circle of friends. These portraits reflect the importance of fellowship, of networking amongst friends and also what Rome meant to young artists in terms of finding one's artistic identity. The aim of this article is to illuminate how a romantic culture of friendship influenced C. A. Jensen's decision to paint his circle of friends at Rome. Taking Jensen's portraits as its point of departure, the article touches upon some artistic and sociological aspects of friendships in the age of romanticism.

.

KEYWORDS *Artist Identity, Rome, Transition, Culture of Friendship, the Nazarenes*

In an early self-portrait (ill. 1), made in Copenhagen in 1815, C. A. Jensen (1792–1870) depicts himself at a desk with a pair of compasses and a piece of chalk lodged in a holder, pointing to the importance of accuracy and sketching from life. On the wall behind the artist are two small portraits of his parents and a copy of the Greuze painting *Girl with a Dog*. The presence of the tools reflects a young man still training at the Royal Danish Academy of Fine Arts, while the portraits of his parents were his debut works as a portrait painter, shown at the Charlottenborg exhibition at the Academy the previous year. Jensen was the son of hard-working burghers and with this painting he clearly paid tribute to his parents who partly paid for his training. In 1816, the artist had to break off his training as his parents could no longer support him financially.[1] From that point onwards, he had to support himself and went first to Flensburg in 1817 to paint portraits and later that year to Dresden, where he stayed until 1818. As Jensen grew up in Bredstedt in the southern part of Schleswig, he spoke and wrote both German and Danish, and it must have seemed natural to him to seek clients

Sine Krogh, art historian at the National Gallery of Denmark
Aarhus University Press, *Romantik*, 04, 2015, pages 27-47

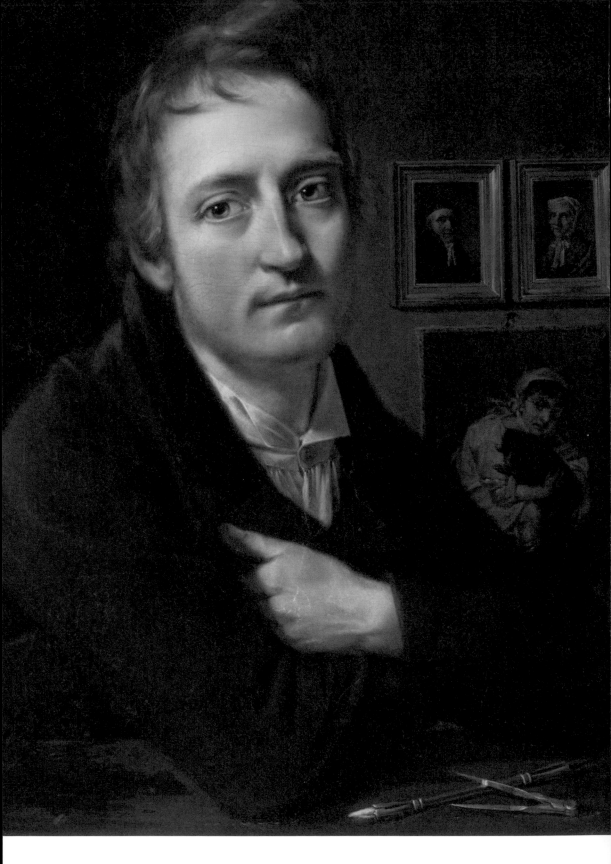

in the German-speaking areas of Schleswig-Holstein. Even though Jensen did not finish his training at the Academy in Copenhagen, he could still apply for a travel grant through the Foundation *ad Usus Publicos*. He did so successfully from Dresden, but the travel grant was less than he had anticipated. A portrait painter such as Jensen was expected to supplement his income whilst abroad by making portraits.[2] Once in Dresden, Jensen kept himself busy copying old masters, which he had been commissioned to do in the Gemäldegalerie, and he also attended the Dresden Art Academy. In 1818, before leaving for Rome, he met with his friend, the painter J. C. Dahl (1788–1857), whom he knew very well from his time at the Academy in Copenhagen. Dahl would settle down in Dresden, where in 1824 he was appointed professor at the Academy and became a colleague of the painter C. D. Friedrich (1774–1840).

Besides the travel grant, Jensen was commissioned by the president of the Academy in Copenhagen, the Danish Crown Prince, Christian Frederik (who later became King Christian VIII), to copy a number of masterpieces in foreign collections. Unfortunately, the painter suffered great difficulties in receiving timely payment for his work for the Crown Prince whilst in Rome, and, as a result of financial difficulties, it is known that he borrowed money from, amongst others, the sculptor Bertel Thorvaldsen (1770–1844) and the archaeologist P. O. Brøndsted (1780–1842), who also served as envoy of the Royal Danish Court in Rome.[3] Despite his lack of funding, it is significant that Jensen found it important to portray his immediate circle of friends in Rome without getting paid.

Jensen painted eight small portraits which are the most significant output of his Roman sojourn. The group of friends consisted largely of young artists, intellectuals and academics who were thought to have a promising career ahead of them and therefore had been awarded public or private funding to travel abroad. Jensen made portraits of the composer Rudolph Bay (1791–1851); the poet B. S. Ingemann (1789–1862) (ill. 2); the sculptor H. E. Freund (1786–1840) (ill. 3); the critic and writer Peder Hjort (1793–1871); the adopted son of the already mentioned Brøndsted, a Venetian nobleman Nicolo Conrad de Lunzi (1798–1885); the historian H. F. J. Estrup (1794–1846); the theologian H. N. Clausen (1793–1877); and the connoisseur of art Georg Ernst Harzen (1790–1853) from Altona, who, on his return to Germany, would establish the Art Society of Hamburg.[4] Freund was already a friend of Jensen's from his years of training at the Academy in Copenhagen. During his time in Rome, Jensen also made larger portraits of Freund and also of Estrup, with whom he had been become acquainted in Dresden. The latter portrait he began in 1818, but he had still not completed it, when Estrup left Rome for France in the spring of 1819. The size of the painting suggests that this was a commissioned portrait.[5] The series of small portraits clearly attracted attention since, in July 1819, Brøndsted reported home to the Crown Prince that

Ill. 1 [C. A. Jensen, *Self-portrait*, 1815. Oil on canvas, 63.3 x 48.3 cm. The Museum of National History, Frederiksborg Castle, photo: Lennart Larsen]

Jensen had painted portraits of, amongst others, Bay, Ingemann, Freund, Hjort and Lunzi 'alla prima'. The portrait of Estrup must have been amongst these works, while the portraits of Harzen and Clausen are dated to 1820.[6]

Out of Friendship

The art historian Sigurd Schultz who, in 1932, published his two-volume monograph *C. A. Jensen*, understood the Roman portraits – small in size and with sketch-like qualities – as the cornerstone of Jensen's subsequent success as a portrait painter upon his return to Denmark.[7] Schultz recognized in these early portraits what he saw as Jensen's trademark, i.e. the ability to adjust the size of his canvases to match the finances of the middle class in Copenhagen. Furthermore, Schultz has pointed out that Jensen's years abroad enabled him to establish a network of future clients at home. This observation by Schultz is essential in understanding how an artist works in order to secure commissions and earn a living. Jensen's eight portraits are indeed a category of artworks apart, as they were intended for his friends and not for display at exhibitions. Schultz has called the group of small pictures *Venneportrætter* [Portraits of friends] as they reveal who Jensen associated with during his sojourn.[8] These portraits were hardly done without a purpose, whether it was emotional or strategic or some combination of the two. Hence it seems reasonable to consider the artworks as part of a friendship-economy, i.e. in which the receipt of a gift creates an obligation to reciprocate the gesture.[9]

Drawing on these ideas, I aim to examine the artist's motivation in making these portraits, and the influences on that motivation, which requires an exploration of the cultural-historical circumstances in which the portraits were made. What other reasons might Jensen have had for making these portraits beyond seeking to establish a network of future clients as Schultz has suggested?

As a group, these small portraits do seem to testify to the importance of fellowship, of what Rome meant socially to young travellers, trying to find a place amongst the like-minded in artistic communities less conventional than those they left at home. In this respect, Rome was the perfect incubator for networking, forming friendships, making the transition from training to becoming an artist at the academy, and for finding a way to express one's personal identity as an artist.

In a letter of November 1819 to his friend in Denmark Gottlieb Schønheyder, the aforementioned Rudolph Bay explained why Jensen had made his portrait:

Nu har jeg dog den Trøst at være kommen in effigie til mit kjære Fødeland at hilse paa mine Venner. Gudskelov, at I finde det ligt. Vor brave Landsmand, *Jensen*, som studerer i Rom, og som jeg dagligen omgikkes med, har malet det af Venskab for mig og uden min Anmodning, naturligviis uden Betaling.

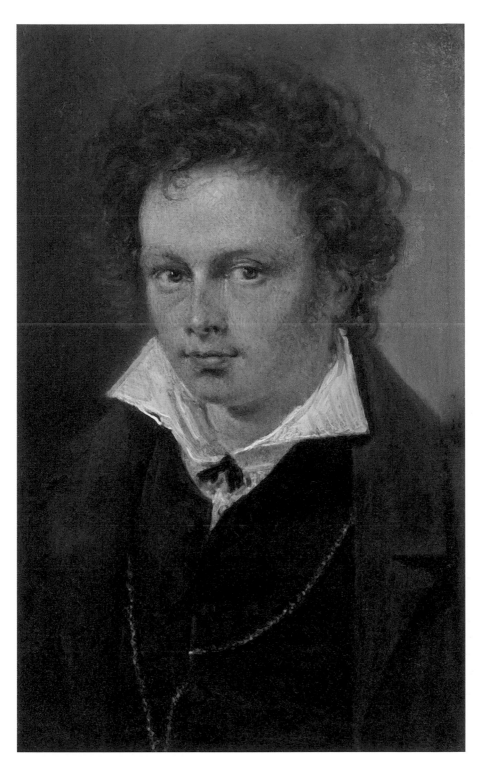

Ill. 2 [C. A. Jensen, *The Poet B. S. Ingemann,* 1819. Oil on copper, 18 x 11.5 cm. The Museum of National History, Frederiksborg Castle, photo: Kit Weiss]

[It comforts me to know that I have arrived in effigy to my dear native land to greet my friends. Thank God you find it resembles me. Our respectable fellow countryman *Jensen* who studies in Rome, and with whom I met daily, has painted it out of friendship without my request and without payment of course.][10]

In the letter, Bay encouraged Schønheyder, who had recently received the portrait from Rome, to place it on the wall of his living room whilst they were apart.[11] With only a few words, Bay describes how the act of having one's portrait painted played a significant role in sealing the friendship between the painter and the sitter. The portrait was not done on Bay's request, nor was it commissioned by someone else, and therefore the question of payment was never raised. The portrait was a gift, as Bay let his friend know, and the gesture of painting the portrait, i.e. the investment of time in front of the canvas whilst letting a dear face emerge on its surface, should be understood as a token of friendship. The gesture of presenting that very same portrait to a close friend at home as a keepsake whilst away, underlines not only the symbolic value of the portrait itself, as a substitute for a missing friend, but also testifies to the importance of friendship, which clearly is articulated in the letter. At the same time, Jensen was aware that his circle of friends in Rome, the ones travelling on scholarships like the artist himself, had limited means and therefore could hardly afford to buy or to commission portraits whilst abroad.

Six of the eight small portraits were painted on copper which distinguishes them from the other portraits Jensen did in Rome.[12] With the use of copper, the artist deliberately chose to work in an old tradition used by the most skilful Renaissance and baroque masters, involving a painting technique far more difficult than using canvas because of the smoothness of the surface. This effort emphasises the artist's ambition to explore the challenges of working on metal sheets and, in so doing, to evoke the glossy and more colourful visual effects of oil paint applied to metal. These images were to be understood as keepsakes and their importance is also stressed by the choice of the more expensive copper plates instead of the use of canvas. In this way, the small-scale portraits resemble the exquisite miniature, its significance largely personal as it belonged to the private sphere of exchange and was often used as a gift to strengthen the tie between the portrayed and the receiver of the miniature. As small images, they were also objects to be held, handled and moved about with ease, which the shipping of the Bay portrait to a close friend in Denmark illustrates. Bay could just as easily have put the portrait (just 23 x 16 cm) in his suitcase, but still he chose to ship it to Denmark. That Jensen would not again paint a series of friendship portraits also establishes the significance of the works done in Rome, which belong to a category outside the usual realm of commissioned portraits. During the spring of 1819 Jensen also did four, presumably small, portraits of Brøndsted, who kindly lent him money, and of the diplomat and baron Herman Schubart (1756–1832), and of the landowner P. B. Scavenius (1795–1868), and the officer C. E. von Scholten (1786–1873).[13] Unfortunately these four portraits have been lost and

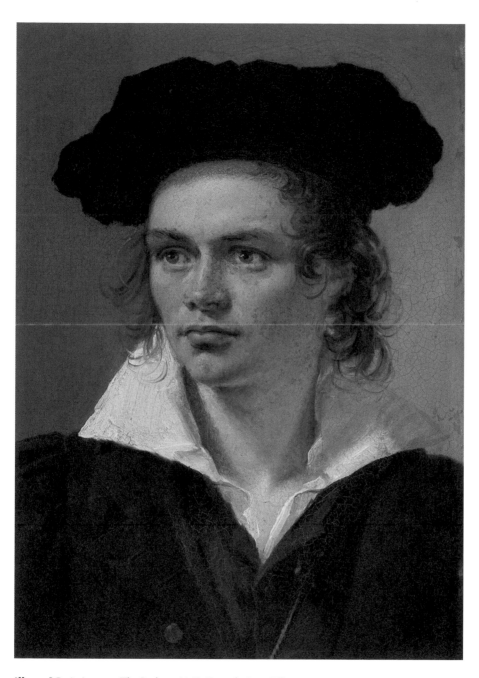

Ill. 3 [C. A. Jensen, *The Sculptor H. E. Freund,* 1819. Oil on copper, 20 x 13 cm.
The National Gallery of Denmark, photo: SMK Foto]

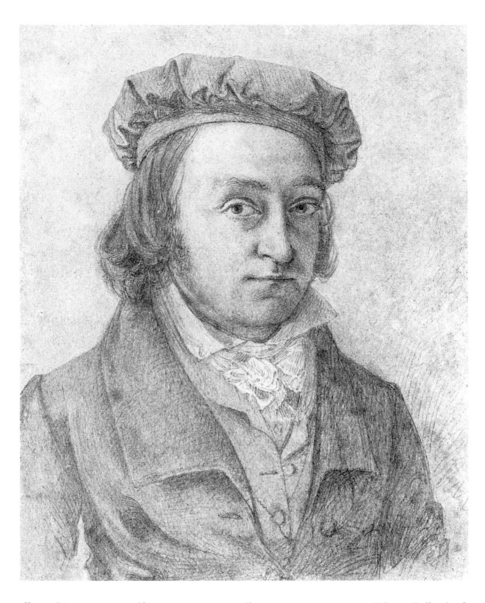

Ill. 4 [C. A. Jensen, *Self-portrait,* c. 1821. Pencil on paper, 17.3 x 13.2 cm. Private Collection]

relevant information on material and size, and whether the artists received any payment or not, is missing today. The time at which Jensen made these portraits suggests that they, and especially the ones of Scavenius and von Scholten, might form part of the series of friends, as the two men were of the same age as the rest of the circle. As to Brønsted and Schubart, they were older men of another league and influence, and both moved in the inner circles that consisted of among others Thorvaldsen and the Danish Crown Prince. Jensen might have painted their portraits as a way of attracting attention from the Crown Prince who was his most important patron.

Rome: A Place of Transition

Despite its poverty and decay in the beginning of the nineteenth century, Rome was a picturesque, pulsating, and cosmopolitan city with its colonies of artists from Germany, Denmark, Holland, England, Norway, and Sweden. Adding to the cultural sphere was the presence of the Academie de France á Rome and the Roman Academia di San Luca. Rome was where most artists went to experience not only the greatness of the past, but also the shifting styles and trends of the dominating movements of classicism and romanticism even though Paris had started to take on the role as the capital of the art world.[14] In more than one respect, Rome was a place of transition. For most artists, the stay in Rome marked the transformation from being a student to becoming an artist. In Rome they went through their last formative years of studying before they had to return to their homeland and prove their worth. The years abroad meant both an artistic and a psychological transition for the artist. In their encounter with a different culture and a community governed by artists and intellectuals, they would need to position themselves in a new context and they should find a way of expressing their identity as artists among artists. In his book *Renaissance Self-fashioning. From More to Shakespeare* (1980), the literary critic and theorist Stephen Greenblatt has dealt with the prominent English authors of the sixteenth century and the formation of identity as a deliberate process. Greenblatt investigates not only the process of fictional characters shaping their identity, but also the ways in which authors themselves fashioned their identities as authors. Greenblatt uses the term *self-fashioning* and points out that in the period described 'there appears to be an increased self-consciousness about the fashioning of human identity as a manipulable, artful process'.[15] The notion of the deliberate performance of the self, a self-fashioning, is useful in order to identify how the Italian sojourn not only served educational purposes for artists like Jensen but was also involved with their formulation of an artistic identity. The comparison of portraits of artists made before the journey to Rome with those made after their arrival very often demonstrate this process of self-fashioning. Hats, a different hairstyle, another type of clothing or the growing of a beard, are some of the visual markers which can be seen in self-portraits and portraits of other fellow artists painted in Rome.

Compared to the portrait of 1815, the drawing from 1821 (ill. 4) gives a quite different impression of a much more self-confident artist. Jensen has depicted himself with long hair and wearing a hat in the style of Raphael, which became very fashionable among artists in the wake of the Raphael cult during the romantic period: very much a suitable self-portrait for an artist whose transformation began as he diligently copied paintings of Raphael in Florence and Rome. The drawing is a personal statement of an artistic identity coming into shape, influenced by the Romantic cultivation of the artist who lives and breathes art. Thorvaldsen was known to be wearing the same type of hat (ill. 5) and Freund is also seen wearing a similar hat in the portrait by Jensen (ill. 3). The choice of clothes,

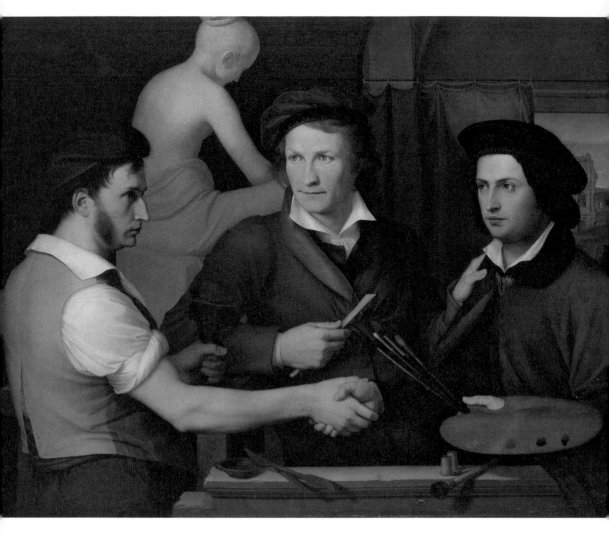

Ill. 5 [Wilhelm von Schadow, *Self-portrait with his brother Ridolfo and Thorvaldsen*, 1815/16. Oil on canvas, 91 x 118 cm. Nationalgalerie, Berlin]

hats, as well as hairstyle, was then, as it is today, a way of signalling one's identity and of positioning oneself in society.

The circles of friends and the communities developed by artists could serve as a sort of stronghold or fraternity comparable in some respects to the guilds of past times. By the end of the eighteenth century, Rome was referred to as the *Frihedsstad* [The city of freedom][16] and had become the ideal place to go since the spirit of the French Revolution seemed to find an outlet amongst artists who found in Rome a place of freedom and equality. Here it was possible openly to express your sympathies, as did several artists, even when it meant opposing the

rules of the academies in their home countries.[17] In Rome there was an oppor-
tunity to become part of circles dedicated solely to art and the artistic life, to
dress and to behave differently, and be part of what has been labelled a *republic
of artists.*[18]

In the portraits of Jensen and Freund, the collar, the hat, and the long hair,
reflect a fashion which was not only associated with certain German artists in
Rome, and with the Nazarenes in particular, but also with the rebellious stu-
dents from Kiel, Heidelberg, and Munich, the opponents of an ultraconservative
political atmosphere – which led to the prohibition of this manner of dressing in
1819.[19] In other words, the style of clothing was a visual statement that one sym-
pathised or affiliated with a certain group of artists within the republic of artists.
C. A. Jensen's biographer, Schultz, has been reluctant to see the painter as more
than a *Provins-Kunstner* [small-town artist] in Rome who was afraid of changes,
but the self-portrait testifies to the opposite, i.e., to a personal transition and po-
sitioning as an artist that only Rome could enable. One's place in the republic of
artists was something to be proud of and to be made visible: hence Thorvaldsen,
often a role model to the younger artists, on one occasion insisted on wearing
his Bajocco decoration awarded by the German artist society together with the
royal decorations he had also received.[20] When Jensen chose to portray his circle
of friends, he demonstrated a growing self-confidence as an artist by articulating,
through his art, a responsiveness to ideas prevailing within certain artistic circles
in Rome. In the remainder of this essay, these eight artworks will be seen in the
light of a cultural phenomenon where visualizing and paying tribute to friend-
ships was considered very important.

Friendships in the Age of Romanticism

Naturally, friendships have long been a theme in the visual arts, but from the
middle of the eighteenth century onwards the importance of friendship became
a prominent subject to German poets, theologians, and writers such as Herder
and Goethe and later of the brothers Friedrich and August Wilhelm von Schlegel,
Novalis, and Wackenroder.[21] What was new in terms of friendships in the age of
romanticism was the intensity with which the bonds of friendships were tied.
Friends were praised in romantic poetry and the number of albums dedicated to
friendships appearing in the late eighteenth century illustrates how fashionable
it became to articulate one's affection. Around 1800, the theme of friendship was
cultivated by various artists which gave way to new visual modes of representa-
tion in German romantic painting, with friends being portrayed on their own, in
pairs, or as a larger group. In Dresden in 1819-20, Friedrich painted his *Two Men
Comtemplating the Moon*, a portrait he shortly after gave to J. C. Dahl as a proof
of their friendship before Dahl went to Naples and Rome.[22] In Rome, artistic
communities such as Die Lukasbrüder, and artists affiliated with the Nazarenes,
as they were nick-named, such as Wilhelm von Schadow (1788-1862) and Carl
Philipp Fohr (1795-1818), interpreted the subject of friendship in different ways.

In German art history, images of friends are often termed *Freundschaftbilder*. It was the art historian Klaus Lankheit who, in his seminal work *Das Freundschafts-bild der Romantik* [The friendship image of romanticism] from 1952, identified a visual display of affection in the romantic movement and outlined an intense sense of community and solidarity within groupings of friends. With the characterization of what was going on as a cult of friendship, Lankheit showed how friendships were idolized as the focal point in life. In its most radical practice, to the revolutionary minds of the late eighteenth century, friendships could even be seen as a substitute for religion or, as Lankheit puts it, as an *Ersatz-Religion*.[23] Lankheit's study offers a different understanding of artists and intellectuals in the nineteenth century, as he sees the cult of friendship as an ideology opposed to the norms and values of the middle class. This approach makes room for a renewed understanding of the importance of friendships amongst young men such as C. A. Jensen and his friends in Rome. Friendships offered a basis for forming an identity within the group and, in this respect, Jensen fashioned himself into the role of portrait painter for the group every time he painted a member of the circle. Seen thus as a part of a process of shaping one's identity, portraiture is not limited to the painter's interpretation of the sitter, which is turned into an image: the painter himself is also very much a part of the transformation.

The romantic culture of friendship was not exclusively, but largely a movement finding its expression amongst the younger artists. In this respect, the Nazarenes became the most significant artistic group who visualised publicly the importance which they attached to their friendships. The members of this artist community, founded in 1810 by Johann Friedrich Overbeck and Franz Pforr, strived to revive ideals found in the art of the early Renaissance, looking to Raphael, Michelangelo and Dürer for inspiration. Today the members of the group are known for their religious motifs and historical topics and for their creation of a brotherhood of painters. But, and no less importantly, in the 1810s these painters were conspicuous for their old-German garb and long hair *alla Nazarena* which attracted a lot of attention. And not surprisingly, they found in Rome just as many who advocated as who opposed their ideal of a society of artists serving art only.

The group's cultivation of an artistic brotherhood was one way of interpreting and expressing the romantic culture of friendship. The numerous portraits (mainly drawings and a few known oil paintings) of themselves and of their friends were another way of visualising the importance they attached to their friendships. These intimate portraits circulated amongst friends as gifts and were not intended for sale.[24] This gesture may have been known by Jensen and might very well have influenced him. As a member of Thorvaldsen's circle, he must also have been familiar with members of the Nazarenes, such as Overbeck, Wilhelm von Schadow, and Peter von Cornelius, and their distinct culture of friendship. Ingemann also joined the circle of artists and much later, in his memoirs, the young romantic poet recalled:

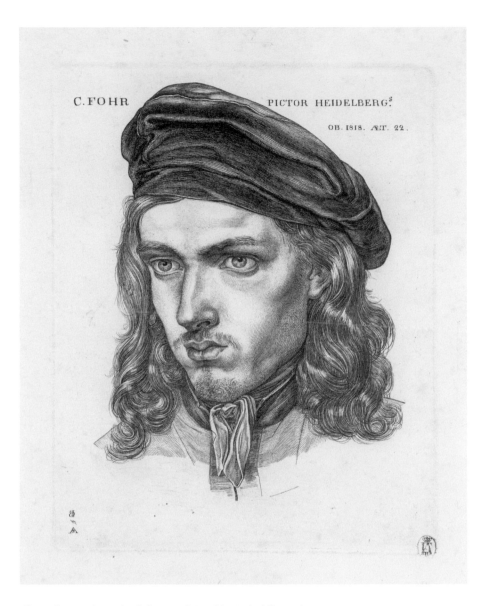

C.FOHR PICTOR HEIDELBERG.ˢ

OB. 1818. ÆT. 22.

Ill. 6 [Samuel Amsler (after Carl Barth), *Carl Philipp Fohr*, 1818.
Engraving/etching, 14.6 x 11.4 cm. Kurpfälzishes Museum der Stadt Heidelberg]

Den nytydske Kunstskoles Heroer, Cornelius og Overbeck, traf jeg i Rom. Thorvaldsen, Freund og alle Kunstnerne i Rom på den Tid hørte her til min jævnlige Omgangskreds.

[In Rome I met the heroes of the new German art school Cornelius and Overbeck. Thorvaldsen, Freund and all the artists staying in Rome then formed part of my social circle.][25]

Just as important in Thorvaldsen's circle was the painter J. L. Lund (1777–1867), like Jensen also a friend of Freund's, who was affiliated with the Nazarenes and their artistic ideals. While private images of friends made by the Nazarenes might

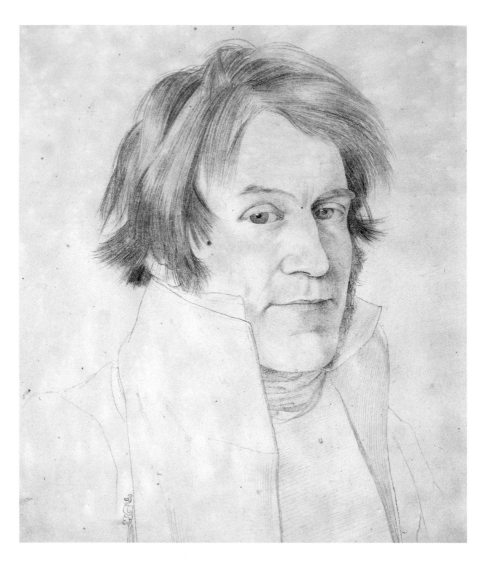

Ill. 7 [Carl Philipp Fohr, *Portrait of J.L. Lund*, 1817. Pencil on paper, 17.3 x 14.8 cm. Kurpfälzishes Museum der Stadt Heidelberg]

have influenced Jensen in choosing to portray his circle of friends, yet another young German artist in Rome could also have inspired Jensen. In 1817, Karl Phillip Fohr, who was associated with the Nazarenes, began making drawings for a composition of artists gathering at the famous Caffé Greco in Rome, a motif which he intended to turn into an etching. Fohr drowned in 1818 in the Tiber before finishing the project, but fifty-three portraits in five different sketchbooks testify to the ambitious plan of making an image of the republic of artists in Rome. After Fohr's tragic death, a print by Samuel Amsler, made after a drawing of Carl Barth, was sold in order to raise money for a monument commemorating the deceased (ill. 6). This gesture emphasized the intensity of the romantic

friendships amongst artists and the way in which the loss of a friend also found an outlet in a very public display of sorrow.

In April 1819, Fohr's friends succeeded in arranging a show of his drawings for the group portrait at Caffé Greco in Palazzo Caffarelli and, as such, the first exhibition of works by German artists in Rome was mounted.[26] Amongst the participants was J. L. Lund who showed two oil paintings and who at the same time was represented in a drawing by Fohr intended for the group portrait (ill. 7).[27] Public exhibitions were rare in Rome and this was organized on the occasion of the official visit by the Austrian emperor and empress. It was an event which attracted a large number of artists, including Thorvaldsen who attended the opening. Here, the group portrait by Wilhelm von Schadow picturing the artist himself, his brother the sculptor Rudolph von Schadow, and Thorvaldsen, must have been of particular interest to Thorvaldsen and his friends (ill. 5). The painting, with its celebration of artist friendships, was a tribute to the renowned sculptor and on public display for the first time in Palazza Cafferelli. It seems reasonable that Fohr's delicate and small drawings of fellow artists served as inspiration for Jensen in 1819–1820. And even if Jensen did not see the works exhibited by Fohr and the other German artists, he could hardly have avoided noticing the cultivation of friendships amongst artists or still less avoided hearing about Fohr's many portraits for his ambitious manifesto of a society of artists located in Caffé Greco, the most important meeting place for Germans and Scandinavians in Rome.

The Caffé Greco was where established artists such as Thorvaldsen were regulars and where the more rebellious artists such as the Nazarenes would make their public appearances. The café in Via Condotti was partly where the fashioning of one's artistic identity began, where one's style of clothing was noticed, and also where artists could meet old or make new friends. Here Jensen himself was a newcomer, when he arrived in the autumn of 1818 and less so when he was forced to leave Rome in 1821 due to his financial difficulties. Jensen tried without success to get commissions by foreigners visiting Rome, but as he explained in a letter of 1821 to J. G. Adler (1784–1852), the private secretary to Crown Prince Christian Frederik, they preferred to have their portraits done by the Nazarenes.[28] This observation is significant in two ways. First, it illustrates how the Nazarenes had become popular outside their own circles and were sought out by grand tourists who commissioned portraits. Secondly, Jensen's remark shows his interest in the success of the Nazarenes in attracting clients. His ambition had been to earn a living by painting copies of old masterworks in collections in Florence and Rome, but the constant waiting for money to arrive from Denmark must have made him realise, perhaps too late, that commissioned portraits of clients in Rome might have helped him out of his financial difficulties.[29] The expected payments from Crown Prince Christian Frederik for the copies of works by Raphael failed to come, while Jensen was in Italy. Adding to the artist's frustration of not being able to secure an income so he could stay, another important commission of copies of Raphael's paintings made by the patron Johan Bülow (1751–1828) also failed

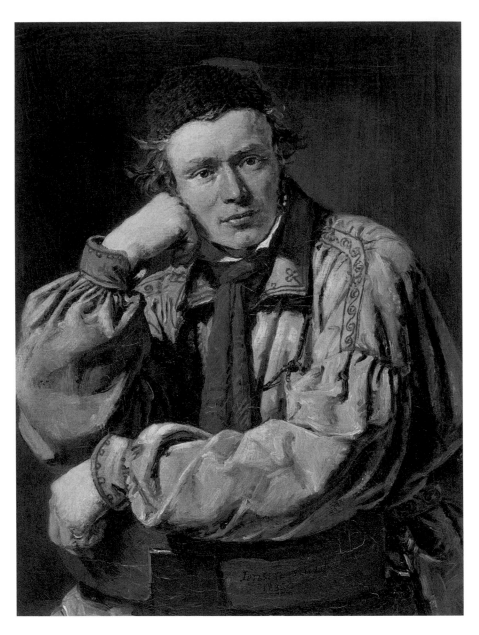

Ill. 8 [C. A. Jensen, *H.E. Freund,* 1835. Oil on canvas, 29 x 22 cm.
Ny Carlsberg Glyptotek, photo: Ole Haupt]

to materialise. These circumstances were the main reason for Jensen's decision
to leave. He was not able to pay off his debts to his patrons in Rome, Brøndsted
and Thorvaldsen, and was reluctant to keep borrowing money.[30] The painter then
travelled back to his parents in Schleswig, had a short and unsuccessful stay in
Hamburg hoping for commissions, and returned to Copenhagen in 1823. The
following year, Jensen became a member of the Academy in Copenhagen which

officially marked the beginning of a career as a portrait painter. Several of the influential Danes, with whom Jensen had come into contact in Rome via the circles of Thorvaldsen, of Brøndsted, and of the Crown Prince, did not have their portrait painted by the young artist whilst abroad, but were to appear as clients later in Jensen's career.[31] As member of the Academy, Jensen was also appointed to take on several official, commissioned portraits, but the small-size portraits that had made him popular in Rome no doubt ensured him commissions in Copenhagen.

Portraits and Gifts

In his book *The Gift* (1925), Marcel Mauss points out that receiving a gift confers an obligation to reciprocate the gesture. As studies of Rembrandt have shown, Rembrandt used gifts strategically by presenting patrons and friends with artworks as a way of furthering his career.[32] Did Jensen also act strategically in Rome whilst waiting for payments and commissions? As this article has suggested, part of Jensen's decision to portray his friends seems to correspond to the romantic culture of friendship, which he experienced in Rome. Acting on a cultural phenomenon, as Jensen did, he embraced the role of being a generous friend. Essential to the story of these eight portraits is the aspect of gift giving. The much admired Thorvaldsen might have served as a role model for Jensen, as it was well known that Thorvaldsen presented a selection of friends with a ring as proof of friendship.[33] When Jensen chose to portray his circle, he must have given thought to the fact that they were men with promising careers ahead of them and painting their portraits was a way of visualising a network, from which he could later benefit. In this respect, the artworks mediated or secured a connectedness with the recipients, whether the presenting of the gift was based on emotional exchanges or motivated by strategies of a future outcome. As tokens of friendship, the portraits came to circulate in a network in Rome based on shared values, interests and emotions, a network of friends which also could be described as an 'emotional community', using a term from Barbara H. Rosenwein.[34] This was an 'emotional community' coming into being in Rome which, for some of its members, would mean a lasting friendship and which, for others, would be confined to the sojourn abroad. As the example of Bay's portrait shows, the portrait was not necessarily a gift which the recipient and friend kept in his own possession. The portrait could also be passed on to a third party, another friend, which meant it entered an extended social network of the painter within the same emotional community.

As seen in the case of Rembrandt, the way of returning a gift from an artist could be commissioning artworks from him, recommending him to potential clients, or in other ways to work in his favour. Of the eight men portrayed in Rome, six returned to Denmark and four of them sat again for Jensen. In 1822, H. N. Clausen was appointed professor of theology at the University of Copenhagen and five years later Jensen did a small-scale portrait of Clausen, followed in 1836 by another small portrait. In 1828, Jensen did a larger portrait of H. F. J. Estrup

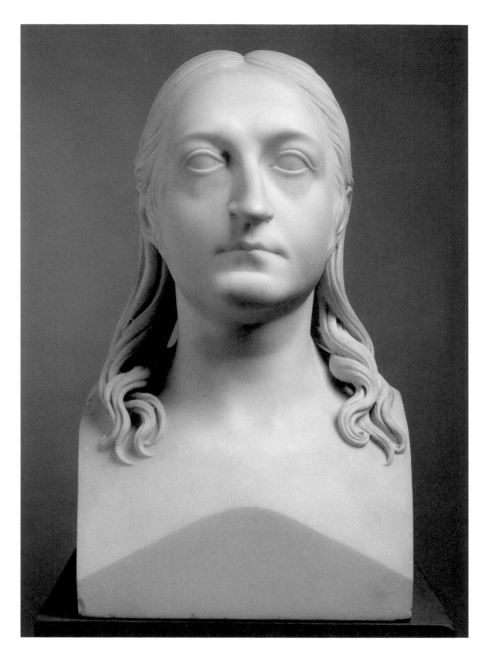

Ill. 9 [H. E. Freund, *C. A. Jensen,* 1820. Marble, 47 cm.
Ny Carlsberg Glyptotek, photo: Ole Haupt]

who, after his return, worked as a lecturer at the Academy of Sorø. In 1844, B. S. Ingemann, who also took up a position lecturing at Sorø Academy, had his portrait made on commission for the Picture Gallery of Frederiksborg Castle, where, in 1832, Jensen had been appointed as portrait painter by Crown Prince Christian Frederik.[35] This suggests that part of the network of friends established in Rome did work in favour of Jensen, which a later incident also confirms: in 1849, Claus-

en secured for Jensen, still suffering financial hardship, a much needed income by helping him to a position at the Royal Collection of Graphic Art.

Between the two artists, Freund and Jensen, the exchange was of a different kind. In 1836 at the annual exhibition at Charlottenborg, Jensen presented several portraits of fellow artists and amongst these was a small portrait of his close friend Freund, painted the previous year in Copenhagen (ill. 8). A much larger portrait of Freund, presumably after the 1835 portrait, was later commissioned for the Picture Gallery at Frederiksborg Castle and entered in 1845 the collection, where Ingemann was already represented. Freund is seen wearing an ornamented smock, a red scarf, and a knitted hat which he himself had designed. Posing as a free spirit, the sculptor has placed his left arm on the back rest of a chair, and rests his head on his right hand while looking calmly at his friend. This charming, self-assured pose derives from the formative years in Rome, where the artists spent time capturing their transitions from newcomers to self-confident men. Shortly after Jensen's arrival, Freund had modelled a bust of both Jensen and Ingemann which, in 1820, he carved in marble (ill. 9).

In the meantime, Jensen reciprocated the gesture and painted a larger portrait of his artist friend which preceded the small-size pictures of 1819. Freund and Jensen, both sons of working-class families, had, by the end of the 1810s, made it all the way to Rome. Now they were moving in the circles of the great Thorvaldsen and some of the most prominent German artists. As friends, they played a significant role in fashioning each other through portraiture. The busts of Ingemann and Jensen were sent home from Rome and exhibited at the Charlottenborg exhibition in Copenhagen in 1826. The decision to display publicly these two busts is remarkable, as Freund had not before turned portraits of his own friends into marble. Ingemann was now a celebrated poet and writer, and Jensen's career seemed very promising. The painter was represented with a hairstyle *alla Nazarena* which undoubtedly attracted attention in Copenhagen. The life-size marble bust illustrated that the artist's transition in Rome had been successful. At this point, C. A. Jensen could hardly have foreseen the hardships he would later face in his career.[36]

Notes

1 Sigurd Schultz, *C.A. Jensen. Hans Liv og Hans Værker*, vol. 1 (Copenhagen: Kunstforeningen i København, 1932), 23.

2 Ibid., 27.

3 Ibid., 43.

4 For information on the eight portraits, see Schultz, *C.A. Jensen*, vol. 2., no. 20–5 and 28–9. The portrait of H. E. Freund, no. 25, is painted on copper and not tin as Schultz has suggested. See Marianne Brøns et al., *Ældre dansk malerkunst. Bestandskatalog* (Copenhagen: Statens Museum for Kunst, 2002), 203.

5 See Schultz, *C.A. Jensen*, vol. 2, 65, no. 19. The size of the painting is 62.5 x 49 cm. In 1932, the portrait belonged to the Estrup family at Skaføgaard.

6 Ibid., 189, n. 170.

7 Schultz, *C.A. Jensen*, vol. 1, 145.

8 Ibid., 36

9 On gift giving, see Marcel Mauss, *The Gift: The Form and Reason for Exchange in Archaic Societies* (London: Routledge, 1990). For more recent studies on the subject, see, for example, Mark Osteen, *The Question of the Gift: Essays Across Disciplines* (London and New York: Routledge, 2002); and Michael Zell, 'The Gift Between Friends: Rembrandt's Art in the Network of His Patrons and Social Relations', in *Rethinking Rembrandt*, ed. Alan Chong and Michael Zell (Zwolle: Waanders, 2002), 173–93.

10 Letter from Livorno of 12 November 1819; see Julius Clausen og P. Fr. Rist, *Memoirer og Breve. Af Rud. Bays efterladte Papirer*, vol. 2 (Copenhagen: Gyldendalske Boghandel Nordisk Forlag Kjøbenhavn, 1920), 133. My translation.

11 The portrait of Rudolph Bay arrived in Copenhagen with Bertel Thorvaldsen in the autumn of 1819.

12 The portraits of G. E. Harzen and H. N. Clausen were not painted on copper: the first portrait was painted on cardboard, the latter on canvas.

13 Schultz, *C.A. Jensen*, vol. 2, 152, no. 478–81.

14 Schultz, *C.A. Jensen*, vol. 1, 28–33, and Kasper Monrad, 'Kunstlivet i Rom 1800-1820 set med danske malerøjne', in *Inspirationens skattekammer. Rom og Skandinaviske kunstnere i 1800-tallet*, ed. Hannemarie Ragn Jensen, Solfried Söderlind and Eva-Lena Bengtsson (Copenhagen: Museum Tusculanums Forlag, 2003), 53.

15 Stephen Greenblatt, *Renaissance Self-fashioning. From More to Shakespeare* (Chicago; London, University of Chicago Press, 1980), 2.

16 Rome was referred to as 'den uvante Frihedsstad', see the historian H. F. J. Estrup's biography on Bertel Thorvaldsen and his arrival in Rome in 1797, http://arkivet.thorvaldsensmuseum.dk/dokumenter/m29I,nr.1-2

17 Lionel Gossman, *Unwilling Moderns. On the Nazarene Artists of the Early Nineteenth Century* (www.19thc-artworldwide.org: Nineteenth-Century World Wide, vol. 2, no. 3, 2003), 20.

18 Rainer Schoch, 'Rom 1797 – Fluchtpunkt der Freiheit', in *Künstlerleben in Rom. Bertel Thorvaldsen (1770-1844). Der dänische Bildhauer und seine deutschen Freunde*, ed. Wolfgang Pülhorn (Nürnberg; Schleswig, Verlag des Germanischen Nationalmuseums, 1991), 20–2.

19 Ejner Johansson, *De danske malere i München* (København, Spektrum, 1997), 26.

20 Ursula Peters, 'Das Ideal der Gemeinschaft', in *Künstlerleben in Rom. Bertel Thorvaldsen (1770-1844).*
 Der dänische Bildhauer und seine deutschen Freunde, ed. Wolfgang Pülhorn (Nürnberg; Schleswig,
 Verlag des Germanischen Nationalmuseums, 1991), 164. The Bajocco decoration was part of a
 welcoming ritual, where artists would become members of the Roman republic of artists.

21 Klaus Lankheit, *Das Freundschaftsbild der Romantik* (Heidelberg: Carl Winter – Universitätsverlag,
 1952), 72.

22 Petra Kuhlmann-Hodick and Gerd Spitzer, 'Anschauung and Aneigung der Natur', in *Dahl und*
 Friedrich. Romantische Landschaften (Dresden; Oslo, Sandstein Verlag, 2014), 97. In 1840, after the
 death of Friedrich, Dahl sold the painting to the Gemäldegalerie in Dresden, today Galerie
 Neue Meister, Staatliche Kunstsammlungen Dresden.

23 Lankheit, *Das Freundschaftsbild der Romantik*, 71.

24 Gossman, *Unwilling Moderns*, 13.

25 Bernard Sev. Ingemann, *Tilbageblik paa mit Liv og min Forfattervirksomhed fra 1811-1837* (Copenha-
 gen: C. A. Reitzels Forlag, 1863), 40. My translation.

26 Ulrike Andersson, Annette Frese, *Carl Philip Fohr und seine Künstlerfreunde in Rom*, (Heidelberg:
 Kehrer Verlag Heidelberg), 22; and Robert McVaugh, 'Nazarene Art', in *Encyclopedia of the Roman-*
 tic Era 1760-1850, ed. Christopher John Murray (London: Routlegde, 2013), 796.

27 On J. L. Lund's portrait and his participation in the exhibition in Palazzo Cafferelli, see Ulrike
 Andersson, Annette Frese, *Carl Philip Fohr und seine Künstlerfreunde in Rom*, 112–3. On Fohr's
 never-finished group portrait, see Georg Poensgen, *C.P. Fohr und das Café Greco* (Heidelberg: F. K.
 Kerle Verlag, 1957), 28. Fohr deliberately chose whom he wanted to include in his artwork, and
 his intention was not to make a true rendering of regulars and artists. He left out prominent
 figures such as Thorvaldsen, who daily visited Caffé Greco, and included others not in Rome,
 when he made his drafts.

28 Schultz, *C.A. Jensen*, vol. 1, 43.

29 The very few portraits which Jensen made during his three years in Rome seem to testify to his
 original ambition of focusing primarily on painting copies of old masters.

30 Schultz, *C.A. Jensen*, vol. 1, 43.

31 The aim of this article is mainly to consider how Jensen was influenced by a romantic culture of
 friendship when painting the small portraits of his friends. The relation between the influential
 men, to whom Jensen was introduced whilst in Rome, and the commissions he later received,
 are also worth a study as they throw light on how a nineteenth-century artist might work to
 secure future clients. It is, however, outside the scope of this article to account for this relevant
 aspect of the artist's broader networking.

32 See Michael Zell, 'Rembrandt's Gift. A Case-Study of Actor-Network-Theory', *Journal of Histo-*
 rians of Netherlandish Art, 3, no. 2 (2011), (http://www.jhna.org/index.php/past-issues/volume-
 3-issue-2/143-zell-rembrandts-gifts)

33 Torben Melander, 'Thorvaldsens slangering – en drillepind', in *Meddelelser fra Thorvaldsens Mu-*
 seum (Copenhagen: Thorvaldsens Museum, 2008), 109.

34 Barbara H. Rosenwein, *Emotional Communities in the Early Middle Ages* (Itchaca; London, Cornell
 University Press, 2006), 24–5.

35 See Schultz, *C.A. Jensen*, vol. 2, 138, no. 377. The portrait of Ingemann is 83.3 x 67.3 cm in size
 and still in the collection of The Museum of National History, Frederiksborg Castle (formerly
 known as Frederiksborgmuseet).

36 I wish to thank the art historian Jan Gorm Madsen for his support while writing this article
 and for asking the right questions.

At Home in 'that Bathing Place'

AT HOME IN 'THAT GAY BATHING PLACE'; OR, REPRESENTING BRIGHTON IN THE EARLY NINETEENTH CENTURY

KATE SCARTH

[ABSTRACT]

Historians have established late eighteenth- and early nineteenth-century Brighton's role in the urban renaissance by tracking its emergence as a centre of fashion, polite sociability, and consumerism. Other versions of the town, such as domestic experiences and home life, have, however, been neglected. Yet in the early nineteenth century, contemporaries increasingly present a version of Brighton that is domestic and retired instead of public; polite instead of fashionable; rational instead of dissipated; intimate rather than crowded; more country and nature-orientated than urban focused. This article explores how Elizabeth Sandham's didactic novel, *Sketches of Young People; or, a Journey to Brighton* (1822), negotiates this transition. It moreover argues for the empowering possibilities that this new Brighton offers middle-class women in terms of satisfying intellectual curiosity and facilitating physical mobility. While Brighton's history has been explored, this article calls for future work into the cultural, including literary, representations of romantic-period Brighton.

.

KEYWORDS *Elizabeth Sandham, Domesticity, Resort and Spa Towns, Sketches of Young People; or, a Journey to Brighton (1822), Didactic Fiction*

In Lydia's imagination, a visit to Brighton comprised every possibility of earthly happiness. She saw, with the creative eye of fancy, the streets of that gay bathing place covered with officers. She saw herself the object of attention, to tens and to scores of them at present unknown. She saw all the glories of the camp – its tents stretched forth in beauteous uniformity of lines, crowded with the young and the gay, and dazzling with scarlet; and, to complete the view, she saw herself seated beneath a tent, tenderly flirting with at least six officers at once.

JANE AUSTEN, *Pride and Prejudice* (1813).[1]

Kate Scarth, PhD and SSHRC Postdoctoral Research Fellow at Dalhousie University, Canada
Aarhus University Press, *Romantik*, 04, 2015, pages 49-70

Lydia Bennet's ill-fated trip to Brighton is probably the most well-known foray to the resort town in early nineteenth-century fiction. Lydia anticipates a Brighton oriented towards busy, public spaces like streets and a military camp. It is a fun, fashionable, often dissipated resort town with 'scores' of exciting and yet unknown people, and, most importantly, for Lydia handsome and fashionable young soldiers. Lydia's highly visual conception of the town also captures the Brighton ethos of display – it is a place to see and be seen. Lydia has such a keen idea of Brighton before even visiting because this version of the fashionable resort town was a common one in the period's cultural consciousness. She could have imbibed it from the soldiers and their wives she has met in her hometown of Meryton as well as from newspaper reports, satirical verses, and novels. Brighton fiction emerged as the town grew in popularity, and works such as Richard Sicklemore's *Mary-Jane* (1800), Mary Julia Young's *A Summer at Brighton* (1807), Mary Jane Anne Trelawney's *Characters at Brighton: A Novel* (1808), the anonymous *Brighton; or, The Steyne. A Satirical Novel* (1818), Innes Hoole's *Scenes at Brighton; or, 'How much?': A Satirical Novel* (1821), and Elizabeth Sandham's *Sketches of Young People; or, a Journey to Brighton* (1822). Brighton was the most popular of the British resort and spa towns in the late eighteenth and early nineteenth centuries, usurping Bath's long-standing hegemony. From 1781 to 1820, Brighton led the resort towns in population growth, and from 1811 to 1821, Brighton was the fastest growing of all British towns, doubling its population and number of buildings.[2] This article asks what happens when the action of domestic novels, in particular didactic ones aimed at young women of Lydia's age, are transplanted to Brighton: how are the genre's emphases on the domestic woman, the private sphere, and rigid codes of behaviour for young people reimagined in a space dedicated to public display and dissipation? I am particularly interested in how even in the conservative parameters of a novel like Sandham's *Sketches*, essentially a female conduct book in narrative form, Brighton offers young women relative physical and intellectual freedom, the possibility of being more than a mere 'object of attention'.

This study is also a call to delve more deeply into how, like Lydia, writers imagined Brighton, and to better understand the cultural, including literary, representations of romantic-period Brighton. Historians have tracked Brighton's emergence in the late eighteenth and early nineteenth centuries as a centre of fashion, polite sociability, and consumerism by explicating its urban development, architecture, population growth, economy, and health provision – in terms of the springs, the sea, and medical practices.[3] Literary critics have meanwhile hitherto only briefly referenced Brighton (or, as it was often known into the nineteenth century, Brighthelmstone).[4] The brevity of these references is brought into relief when compared to the considerable literary criticism on other spa and resort towns thanks in large part to Jane Austen's depictions of Bath and the fictional Sanditon.[5] While there is admittedly no great Brighton novel or poem of the period, literary critics' very brief considerations of the resort town overlook the rich trove of documents negotiating the meanings of a town that was increasingly a part of people's annual calendars and that embodied many of the changes

occurring in British society in terms of the expansion of the middling ranks, increased social mobility, greater access to leisure time and recreation, the fashion for landscape aesthetics like the picturesque and sublime, urbanization and suburbanization, the luxury debates, women's role in society, and a general trend of proliferating spa and resort towns wedded to increased attention to health.

The image of a fashionable, urban, and public Brighton is a dominant one in the early nineteenth century and this is what literary critics have focused on in their brief references to the town in the period.[6] At the centre of dissipated Brighton was its most high-profile Brighton resident, the notoriously libertine Prince Regent (by 1820, King George IV), who transformed a farmhouse into an oriental-inspired palace, the Pavilion. Whole works like the *Prince of Wales in Brighton* (1796) centre on him and a Prince Regent cameo appearance is a standard feature of the Brighton novel; see, for instance, Young's *A Summer at Brighton* when he appears at a fashionable party at a Brighton villa and Sandham's *Sketches* when he is spotted riding by the Pavilion.[7] The Prince took his court to Brighton in the summers, affirming the fashionability of the Brighton season (the peak of the season was from July to the end of October, but became longer as time went on) and inspiring Londoners from the middling ranks to the nobility to visit the Sussex seashore.[8] George Saville Carey, in *The Balnea; or, an Impartial Description of all the Popular Watering Places in England* (1799), versifies that Brighton is a town '[t]hat coaxes all our courtiers down,/And half depopulates the town'.[9] Merchants from the City of London also escape to Brighton; as the author of *Brighton!!* remarks '[e]'en cits the spot [London] a desert call'.[10] People, goods, activities, and indeed the whole polite civic culture were transplanted from London.[11] The urban, specifically metropolitan, status of Brighton was routinely stressed: '[s]ome say [Brighton] is London in miniature',[12] and it was called a 'seaside London'.[13] Brighton's answer to London's fashionable hot spots like Hyde Park or Vauxhall Pleasure Gardens where people dressed in their best to see and be seen was the Steyne. The Steyne, adjacent to the Prince Regent's Pavilion, was a grassy area used as the town's fashionable promenade.[14] This is where, especially in the early days of Brighton (before the 1820s), fashionable visitors wanted to stay.[15] It was also the focus of Brighton's social life; for example, the circulating library, which doubled as a gambling venue in the evenings, was adjacent to the Steyne.

Writers of guidebooks, verse, musical compositions, and fiction documented the lifestyles of visitors to this London by-the-sea, either to excite readers with the town's possibilities or, more often, to satirize and condemn them. Novels like those mentioned above highlight and criticize the public display, fashion, dissipation, consumerism, and middling-rank vulgarity characterizing the resort town. All of these issues are captured in a description of Brighton in Mary Robinson's *The False Friend: A Domestic Story* (1799), which I quote at length since it provides a typical satire of the fashionable resort town: the novel's heroine Gertrude writes from Brighton that

We have passed the whole morning in the *routine* of occupations which here it is both healthful and fashionable to follow: such as bathing, strolling on the Steine, crowding to the libraries, driving on the downs, and idling time away in the busy avocation of doing nothing. But example is every thing; and that which the leaders of refined taste zealously adopt, the followers of folly will not fail to imitate. Hence we behold one sex, recently emerged from the salt waves, scorching in the morning sun for the embellishment of beauty; and the other, riding races in the full blaze of noon, or wasting the midnight hour at a gaming-table, for the benefit of the constitution! For this purpose the sober cit quits the dull toil of commerce, and exhibits his wealth in proportion to the follies of his family. The emaciated libertine, and the lisping coquette, labour through the day in a perpetual round of fatigue, in order to repair the ravages of dissipation, or to shake off the languor of a nervous fever. Thus, by the powerful force of example, toil becomes a pleasure, and reason is sacrificed to the supremacy of custom: the wise condemn even that which they countenance; and the senseless eagerly pursue the footsteps of Fancy, because she has Fashion for her guide, and Folly for her companion.[16]

Before about the 1820s, this routine – modelled on Bath's – imposed a culture of fashion, dissipation and display that visitors 'senselessly' followed. It is opposed to and even destructive of health (the ostensible *raison d'être*, at least initially, of the town). As well as health, money, looks, and time are dissipated. This mode of life does not allow for the proper appreciation and enjoyment of nature. Part of the critique also centres on how normative categories of gender and rank are disrupted and blurred. The middling ranks (or 'cits') exhibit their folly as well as their wealth when they imitate their more tasteful betters, and the Steyne is full of effeminate men like the 'emaciated libertine' and women who neglect their domestic duties in favour of a very public display of their sexualized, fashionable bodies. Gertrude describes visitors exhibiting themselves in public spaces – the Steyne, libraries, the downs – but pays no attention to domestic spaces, reflecting that Brighton culture in this representation is publicly oriented away from the home.

Indeed, as critics have sought to establish the Brighton's role in the urban renaissance – its emergence as a town with fashionable and polite amenities – other versions of the town, such as domestic experiences and home life, have been neglected. This is part of a wider trend in eighteenth- and nineteenth-century scholarship in which the home in urban context is elided and the emphasis instead is on more public urban spaces, including theatres, museums, coffee houses, and streets.[17] Yet, amidst the satirical verse, guidebooks, and novels lampooning the aspiring middle ranks, effete libertines, and dissipated ladies of fashion flocking to Brighton, contemporaries also present a version of Brighton that is domestic and retired instead of public; polite not fashionable; rational instead of dissipated; intimate rather than crowded; more country and nature-orientated than urban focused. Sandham's *Sketches* is just one example of a contemporary text offering this alternate Brighton. For example, in 1812, a George Jackson wrote from Brighton to a relative that: '[t]his is now becoming our country house without

the drawbacks of country life. Nobody breaks down our hedges, our sheep do not die of the rot, our cows do not lose their calves, etc. and I can follow my indoor occupations without being interrupted by any visits'.[18] Meanwhile, in Richard Sicklemore's novel *Mary-Jane* (1800), the characters seek out rural advantages in Brighton. They 'hired a pleasant house on the Marine Parade', a residential street immediately facing the sea with easy access to the Steyne, and one of them asks: 'Who would live in London . . . in the dry part of the year, when they can be so much cooler and comfortably accommodated in the country?'[19] Guidebooks also acknowledge that not all visitors to Brighton would want to be in the centre of fashionable society. The *Brighton New Guide* (1800) gives Dorset Gardens as one example of the many rows of terraced townhouses that provided the best of the town and the country.[20] Dorset Gardens is

a handsome row of houses . . . uniformly built: in front is an extensive garden, laid out with much taste; two octagon temples or summer-houses ornament the pleasure-ground; and for those who wish retirement and rural prospects, with the advantage of being in the centre of every gaiety in a few moments (if required), there cannot be a more eligible situation about Brighton.[21]

Rural retirement and urban gaiety are both accessible here thus evincing a similar desire for the *rus in urbe* that was a feature of the suburbanization occurring in London at this time.[22] The *Guide* does not assume that visitors will rigidly follow the Brighton routine. Individual choice dominates over fashionable prescriptive-ness: rural retirement is available 'for those who wish' it, while the aside of '(if required)' emphasizes that visiting the 'centre of gaiety' is optional.

The villages around Brighton offered even greater retirement while still hav-ing proximity to amenities, including those associated with fashionable Bright-on. For example, according to the *Brighton New Guide*, the village of Rottingdean, about four miles from Brighton,

has of late been the resort of a considerable number of genteel company; for which bath-ing-machines, and every accommodation, have been provided. Here are a variety of well-fitted up lodging-houses, a good inn, with convenient stabling, coach-houses, &c. It is mostly frequented by such families as prefer a little retirement to the bustle and gaiety of Brighthelmston, and who occasionally may wish to mix with the company there, for which its situation renders it, at any time, perfectly convenient.[23]

Again choice or what individuals or families 'prefer' or 'wish' is emphasized. Young's *A Summer at Brighton* offers a sustained fictional portrayal of domestic life in Brighton's rural hinterland. Rather misleadingly and intriguingly named, this three-volume novel only ventures to Brighton for a few chapters, spending the rest of the time at a country estate, Beacon Priory. The Priory contains those amenities like bathing machines mentioned in the *Brighton New Guide*, and offers easy access to the centre of Brighton. This 'summer at Brighton' is primarily a

retired, intimate one, and the Priory is configured as a retreat distinct from both Brighton and London. The main characters, two affectionate sisters Amelia and Sybella, favour 'rational and elegant amusements' and the Priory 'had never been the fashionable resort of significant and dissipated characters'.[24] Sybella says, 'I did not enjoy the gay scenes at Brighton half so much as I have the happy hours we have shared in the dear Priory'.[25] The sisters are repeatedly contrasted with their dissipated sister-in-law, Lady Orient, who is most at home in London's most elite area, the West End, and who comes to Sussex for fashionable parties at villas near the Steyne boasting a range of aristocratic guests and the Prince Regent.

The pursuit of domestic retirement in Brighton and its environs thus existed through the early nineteenth century, but according to Sue Berry, an historian of the town, this became more pronounced in the 1820s. The Steyne started losing its fashionable status since views of the sea became more coveted and entertainment shifted from public areas to private homes on Brighton's edges.[26] In many cases, fashionable behaviours were merely shifted from the Steyne to private residences – increasingly big houses were built to cater for large-scale entertainment. The turn to privatized leisure and the increase in population meant that the master of ceremonies could no longer impose a single lifestyle on Brighton. People were more and more at liberty to determine their own mode of life, ones that could be, as in *Sketches*, distinct from the earlier fashionable social routine described above by Robinson. This anticipates the next step in the development of the resort town, since the 'sedate, protected middle-class family was probably the most important constituent of the mid-Victorian holiday market'.[27]

Domesticity, Women, and Brighton

Sandham's *Sketches* captures this transition. This is a novel that explicitly champions rigid gender conventions – initially in London, men work in the public sphere, while women are almost completely relegated to the private, domestic sphere. However, I argue that Brighton offers middling-rank women the opportunity to engage in physical mobility and intellectual curiosity not accessible in their quotidian London lives. Moreover, women can take advantage of these Brighton opportunities without having to sacrifice their virtue or respectability as domestic women – even when in Brighton, they are never in danger of becoming the lady of fashion or aspirational coquette so often lampooned in contemporary works on the resort town.

In addressing these issues, this study explores the gendered geographies of Brighton. Romantic-period women operated in spaces that were coded as male or female. Marilyn Francus notes that:

[w]hile the chronology of domestic ideology may be disputed, there are two points of general consensus: first, that the idealized image of the domestic woman served as a cultural shorthand for standards of female behavior, applicable to all women regardless of specific

situation or subject position; and second, that domestic discourse relied upon a gendered geography of space.[28]

Markman Ellis explains that the domestic woman, as represented by conduct books, follows:

a model of feminine behaviour consciously different from the aristocratic (which was criticised as ornamental, luxurious, exhibitionist): one whose virtues were to be found not in display but in inner virtue. They value a woman who has emotional and moral depth rather than a splendid show of surface.[29]

Usually scholars' understanding of the domestic woman in gendered geographies builds on a Habermassian notion of the separation of the public and private spheres and is rooted in a binary between male spaces (public, work, non-home) and female spaces (private, domestic, home), as in Leonore Davidoff and Catherine Hall's study of the middle classes between 1780 and 1850.[30] In practice, a rigid distinction between public and private spheres, male and female spaces is not always evident, as various critics, including Lawrence E. Klein, Amanda Vickery, and Marilyn Francus have indicated.[31] Women entered the public sphere as consumers and professionals, and welcomed the public sphere into their homes by hosting assemblies and writing letters to parliament.[32] While rigidly gendered geographies may not always apply to how men and women seemed to have actually lived their daily lives whether in 'real' life or in literature, the gendered separation of spheres has without a doubt a strong discursive power, as Marilyn Francus, among others, has indicated.[33] This is evident in the dedication with which writers of educational tracts, conduct books, and fiction, including Sandham, propound the virtues of the domestic woman ensconced in the domestic sphere. In *Sketches*, women's increased agency and freedom comes from a breaking down of rigid distinctions between public and private spheres, and so I trace how this binary is configured and re-configured as women move between holiday Brighton and London's routines.

In order to make sense of shifts in configurations of public and private and relations between men and women, feminist geographers' descriptions of the gendered power dynamics at play in space are useful. Linda McDowell states that '[p]laces are made through power relations which construct the rules which define boundaries . . . These boundaries are both social and spatial – they define who belongs in a place and who may be excluded, as well as the location or site of the experience'.[34] Vickery has applied power relations to her reading of eighteenth-century domestic interiors: she 'opens the door of the London house to consider how internal space was conceptualised, demarcated and policed'.[35] I follow Vickery's use of 'space' to refer to the multi-facetedness of spaces made up of a geographical location, physicality, and social relations, while 'place' refers simply to a geographical location or site. Sandham's novel is interested in the gendered implications of who controls entry into spaces (the home, the outdoors,

the Steyne) and what experience or activity occurs in a particular space (flirting on the Steyne versus distanced observation and critique). The degree to which people benefit from a particular space is a powerful indicator of who is making the rules. While in Sandham's novel, the heroine's father ultimately constructs the rules and defines who belongs in various spaces, and the novel thereby never abandons the strictures of conduct book domesticity and gender roles, the different gendered geographies of London and Brighton are subtle yet significant. In the resort town, with the patriarchal father largely physically absent, the women have more control over their spatial experiences and benefit more from them; specifically they gain reprieve from domestic chores, control over reading, and unprecedented physical mobility. While in London the women are largely confined to the smoke of London, in Brighton, they explore the town, adjacent villages, the Sussex downs, and the seashore.

Beyond this novel, contemporary spa and resort towns offered women possibilities not available in other spaces. These holiday towns had particularly high female populations, and allowed women '*comparatively* more autonomy in fields such as human relationships, marriage brokering, charitable work, gambling and leisure in general'.[36] Literary critics have also broached female agency in spa and resort towns. Melissa Sodeman explores how Austen's female characters take notions of domesticity out into the public, urban spaces of Bath and Sanditon which offers them new possibilities, security, and escape from confinement.[37] Sodeman's interrogation of mobility and domesticity aligns in many ways with the benefits that the women in Sandham's novel experience in Brighton. I am however interested in how this plays out in the specific context of Brighton as it becomes the country's premiere resort town and one focused on privacy rather than more eighteenth-century resort town ideals of display. I am also interested in how a highly didactic novel, one that unlike Austen's, is explicitly invested in defending the separation of spheres and gender roles, negotiates fashion, display, and female agency in the resort town milieu. While I, like Sodeman, explore how notions of domesticity extends beyond the home – in my case, into the urban centre of Brighton and its rural environs – in Sandham's novel, the bricks-and-mortar home remains significant. The home is central to the novel's shifting notions of female agency, since the home, as a particular location, physical structure, social and experiential space, as well as an idea, becomes a space in Brighton more focused on women's well-being than is the London home. The home is moreover the core of Brighton experiences and so all the intellectually and physically liberating excursions circle back to the home; home and not-home are in this way mutually enriching. Alison E. Hurley has meanwhile looked at correspondence to show how watering places, including Brighton, offered women, and in particular Elizabeth Montagu and her bluestocking circle, greater agency than did other spaces.[38] *Sketches* and my discussion of it are concerned with unpacking what such empowering spaces would look like for domestic-oriented, middling-rank women rather than the wealthier and/or higher-rank and more publicly visible female literati like Montagu and Frances Burney whom Hurley

addresses. This aim is reflected in my choice of both characters and writer. Instead of rehearsing the commentary on resort towns offered by well-studied and well-known women, this essay recovers a largely lost but once popular female writer; the online Hockliffe Project at DeMontfort University states that '[l]ittle is known about Elizabeth Sandham except that she was one of the most prolific and successful children's authors of the early nineteenth century'.[39]

'Home is the sphere of females': gender and spatial restrictions in London

Sketches focuses on the Hamilton family, and since their Brighton holiday home is set up in relation to their London residence, I start with an interrogation of their metropolitan home life. The London domestic routines of the Hamiltons – Mr., Mrs., Charles, Caroline, and baby Harriet – are clearly gendered with strict divisions between the spheres and spaces of male and female daily activity. Men's work is in the 'counting-house' and 'warehouses' and women's is in the home.[40] Mr. Hamilton explicitly confirms this strict gender division, explaining that 'boys . . . must be more in the world', while '[h]ome is the sphere of females'.[41]

This distinction allows the men to retreat at the end of the day from their place of work to the pleasure and ease of the home, as is evident in this description of a typical evening at the Hamiltons':

Mr. Hamilton left his counting-house at four o'clock. They dined at five; after which, the baby engaged their attention, till it was her hour of going to bed. The tea was then brought in; and when this was removed, and his mother and sister had taken their work, Charles read aloud. The happy father resigned himself to the luxury of ease and parlour comforts, which can only be enjoyed among affectionate relations, where each finds pleasure in the same employment.[42]

While each family member supposedly finds pleasure in the same employment and they are all indeed listening to Charles's reading, it is evident that each person depending on age and gender is experiencing this domestic space – the parlour – differently. The sequence of activities runs according to Mr. Hamilton's schedule, specifically when he leaves work at four o'clock. The 'happy father', the head of the household, is apparently both mentally and physically completely resigned to 'ease' and 'comfort'; indeed, listening to reading is the only activity he engages in while in the parlour. For Charles, as a younger man, this space is not so straightforwardly one of ease. He has to choose the books at the library, bring them home, and read them aloud. A hierarchy is in evidence: he selects the books in order to please his father, having been carefully educated along the lines of his father's taste (he 'prefer[s] those avocations which, from his infancy, he had seen his father follow')[43]. So while as a younger man, Charles does not enjoy the same power and leisure as his father, he has a range of mobility and access to knowledge denied to his mother and sister. They are never entrusted to choose

books, and they are passive receivers of knowledge: Mr. Hamilton reflects that 'on returning to my parlour for the evening, I can almost fancy myself a learned man, when I see a new work spread before me, and my wife and daughter waiting to hear my opinion of it'.[44] For the most part, the women are taxed with making this a peaceful retreat for the men, and so the home is never completely a space of ease for the women. During this scene they care for the baby, they do (needle)work, and likely pour the tea. The opportunities that women do have for leisure and pleasure are subordinate to the men's; as Mrs. Hamilton explains to her daughter: 'When [your father] is at home, we should consult his pleasure, rather than our own'.[45] This subordinating of self to the patriarch applies to reading as well: while there are indications that Caroline studies and reads on her own, when he is in the house, reading, like other activities, is centred on him.

Nature and the country are positioned as important recreational extensions of the home, particularly for the men. Caroline does sometimes leave her 'confined mode of life' in her house 'in a confined part' of the City of London, but her morning walks have limited geographical scope: she 'walk[s] in the gardens (which even the city affords) on the banks of the Thames' and her and Charles's 'utmost wishes for a walk. . . extended no further than to the Parks or Kensington Gardens'.[46] The health benefits of this exercise for Caroline are dubious; the reason she gets pleasure from these City walks is because she is 'inured to the atmosphere of London' which does not suggest an ideal physiological state.[47] These limited walks reflect corresponding experiential, literary, and intellectual limitations. The siblings' reading does not map onto their experience of space – this will have to wait for Brighton – and they are reliant on second-hand accounts of the countryside, since while still in London:

[r]ural scenes and pleasures were unknown to Caroline and her brother, except that they had read of them in books. They thought these accounts very pretty, but did not give them full credit; as they had heard from many of their father's acquaintances, that the country was either dry and dusty, or wet and dirty, and always very dull.[48]

While Caroline's and Charles's exercise is connected here, his regularly encompasses an area beyond the smoke of London. Mr. Hamilton keeps saddle-horses so that he and his son can ride out. After all, 'it was [Mr. Hamilton's] ambition, that neither himself nor his son, though born and bred in London, should, in this respect, be a *cockney*', and Mr. Hamilton's 'health was established by the air and exercise they afforded him'.[49] The saddle-horses thus have health and social benefits, but only for the men, and in fact the novel only signals the positive physical effects of these longer rides on the family's patriarch not on his son. The novel consistently reinforces that the family and their understanding of space are centred on ensuring Mr. Hamilton's well-being, health, and social status.

So while the horses benefit the men, especially Mr. Hamilton, these advantages are directly related to the women's limited movements: 'Mrs. Hamilton also had her *friends*, who attempted to insinuate, that a carriage would have been bet-

ter for the family, as then all might partake of the benefit of it; but their opinion had no weight with her'.[50] Here the concerns of the family are secondary to those of the men, and the women, unlike the men, are confined to the City's bad air. Mrs. Hamilton has internalized the 'benefits' of this unequal access to mobility, air, and exercise that disenfranchise herself and her daughters. Soon the Hamilton women are spending almost all their time in their home (in a 'confined', and thus likely miasmatic part of London) engaged in 'domestic affairs', especially childcare, since 'after the birth of her little Harriet, Mrs. Hamilton] found more pleasure in nursing and attending upon her, than an airing every day would have afforded'.[51]

'[W]alk over half the country': gender and spatial possibilities in Brighton

Ultimately, Mrs. Hamilton's confinement in the home and in London has serious consequences, making her ill, and her doctor 'recommended her trying the air of Brighton for a few months, as the summer was far advancing, and the confinement of London very injurious to her present state of health'.[52] The house the Hamiltons rent on Brighton's Marine Parade is thus configured as a retreat from London, particularly for Mrs. Hamilton, and is immediately contrasted with the bad air, confinement, and resulting ill health of the City house. Upon first arriving, Mrs. Hamilton finds a place in 'the drawing-room' where she 'reclined on the sofa, which had been drawn towards the open window, enjoying the view of the sea; and, to use her own expression, "inhaling health and vigour from every breeze"'.[53] The drawing room opens out not into confined streets and buildings but onto the ocean which is 'wide-spreading' and 'extended' with a 'wide expanse'.[54] Later Caroline takes in this view which is explicitly contrasted with the metropolis: the 'clouds are as variable as the ocean; and to Caroline, who had never been out of London, nor viewed their fleeting changes, but through the smoky atmosphere of the city, they affected ample room for admiration'.[55] Mrs. Hamilton and Caroline finally have access to fresh, health-giving air.

This house is also a different kind of social space, particularly in terms of gender: in Brighton, the home and drawing room are no longer dedicated to Mr. Hamilton's 'ease and comfort' from a day at work, but to Mrs. Hamilton's enjoyment and recovery from a lifetime of household management. The Brighton home can be such a space for Mrs. Hamilton, because she is relieved from her typical household duties, which are taken over by her husband and her daughter. When her father returns to London for work, Caroline will take care of her mother. While Mrs. Hamilton's dedication to her domestic affairs made her ill, Caroline's take-over of these duties does not have such negative recuperations – indeed, her time in Brighton is also enjoyable and health-giving – and this is directly tied to the uniqueness of Brighton as a holiday resort town. Caroline's duties are lighter than her mother's at home, because for most of the trip, she does not have to take care of her brother or father who are not in Brighton but

are for most of the time working in the City of London. This is, for the most part, a holiday set up specifically for women – a holiday they rarely (never?) get in London. Significantly, Caroline is not confined to the home or to the bad air of the City: from her Marine Parade home, she has access to those resort town advantages that attracted so many people to Brighton: the sea, the downs, and polite amenities like the circulating libraries.

The Hamiltons set their Marine Parade home up not just as a retreat from London but also from fashionable Brighton. Early on, Caroline momentarily worries about becoming a Lydia Bennet, making a mad dash to the Steyne. However, the presence of her family solidifies her commitment to her mother and to the home, and she reaffirms that '[w]herever [my mother] is, there is my station'.[56] Caroline and her father do venture into the heart of the Steyne. While evidently most visitors to Brighton are piling onto the crowded Steyne and embracing its nightlife, Mr. Hamilton and Caroline retain their status as an intimate, family unit clearly separate from the crowd. They do so by maintaining a tourist's distance – while they see the sights of the Steyne, they have no desire to become a sight in turn. They verbalize the paraders' ridiculousness and do not participate in the Steyne activities such as gambling. Indeed, the Steyne is an unpleasant space physically, aurally, and rationally in which immersion is implicitly not desired. Caroline for the first time becomes a social critic, as she wonders: '[C]an people . . . prefer sitting in that hot place, and listening to the din of such continual noise, to walking by the sea-side? or even to parading up and down these bricks, where, at least, there is more air, if not greater variety?'.[57] Excursions out of the home always circle back to it in this novel, and this venture onto the Steyne has its domestic benefits: before leaving for their walk, Mr. Hamilton promises that he and Caroline will return with stories of 'fine ladies and gentlemen' and will thus 'bring [Mrs. Hamilton] home some amusement'.[58]

In the Hamiltons' experiences of urban Brighton, two versions of it emerge: the fashionable, dissipated one above, which the Hamiltons observe at a tourist's distance, and a genteel, polite one in which they participate. This polite Brighton includes attending concerts on the promenade and book borrowing from the circulating libraries. While the Hamiltons do not even enter a library appropriated for gambling, Mr. Hamilton envisages that library books will be the building blocks with which they re-create in Brighton the rational activity they cultivated in London. He tells Caroline:

You must subscribe to a library while you are here; but as reading will be your chief motive for doing so, we must go where there is the best collection of books. You will not wish to spend much time away from your mother; therefore it is unnecessary for you to put your name down at each library, as many do, that they may have free access to all.[59]

Mr. Hamilton here alludes to the fact that gambling is not the only way that Brighton's circulating libraries are implicated in the fashionable routines of the resort town. Most people's 'chief motive' for subscribing to the town's libraries

was to advertise their arrival at Brighton, and thus enable their quick assimilation into its public, fashionable social circuit.[60] Caroline will use the library with the best choice of books differently as she will engage only in non-domestic spatial experiences that improve the home, as she says 'it will give me more pleasure to read to her, than all of the variety these places afford'.[61]

Mr. Hamilton directs and insists on Caroline's use of the library, and he controls the creation of domestic activity in Brighton similar to that he has overseen in London. Indeed, even when he's gone back to London, the 'mother and daughter pursued the same regular plan they had adopted at home'.[62] Yet there are important differences for the women between the Marine Parade and City homes once Mr. Hamilton leaves Brighton. Caroline will have unprecedented mobility, access to knowledge, and power in shaping domestic activity; by venturing to the library, choosing the books, and reading them aloud, Caroline takes over a role belonging to a male, her brother, in London. While Brighton libraries are never named in *Sketches*, Sandham describes them as commercial and sociable spaces both men and women could enter to buy fripperies, converse, and make charitable donations, so they are likely representations of some of the town's many circulating libraries which included, for example, Bowen's shop (described by Hester Thrale to Fanny Burney in a 1780 letter).[63] Since Caroline or indeed the reader never go with Charles to the library in London, it is possible that he frequents a subscription library, a non-commercial library generally only open to men. Circulating libraries, by contrast, were feminine spaces. In the popular imagination, circulating libraries provided sensational romantic and gothic novels for impressionable young women. While this is far from the whole story, circulating libraries were spaces of female agency, something Caroline experiences for the first time in Brighton. Women could take out memberships, as they do in *Sketches* – women accounted for about half of the nation's circulating library memberships – and Fanny Price in Austen's *Mansfield Park* reflects on the sense of empowerment that subscribing to a circulating library gave women: 'She became a subscriber – amazed at being any thing in *propria persona*, amazed at her own doings in every way; to be a renter, a chuser of books!'.[64]

Like Fanny, Caroline has agency through the act of choosing. Intriguingly, Sandham never specifies what the 'best collection of books' would look like or indeed the kind of 'books' that Caroline borrows. Caroline could be bringing home a whole range of works, and the lack of specificity points to how Mr. Hamilton's reading regime is quite relaxed, giving his daughter a lot to choose from when the decision of what to read falls to her. Charles's education encompasses Virgil and Horace, but Mr. Hamilton does not believe a future merchant should be too intellectual and should be able to relax along with his female relatives with entertaining, even funny, works like '"Rejected Addresses," "Letters of the Fudge Family," and others in that style'.[65] Meanwhile, the 'education of Caroline was on the same plan as her brother's' and she studies 'the English and French languages, geography, and other branches of useful knowledge', while also having the time to laugh along with her brother at these lighter pieces.[66] By not merely

allowing but actually emphasizing the importance of entertaining literature and introducing his daughter to circulating libraries, Mr. Hamilton distinguishes himself from the alarmist school of thought which held that circulating libraries were corrupting the morals of young women and destroying Enlightenment ideals. Such rigid, moralistic, even misogynistic attitudes are embodied in *Pride and Prejudice*'s Mr. Collins who refuses to read novels or anything from a circulating library, choosing Fordyce's *Sermons* instead.[67]

Caroline not only picks out books in Brighton, but the women will have to develop their own opinions of these works, since Mr. Hamilton will not be available to dispense his literary insights. Meanwhile, Mrs. Hamilton is in the more fully leisured position of listener normally restricted to Mr. Hamilton; this space is set up to ensure her well-being, health, and social status (as here she plays the role of genteel lady, while claims to gentility are usually restricted to her husband and son who can escape the cockney [i.e. lower middle class] City on their saddle horses). The advantages of the Hamilton's City home are therefore transposed to Brighton primarily benefitting women rather than men.

Another advantage accorded to Caroline in Brighton is her increased access to nature. The Marine Parade house faces the sea and is not far from the Sussex downs. While Caroline explores the country and nature, the home is always the most significant space for her in Brighton. Domestic affairs, particularly as they relate to Mrs. Hamilton's comfort, must be attended to before going on a seaside walk. As with the visit to the Steyne, the excursion to the sea will benefit the home by enlivening domestic conversation. Moreover, when admiring the sea, Caroline's thoughts turn back to the home, as she thinks about her ill mother and the ways that the sea might complement Mrs. Hamilton's recovery already underway in the Marine Parade drawing room. Caroline's appreciation of the sea is also mediated through the literature her family has read together in their London home: the waves remind Caroline 'of a small extract from Mason's English Garden', which she goes on to recite.[68] However, or the first time, she can map literature onto the space in which she stands, and she thus has an enhanced experience of both space and literature. Significantly, she no longer relies on her father's literary opinions: she advances her literary impression first and it differs from her father's who invokes 'Gray's letters'.[69] Nor must she be satisfied with his male friends' ideas of the dull and dirty country.

Charles Hamilton's and Mr. Hamilton's visits to Brighton demonstrate that even when the men are present, women do enjoy greater freedom in the resort town than they do in London. In Brighton, women are part of men's excursions to Brighton's hinterland and to the library; women's inclusion has in the resort town become normalized. During Mr. Hamilton's visit, the family explores the town, including one of the libraries, together. Mr. Hamilton's attention is focused on his female relatives' health and happiness at the library: he buys them the products they want and makes a generous charitable donation as a thank you to the town that has been instrumental in his wife's recuperation. When Charles visits, he and Caroline explore a multiplicity of spaces in ways that support intel-

lectual curiosity, imaginative exploration, and physical well-being. Charles writes to Caroline, anticipating their trip: 'Gather up all your strength, as I shall expect you to walk half over the country with me. Prepare the Brighton Guide, and we will see all that is worth seeing within ten miles of the place'.[70] Although he instigates the plans and gives her advice (such as '[p]repare the Brighton Guide'), he sees them as joint planners of these excursions – he wants her to do preparatory reading as he himself has done. Unlike in London, Charles's retreat from work does not centre on his sister creating a domestic refuge for him. While extensive journeys were confined to himself and his father in London, Charles plans to explore Brighton and its environs with his sister. Caroline replaces her father and this is in one way a more equal team consisting of siblings (with near matching names) than the generational imbalance of the father-son relationship and its total exclusion of women.

Again reading directs exploration, and when planning the trip Charles also mentions 'Mr. Wilson's description' of Brighton, Mary Lloyd's *Brighton: A Poem* (1809), Shakespeare, and Byron.[71] A range of writers shape Caroline and Charles' explorations, enhancing their imaginative, aesthetic, emotional, and historical understanding of natural, aesthetic, historical, and religious sites. For example, at one point, Charles pictures himself 'with the power of Prospero' raising a '*tempest*', while Caroline's imaginings of a storm are mediated through her reading about the destruction caused by the storm of 1816 and Thomson's 'dreadful description' of an enraged sea.[72] This is the moment Charles and Caroline most clearly break out of the conduct book narrative in which they spend most of the novel and play at being characters in a novel of sensibility with the possibilities for the expression of deep feeling for others, nature, and literature that that genre offers.[73] This is Caroline's Evelina or Celestina moment. This spatial experience is an alternative to domestic confinement, drudgery, and ill health and to urban consumerism and superficiality. Again, Caroline is able to apply her reading to the landscape in a way that was not possible in London, and her domestic reading and her experiences of nature are mutually enriching.

The multi-faceted possibilities that Caroline takes advantage of in Brighton are underlined by her foil, a Miss Dobson. Miss Dobson and her mother are the vulgar, emulative middling-rank women so often satirized in works on Brighton including Robinson's novel quoted above; they are the family of the 'the sober cit' who 'exhibit' their 'follies'.[74] They reveal their lack of interest in managing the home financially or emotionally: they, in their own words, 'cheat' Mr. Dobson 'by using some of that which he allows for housekeeping, on our own wants' in urban shops.[75] They spend money and enjoy Brighton's fashionable and commercial amenities as much as possible. For example, unlike Caroline, Miss Dobson uses the library to announce her arrival in Brighton and thus her readiness to participate in the Brighton 'routine': she 'said [to her father], none of our acquaintance would find us out, unless our names were in this [subscription] book'.[76]

Caroline and Miss Dobson's different experiences of Brighton spaces are highlighted when one day our heroine goes for a walk with Miss Dobson and

some of her Brighton friends (Caroline, of course, makes sure everything is in order at home and makes Harriet promise to be 'a very good girl' in her absence):

instead of going by the sea-side, or on the hills, as [Caroline] hoped they would, their walk extended no further than the Steyne, and from the middle of North-street to the top of St. James's-street, looking in at the various shops, and giving their opinion of the people who passed.[77]

They walk only in a geographically limited area at the very centre of town, including the fashionable promenade, the Steyne, and the central shopping streets of North and St. James's. Moreover, their exploration of Brighton is confined to window-shopping and people-watching. Miss Dobson and the Brighton ladies thus limit themselves to a very narrow, namely fashionable and highly visual, version of Brighton. Caroline repeatedly expresses a desire for greater physical mobility and exhibits a more general curiosity about Brighton. Her admiration of 'the distant hills, with the windmills on them' and 'the parish-church' and its 'prospect', as well as her interest in better understanding the architectural merits of the Pavilion are dismissed by the Brighton ladies.[78] They favour the more fashionable Chapel Royal and unquestionably, and without reflection or a desire to understand more about architecture or aesthetics, venerate King George IV's Pavilion as the pinnacle of good taste. Caroline is all together more critical and curious and hopes to learn more about these spaces by returning for a more in-depth tour. All in all, this adventure with the Brighton ladies, unlike her rambles with her family, fails to satisfy her intellectual curiosity or her need for physical activity, and Caroline 'returned from her walk more fatigued than when she had been a greater distance'.[79]

As is common in the domestic or sentimental novel, influenced by female conduct books, the lady of fashion (or her middling-rank emulator) gets her comeuppance. This comes after the Dobson women:

purchased a large quantity [of the best smuggled silks and laces], unknown to Mr. Dobson, who would never discover it, as his eyes were not good, and they intended to wear them only by candlelight. Besides, [Miss Dobson] said, he will never suspect us, because we pretend always to be of his opinion in these matters.[80]

Miss and Mrs. Dobson's behaviour is undercut in multiple ways. They fail as proper domestic women: they practice duplicity with their patriarch and they bring the public sphere into the private in ways that the narrative and the Hamiltons find problematic. Despite acknowledging Mr. Dobson's tyrannical, parsimonious behaviour, the Hamilton women find Miss Dobson to be most at fault here because she has deceived her father and thus failed in her duty as a woman and a daughter. Furthermore, the Dobsons import fashionable Brighton, which the novel finds problematic even when safely located in its proper site of the Steyne, into the rarefied private sphere of the home. They transgress the separa-

tion of the spheres and there are no advantages here for women in bringing the public sphere home. Instead of affection and togetherness there is deceit. Miss Dobson and her Brighton friends pretend French study is the reason for her silk shopping. Caroline sees this as merely an excuse: 'I imagine the dialect of French milliners and toymen not very improving'.[81] Moreover, there is no mention in the descriptions of the Dobsons' Brighton house of the kind of domestic- and book-oriented rational study Caroline engages in. The Dobsons are also failed ladies of fashion and made ridiculous in their attempts at being chic: instead of parading on the Steyne, they wear their silks in their darkened rooms where they just have each other as an audience. Moreover, the Dobsons disobey the authority not only of their domestic patriarch but the nation's as well. The family is arrested by customs officials for possession of smuggled goods, and their silks are confiscated. They fail as both ladies of fashion and domestic women.

In the face of such transgressions, the novel strongly reasserts the ideal of the domestic woman, male authority, and the separation of the spheres. Mr. Dobson reaffirms his control over his female relatives by confining them to the home: he 'allowed them no superfluous money; and, from that time, their annual visits to watering-places were given up. They were deprived of every recreation, except what their house and garden at Islington afforded, or occasional visits to their brother's shop'.[82] While the Dobson women must be forcibly restricted to the home, Mrs. Hamilton and Caroline have internalized their roles – their place values – as household managers. During her time in Brighton, Mrs. Hamilton starts to resist her continuation in this space of retreat and recuperation, and is eager to return to her domestic affairs. Moreover, once they're back in London, Caroline becomes the primary agent in reconciling the Dobson women to patriarchal power. Caroline helps the Dobson women transform their home into one centred on intimate, familial reading similar to the Hamiltons'. Miss Dobson 'imperceptibly began to find pleasure and instruction in the pursuit' of reading and their new confined position in domestic space even becomes agreeable.[83] Miss Dobson 'began to find pleasure in obeying her father. . . . She became better tempered, and her mother more comfortable; though there was little prospect of their being under less restraint'.[84] At this point in the novel, reading is an instrument of soft patriarchal power. This home is one clearly run by a man, Mr. Dobson, and so reconciliation to domestic confinement means internalizing gendered hierarchies and also learning to experience a lack of power as pleasurable.

Back in the workaday world of London then, men, especially older patriarchal figures, are overtly the centres of power. In this novel's logic, a model of quiet, rational domesticity with clearly demarcated roles according to gender and age triumphs. Of course, even Brighton was far from a female utopia. The feminine-centric spaces of Brighton have clear temporal, spatial, and experiential limits. Mrs. Hamilton has to attain a point of illness and fatigue that the Hamilton men with their daily access to 'comfort and ease' never reach before she is granted her own space in which to recuperate. Brighton is importantly a holiday location – denoting its *temporary* departure from normal spatial and temporal routines.

Mrs. Hamilton insists on returning to her routines at home which have proven hazardous to her health. Moreover, even when Brighton is a space of leisure and recuperation for Mrs. Hamilton, a woman still needs to be doing the work of hands-on household management and Caroline assumes that role, while Mary (Mrs. Hamilton's sister) takes over in London. Although Caroline does have greater leisure time in Brighton than in the City, the Brighton house becomes a sort of apprenticeship for her, inducting her more fully into an adult world in which women are taxed with household affairs in order to create domestic retreats for men. This is quite clearly illustrated in her success at reconciling the Dobson women to domestic patriarchal power. Indeed, only female agency – like Caroline's – that does not challenge patriarchal power is allowed, even in Brighton. After all, Mr. Hamilton's domestic model of rational reading was copied by the women in Brighton; his control over shaping that domestic space is reflected by the fact that he did the initial choosing of the house, its situation, and its furnishings, and he goes to Brighton to set the house up. Mr. Hamilton also ultimately benefits from the Brighton trip – he was a healthier, and more productive, worker than his wife after her brief recuperative vacation.

Sandham's novel could then be read as a run-of-the-mill tirade against fashionable women who dare to go out on their own and spend money as they want and a treatise on how women must be controlled by men and kept safely in the home. Having said all this, *Sketches* still offers suggestive possibilities for how middling-rank women might benefit from the growing popularity of resort towns. Caroline may be limited in her role as a good 'daddy's girl', but her domestic life also gives her a richer experience of public spaces – unlike the other more fashionable young women, she is curious and critical as she moves through a whole range of spaces. Significantly, at the end of the novel, the Dobson women are not the only ones to change; Mr. Dobson becomes more mellow with age and attracted by his daughter's better temper finally weans himself away from his City shop to spend more time at home. It is interesting that the Dobson women's punishment specifically involved giving up their 'annual visits to watering-places' where women do have comparatively more agency. The last we hear of Miss Dobson she is in Margate, another resort town, buying silks (English this time). In resort towns then as long as women work within the bounds of patriarchy, both national and domestic, they can access some freedom too.

After all, in towns like Brighton and Margate, women could become savvy consumers, make friends with a range of fellow visitors, and enjoy various cultural experiences such as concerts on the promenade. Opposed to the more common image of the fashionable resort town, visitors increasingly sought domestic retirement in Brighton which offered different opportunities for women: intellectual development, intimacy, and health-giving exercise. Resort towns could allow access to advantages until recently relegated to middling-rank women's social superiors and often accorded only to men in ordinary, non-holiday life.

Notes

1 Jane Austen, *The Complete Novels of Jane Austen* (London: Penguin, 1996), 356.

2 Sue Berry, *Georgian Brighton* (Chichester: Phillimore, 2005), 19. Berry bases this information on the decennial census.

3 See Sue Berry, *Georgian Brighton* (Chichester: Phillimore, 2005); Anthony Dale, *Fashionable Brighton, 1820–1860* (London: Oriel P, 1947); Dale, *The History and Architecture of Brighton* (Wakefield: SIR, 1972); Dale, *The Theatre Royal Brighton* (Stocksfield: Oriel, 1980); and Dale, *Brighton's Churches* (London: Routledge, 1989); Sue Farrant, *Georgian Brighton, 1740–1820* (Brighton: University of Sussex, 1980); Edmund W. Gilbert, *Brighton: Old Ocean's Bauble* (London: Methuen, 1954); and Clifford Musgrave, *Life in Brighton* (London: Faber & Faber, 1970). Brighton is also addressed in histories of the resort town more generally. See Peter Borsay, 'Health and Leisure Resorts, 1700–1840', in *The Cambridge Urban History of Britain, 1540–1840*, vol. 2, ed. Peter Clark (Cambridge: Cambridge University Press, 2008), 775–803 and John K. Walton, *The English Seaside Resort: A Social History, 1750–1914* (Leicester: Leicester University Press, 1983).

4 For brief references to romantic-period Brighton and its hinterland in literary criticism, see Tim Fulford, 'Sighing for a Solider: Jane Austen and Military Pride and Prejudice', *Nineteenth-Century Literature* 57, no. 2 (2002): 153–78; Andrea Henderson 'Burney's *The Wanderer* and Early-Nineteenth-Century Commodity Fetishism', *Nineteenth-Century Literature* 57, no. 1 (2002): 1–30; Alison E. Hurley, 'A Conversation of Their Own: Watering-Place Correspondence among the Bluestockings', *Eighteenth-Century Studies* 40, no. 1 (2006): 1–21; Michael Wiley, 'The Geography of Displacement and Replacement in Charlotte Smith's *The Emigrants*', *European Romantic Review* 17, no. 1 (2006): 55–68; and Sarah M. Zimmerman, 'Varieties of Privacy in Charlotte Smith's Poetry', *European Romantic Review* 18, no. 4 (2007): 483–502.

5 The Jane Austen Society of North America's 1997 Annual General Meeting had the theme, 'Sanditon: The New Direction?' which resulted in a special issue of *Persuasions* (no. 19, 1997). For Austen criticism on Bath, see, for example, Jocelyn Harris, 'The White Glare of Bath', in *A Revolution Almost beyond Expression* (Newark: University of Delaware Press, 2007), 160–87.

6 See Fulford on dissipation and display in military camps and Henderson on commerce.

7 For a detailed discussion of the royal Pavilion, see Berry, *Georgian Brighton*, 46–62.

8 For descriptions of the season and how it changed, see Berry, *Georgian Brighton*, especially 32 and 39.

9 George Saville Carey, *The Balnea; or, An Impartial Description of All the Popular Watering Places in England* (London: J. M. Myers, 1799), 70.

10 Anonymous, *Brighton!!: A Comic Sketch* (London: William Kidd, 1830), 9.

11 See Berry, *Georgian Brighton*, especially 12.

12 Elizabeth Sandham, *Sketches of Young People; or, A Visit to Brighton* (London: Harvey and Darton, 1822), 54.

13 Anonymous, *Brighton!!*, 41.

14 Many spellings exist for the Steyne (particulary Steine, Stein, and Stayne). I have elected to use Sandham's usage, the Steyne, but where variants appear in quotations I do not change them.

15 Berry, *Georgian Brighton*, 97.

16 Mary Robinson, *The False Friend*, in *Works of Mary Robinson*, vol. 6, ed. Julia A. Shaffer (London: Pickering and Chatto, 2010), 88.

17 Benjamin Heller, for example, writes that the 'history of leisure and pleasure in the eighteenth century has largely been written as one of commercialization and public places' and this 'emphasis' has 'often obscured the importance of people's homes' (623-4). See Heller, 'Leisure and the Use of Domestic Space in Georgian London', *The Historical Journal* 53, no. 3 (2010): 623-45. For an example of the emphasis on urban public spaces in romanticism, see James Chandler and Kevin Gilmartin, eds., *Romantic Metropolis: The Urban Scene of British Culture, 1780-1840* (Cambridge: Cambridge University Press, 2005).

18 Quoted in Berry, *Georgian Brighton*, 45.

19 Richard Sicklemore, *Mary-Jane*, vol. 1 (London: Minerva, 1800), 58.

20 Berry, *Georgian Brighton*, 113.

21 F. G. Fisher, ed., *Brighton New Guide; or, a Description of Brighthelmston*, 4th ed. (London: T. Burton, [1800]), 26.

22 See Henry Lawrence, 'The Greening of the Squares of London: Transformation of Urban Landscapes and Ideals', *Annals of the Association of American Geographers* 83, no. 1 (1993): 90-118 and Chris Miele, 'From Aristocratic Ideal to Middle-Class Idyll: 1690-1840', in *London Suburbs*, ed. Julian Honer, especially 45-6. For discussion of Brighton in suburban terms, see Borsay, 'Health and Leisure Resorts, 1700–1840', 777-8 and Berry, 'The Suburbs', in *Georgian Brighton*, 87–110.

23 *Brighton New Guide*, 53.

24 Mary Julia Young, *A Summer at Brighton. A Modern Novel* (London: D.N. Shury, 1807), vol. 1, 53, 126.

25 Young, vol, 3, 16-7.

26 See Berry, *Georgian Brighton*, 45, 62 and 97-110. This privatization of resort life also occurred in other resort towns; see Borsay, 'Health and Leisure Resorts, 1700–1840', 793-4.

27 Walton, 190.

28 Marilyn Francus, Monstrous Motherhood: Eighteenth-Century Culture and the Ideology of Domesticity (Baltimore: Johns Hopkins University Press, 2012), 2.

29 Markman Ellis, *The Politics of Sensibility: Race, Gender, and Commerce in the Sentimental Novel* (Cambridge; New York: Cambridge U P, 1996), 28.

30 Leonore Davidoff and Catherine Hall, *Family Fortunes: Men and Women of the English Middle Class, 1780-1850* (London: Hutchinson, 1987).

31 Francus; Lawrence E. Klein, 'Gender and the Public/Private Distinction in the Eighteenth Century: Some Questions about Evidence and Analytic Procedure', *Eighteenth-Century Studies* (1995): 97-109; and Amanda Vickery, *The Gentleman's Daughter: Women's Lives in Georgian England* (New Haven, Conn.: Yale University Pres, 1998).

32 Francus, 4.

33 Francus, 5.

34 Linda McDowell, *Gender, Identity and Place: Understanding Feminist Geographies* (Cambridge: Polity Press, 1999), 4.

35 Amanda Vickery, *Behind Closed Doors: At Home in Georgian England* (New Haven: Yale University Press, 2009), 28.

36 Borsay, 'Health and Leisure Resorts, 1700-1840', 796. Borsay points out that '[s]uch a system did not, of course, undermine the fundamentally gendered character of social behaviour' (796). For further discussion, see pp. 795-6.

37 Melissa Sodeman, 'Domestic Mobility in *Persuasion* and *Sanditon*', *Studies in English Literature 1500–1900* (Autumn 2005): 787–812.

38 Hurley, 'A Conversation of Their Own', 1–21.

39 'Stories Before 1850. 0205: Elizabeth Sandham, *The Twin Sisters; or, the Advantages of Religion*'. *The Hockliffe Project*. DeMontfort University, n.d.

40 Sandham, *Sketches*, 13.

41 Ibid., 4, 5.

42 Ibid., 21.

43 Ibid., 14.

44 Ibid., 16.

45 Ibid., 17-8.

46 Ibid., 18, 117, 19, 20.

47 Ibid., 19–20.

48 Ibid., 19–20.

49 Ibid., 20.

50 Ibid., 21.

51 Ibid., 18, 21.

52 Ibid., 29.

53 Ibid., 41.

54 Ibid., 39, 41, 43.

55 Ibid., 72.

56 Ibid., 38.

57 Ibid., 49.

58 Ibid., 45.

59 Ibid., 50.

60 Berry, *Georgian Brighton* 28–9.

61 Sandham, *Sketches*, 50.

62 Ibid., 52.

63 Hurley, 'A Conversation of Their Own', 13.

64 Austen, *The Complete Novels*, 676.

65 Sandham, *Sketches*, 17.

66 Ibid., 17.

67 Austen, *The Complete Novels*, 263. My discussion of libraries is informed by John Brewer, *Pleasures of the Imagination* (London: Harper Collins, 1997), 176-86; James Raven, 'From Promotion to Proscription: Arrangements for Reading and Eighteenth-century Libraries', in *The Practice and Representation of Reading in England*, eds. James Raven, Helen Small, and Naomi Tadmor (Cambridge: Cambridge University Press, 1996), 175-201; and William St. Clair, *The Reading Nation in the Romantic Period* (Cambridge: Cambridge University Press, 2004), 235-67.

68 Ibid., 43.

69 Ibid., 43.

70 Ibid., 97.

71 Ibid., 54.

72 Ibid., 105.

73 See Ellis; Claudia Johnson, *Equivocal Beings: Politics, Gender and Sentimentality in the 1790s* (Chicago: University of Chicago Press, 1995); Gillian Skinner, *Sensibility and Economics in the Novel, 1740-1800* (Basingstoke: MacMillan Press, 1999); and Ann Jessie van Sant, *Eighteenth-Century Sensibility and the Novel* (Cambridge: Cambridge University Press, 1993).

74 Sandham, *Sketches*, 88.

75 Ibid., 91.

76 Ibid., 88.

77 Ibid., 74.

78 Ibid., 74, 76, 76.

79 Ibid., 78.

80 Ibid., 81.

81 Ibid., 79.

82 Ibid., 114.

83 Ibid., 126.

84 Ibid., 139.

The
Romantic

THE ROMANTIC CANON AND THE MAKING OF A CULTURAL SAINT IN THE FAROE ISLANDS

KIM SIMONSEN

[ABSTRACT]

This article explores the role of literature and romantic nationalism in the creation of nations as this applies to the Faroese nation, in particular the case of the poet Nólsoyar Páll. It is the ambition to discuss how literature can be a medium of collective identity-making, as it involves the canonisation of what is termed *cultural saints* (i.e. the heroic, mythological, and legendary figures who are seen as founders of communities). The article will give an introduction to the research that considers the dynamics of selected vernacular writers, artists or scholars for inclusion into the canon of cultural sainthood. The following will link a hitherto underexplored part of European romanticism to the developing theory of how durable forms of memory, such as public monuments, banknotes, hagiographies, are constructed.

.

KEYWORDS *Romantic Nationalism, Cultural Memory, Canonisation, Cultural Saints and National Heroes*

This article will explore the role of literature and romantic nationalism in the creation of nations, specifically as it applies to the Faroese nation. The article seeks to answer three questions: (i) how were vernacular writers, artists, or scholars selected for the canon and later elevated into cultural saints? (ii) what does the choice of certain writers tell us about canonicity in the nineteenth century? and (iii) how did these acts of canonisation relate to more durable forms of memory, such as public monuments, banknotes, hagiographies, and the politics of memory? The case study I shall use to address these questions focuses on the Faroese poet Nólsoyar Páll.

However, before turning to the Faroese case study, it is important to understand the concept of the cultural saint. A good place to start is with David Aberbach, who comments that, in the nineteenth century, national poets became public figures who understood how to mediate a sense of national pain that would, in turn, stimulate or create national hope.[1] European national poets had high aims for their nations; they strove for independence, unity, power, or recognition. For this reason,

Kim Simonsen, PhD and postdoctoral researcher at the Study Platform of Interlocking Nationalisms (SPIN) at the University of Amsterdam, Netherlands
Aarhus University Press, *Romantik*, 04, 2015, pages 73-93

national poets often convey not just an image of stable national identity but also its op-posite: weak identity, which gives an edge of desperation to national assertion. A tendency for a poet to identify with a wounded, weak, humiliated nation might be enhanced by childhood trauma or disability.[2]

Ann Rigney, in her article on the worldwide commemoration of the nineteenth-century writer Robert Burns (1759-1796), notes that recent critical analysis of the canon has opened up new perspectives on the question of how a nation is formed through the use of cultural memory and symbols, such as literary works and cul-tural saints.[3] Therefore, the study of nineteenth-century canonisation processes amounts not only to a study of cultural pathology, but also to an examination of how a society cultivates its self-image through an active use of cultural memory. Historical heroes were also selected for national honour and elevated to embody a community's political and moral ideals. Jón Karl Helgason sees 'cultural saints' as persons who have been 'singled out as leading representatives of their national culture, giving them a status previously held by regal authorities and religious saints'.[4] He further argues that it can be revealing 'to refer to these national he-roes simply as "cultural saints" and analyse their legacy with reference to con-cepts traditionally reserved for discussing religious phenomena'.[5] If nationalism is seen as a secularised, civil religion, cultural saints represent the patriarchy of this religion.

Cultural saints are individuals who are seen to have done service to the na-tion, fought for the nation, or died as martyrs for the nation. This caused them to be selected for inclusion in the nation's pantheon.[6] In the following pages, I will build on a framework of ideas put forward by the Cultural Saints of the European Nation States (CSENS) research project.[7] I will unfold some of the pa-rameters established by the project and use some of the key notions of the entire framework.[8]

The study of cultural saints is based on the analogies which exist in the cul-tural history of Europe between the selection and the celebration of national artists and the traditional canonisation of religious saints. Hence, a study of cul-tural saints will need to investigate the artists' 'saintly' status: their *vitae* and their canonisation. It is important to concentrate on the life and the work, as well as on the intellectual context of the individuals in question. Often the canonisa-tion process implied self-conscious strategies of 'culture planning', which is why it is important to focus on shared features that made the cultural saints eligi-ble for canonisation.[9] Joep Leerssen and Ann Rigney argue in their latest book, *Commemorating Writers in Nineteenth-Century Europe – Nation-Building and Centenary Fever*, that

The wave of commemorations that passed over Europe in the long 19th century was not only cultural in nature. It was remarkably often – and this was part of its self-reflexivity – focused on culture itself. An inventory of centenary celebrations shows that attention was indeed paid to the recollection of historical events . . . But particular attention was

paid to heroes from the cultural sphere . . . But it was above all literature which stole the commemorative limelight. The large-scale celebration of European writers arguably began with the successful celebration of Shakespeare in 1769 and went on to include, among many others, the centenaries of Goethe (1849), Schiller (1839, 1859), Tasso (1857), Burns (1859), Shakespeare (1864), Dante (1865), Scott (1871), Hooft (1881), Petrarch (1874), Rousseau and Voltaire (1878), Moore (1879), Camoes (1880), Pushkin (1880), Runeberg (1904), Prešeren (1905), Wergeland (1908).[10]

Cultural saints are often canonised in the same way as literary works in a given culture.[11] Nólsoyar Páll has been canonised as a national hero and a cultural saint. Today, he is commemorated as a national hero because he was the first Faroese to build his own ship and start his own trading routes. It is because of this reception that he is still important to the self-image of the Faroese nation today. The case of Páll, which is examined in this article, is furthermore relevant to the question of how a self-image of the nation can be 'instrumentalised', crystallised, and later canonised.

The term 'pantheon' is used here to refer to the canon of a nation. It has both a symbolic meaning and a physical presence. In some respects, discussions of nineteenth-century hero-worship may appear strange or unusual within the context of the study of literature, memory, and nationalism. At the end of the eighteenth century, and especially in the nineteenth century, new pantheons emerged all over Europe. In France the old church of Sainte-Geneviève in Paris became the resting place for the nation's most important citizens. Prior to this, in Jægerspris, Denmark, a memorial park was built in 1776. These various pantheons are national 'Halls of Fame' through which people could familiarise themselves with the nation's heroes, the cultural forefathers of the nation.[12]

Romantic Nationalism

The dynamics involved in the creation of cultural saints described above is intrinsically tied up with the romantic nationalism. It should be pointed out that the ballads discussed in this article were not written as romantic or nationalist poems, but they were adapted as such during the period of romantic nationalism. Thus, this article focuses on the usage of old material within a romantic paradigm. In a similar fashion, whilst Nordic mythology, *Beowulf*, and runes, had little or nothing to do with a romantic aesthetics; they became intertwined with a romantic mode of thinking, which established the value of landscapes, myths, memories, and the canon of what is known as cultural saints (i.e. the heroic, mythological, and legendary figures who are seen as founders of communities). These cultural saints, folk heroes, and historical figures, were reimagined through a romantic aesthetics, and thereby acquired a new cultural importance, a process which occurred in nations across Europe.

The (re)discovery and use of medieval literary and historical sources increased the sense of national culture and helped to foster the nineteenth century cult of

the nation state. Put differently, the modern state was legitimised by appealing to the long traditions of its constituent 'nation'. National poetry, historical novels, operas, and national theatre stimulated a sense of identity and were enlisted behind the people's demands for political liberty. Even if the Faroese poet Nólsoyar Páll's ballads (which will concern me in this article) were composed prior to the age of romantic nationalism, Jakob Jakobsen and other literary men later turned him into a national poet and a cultural saint. In fact, the version of Páll that grew out of Jakobsen's writing is a selective vision – for example, Páll came to be seen as innovative, strong, clever, as well as a victim of persecution.

Romantic nationalism occupies a wide spectrum, formulating a link between national essentialism, organicism, and historicism.[13] The making of nationalism and national identities is a truly transnational paradigm in Europe. Anne-Marie Thiesse refers to the radical change in the 'identity cartography' of European nations, which prepared the ground for a crystallisation of imagined communities which then formed into nations.[14] A considerable amount of cultural creativity and even 'forging' of myths and texts was required in order to provide the symbolic and material basis for shaping new identities. It was important to transform a national ideal into a political force. This led to a century of intense activity in constituting the German, Italian, and Hungarian identities.[15] As Tom Shippey argues, forging can mean both creating a unity of diverse materials or in some cases creating a document with deliberate attempt to deceive.[16] The best-known examples of national epics are Elias Lönnrot's creation of the *Kalevala* (from the *runor* he had collected); James Macpherson's *Ossian* poems; the Old Russian *Lay of Prince Igor* (1795), the Welsh *Triads* (*Trioedd Ynys Prydein*) by Iolo Morgannwg, F. R. Kreutzwald's Estonian *Kalevipoeg* (1853), and T. H. de la Villemarqué's *Barsaz Breiz* (1839). There are also the examples of the *Nibelungenlied*, *La Chanson de Roland*, and *Beowulf*, in which many nations and philologists throughout Europe took an interest.

It is imperative to understand that romantic nationalism nearly follows the same timeline as romanticism itself as a cultural paradigm, but, nevertheless, has a longer afterlife which stretches into the twentieth century. While some cultural saints were still living, when they were recognised, others were canonised posthumously. In the case of small nations, or in young and peripheral nations, those who could gain respect and raise a voice in the fierce combat for cultural capital in the world literary-space became the heroes. Aberbach argues that the smaller and more vulnerable a country, the more its national poets tend to be sensitive to threats to its language and react to protect its national integrity.[17] This has always been true of the Faroese poets, who, in the twentieth century (and probably still today), were supposed to strengthen the community and function as nation builders. I may add to this that the afterlife of romanticism endures especially in smaller nations, such as Iceland and the Faroe Islands, where romantic nationalism continues to be a defining ideology.

According to Joep Leerssen, the construction of a national-romantic histori-

cal consciousness is the very beginning of nationalism. Furthermore, romantic nationalism is a truly cross-European phenomenon:

Romanticism and nationalism, each with their separate, far-flung root-systems and ramifications, engage in a tight mutual entanglement and *Wahlverwandschaft* in early-nineteenth-century Europe; and this entanglement constitutes a specific historical singularity. We can give this singularity a name: Romantic nationalism. And we may understand that to mean something like: the celebration of the nation (defined in its language, history, and cultural character) as an inspiring ideal for artistic expression; and the instrumentalisation of that expression in political consciousness-raising.[18]

The special celebration of the nation, its language, history, and the cultivation of a certain national self-image, merged with contemporary, romantic ideals of artistic self-expression. It is 'the instrumentalisation of these expressions in political consciousness-raising' which made romantic nationalism particularly powerful.[19] Furthermore, the *Volksgeist*-historicism of the long nineteenth century created a myth of a possible reconnection with ancient roots which gave birth to a new sense of historical dynamics. Intellectuals, artists, and writers were amongst the first to participate in creating national identities as Thiesse explains:

The formation of national identities was a matter of constant emulation, as indicated by the invocations regularly uttered by national militants to their fellow countrymen: 'Look what the Germans, the English, the Swedish have done . . . if we French, Spanish, Russian . . . want to serve our nation as it deserves we must show that our national heritage is just as rich and glorious'.[20]

The process of emulation is an ambition and an effort to equal, excel, or surpass another person (or in this case, nation), and thus to compete or rival with some degree of success through imitation. This was especially true during the World Fairs, from the middle of the nineteenth century onwards, when representations of national identity and accomplishment were displayed visually.[21]

The nation-building processes described in this article took place at a time when Europe was witnessing the break-up of the *ancien régime* and its reconstruction into a system of nations, as well as new nationalist or autonomist separatist movements. At the centre of this process was the transition towards a shared institutional and social framework situated within letters. Librarians, professional academics, archivists, and many others, were concerned with early romantic nationalism and its relation to the notion of the cultivation of culture.[22] Once the sense of being different from foreigners was established in the community or in a nation, it was necessary to overcome internal differences in order to create a unified national consensus about a common identity. Therefore it took educational efforts to include larger sections of the population in what Thiesse calls 'education to the national ideal', whereby a common cultural heritage became the basis for belonging.[23] The course of this educational process in the Faroe Islands is

the topic of this article, which explores the emergence of a part of this 'identity checklist' and analyses how literature, myths, legends, and memories of heroes have been used to construct a new Faroese canon of cultural saints.[24]

National Stereotypes in the Canonisation of a Faroese National Hero: The Case of Nólsoyar Páll

The preliminaries to the cultural saint and romantic nationalism clear the ground for understanding the dynamics at work in the aggrandisement of Nól-soyar Páll in the Faroese Islands. It is worth noting that several monuments have been constructed in his memory. Two of them are in Suðuroy, where his ship *Royndin Fríða* was built in 1804. Generally speaking, the body of a cultural saint is represented in statues and paintings that are displayed publicly, and this is happens to be the case with Páll. Like cultural saints in other nations, his image has been reproduced on banknotes and stamps, and his name adorns significant urban features including the main street of Klaksvík, the second largest town in the Faroe Islands.[25]

After the consolidation of Faroese literature in the 1820s and 1830s, and the establishment of a new language standard in 1846, the question in many minds must have been who should be included in the new Faroese canon? Who, for example, would occupy the position of the new 'national poet'? Who would be regarded as the leading men of letters? Early Faroese writers such as Claus Lund, Jens Christian Djurhuus, and Jens Hendrik Djurhuus wrote ballads, but were not commemorated as cultural saints. From the 1840s onwards, however, a wealth of writers and readers appeared, as did a library, an extensive body of travel writing, and the works of J. C. Svabo, V. U. Hammershaimb, Nólsoyar Páll and others. However, when speaking of Faroese cultural saints, we must turn to a group of more modern figures associated with the Faroese national movement of the 1840s. Indeed, it was only after this time that a pantheon of special Faroese cultural saints began to emerge.[26]

Nólsoyar Páll, whose actual name was Poul Poulsen Nolsøe (1766–1808), was a seaman and a poet. He is remembered both for his life as a captain and for his literary texts.[27] Páll composed seven ballads and a number of minor poems. Besides *Fuglakvæði* (Ballad of the Birds), the most beloved and entertaining of his ballads is the grotesque and humourous *Jákup á Møn*, in which a shy youth proposes to a young woman, Gýðju, but is rebuffed and ridiculed. The ballad's famous stanzas are known to every Faroese person today. Páll's ballads were satirical and critical of the Danish ruling class in the Faroe Islands. Like his predecessor, the more famous Faroese man of letters J. C. Svabo (1746–1824), Páll seems to have been interested in improving the living conditions of the people in the Faroe Islands. For his perceived national deeds, Páll's portrait was selected as an image to be printed on banknotes. His portrait was drawn by the artist Anders Peter Christian Aigens (1870–1940), who used Páll's granddaughter Sigga Sofía as a model,

Ill. 1 [Faroese stamps from 2008 featuring historical figures. Clockwise from top left: the first historian and editor of the first newspaper *Færingetidende* [Faroese news] Niels Winther (1822–1892); the first female editor Súsanna Helena Patursson (1864–1916), who founded and edited the magazine *Oyggjarnar* [The islands], from 1905–1908; Rasmus Christoffer Effersøe (1857–1916), the editor of the first Faroese newspaper Føringatíðindi [The Faroese news]; Andreas Christian Evensen (1874–1917), who wrote the first textbooks for public schools; the cleric Fríðrikur Petersen (1853–1917) is famous for writing some of the first national romantic poems; and the teacher and politician Jógvan Poulsen (1854–1941), who wrote the first Bible history for children in Faroese.]

since no portraits of Páll were made during his lifetime. In 1951, the first Faroese banknote (a 5 kroner note) was circulated. A Faroese 10 kroner banknote appeared in 1954, followed by a 100 kroner note in 1964 and, in 1967, a 50 kroner note. The 5 kroner note featured a sheep, while Páll and V. U. Hammershaimb were depicted on the 50 kroner and 100 kroner notes, respectively. The reverse side of each of the notes depicted Faroese landscapes by leading Faroese artists, such as Janus Kamban (1913–2009) and Ingálvur av Reyni (1920–2005).

Having briefly introduced Páll's public image, I will now examine concepts of martyrdom in Páll's work and how he later came to be seen as a visionary. I will also explore remembrance and the visions of Páll in order to illustrate how his ballads became the founding pillars of national culture and identity.[28]

Thiesse explains that, at the beginning of the nineteenth century, many nations in Europe did not have a written history and the story of national found-

Ill. 2 [Nólsoyar Páll on the 50 Faroese Kroner banknote issued in 1964.]

ing fathers existed only as a few incomplete chapters of a longer narrative that was still to be written.[29] Nevertheless, just a few decades later, most nations had tales of heroes who undertook long and painful marches towards freedom. The same holds true in relation to the canonisation of Páll. In 1892, Jakob Jakobsen (1864–1918), a doctor of philology, gave eight lectures at the Faroese Union in Copenhagen on the themes of language and history. On this occasion, he chose to focus on three Faroese heroes: Tróndur, the chieftain in the *Faroe Saga*; Magnus Heinason, the naval hero; and Páll.[30] From this point onwards, Páll became a national hero of the young Faroese nation.[31] Jakobsen's book *Poul Nolsøe. Lívssøga og irkingar* from 1912 created a 'national narrative' which turned Páll's life into historical fiction.

Jakobsen's book and an article of 1892 portray Páll as a man devoted to his native country and culture.[32] He is perceived as someone who fought for the Faroese both in life and in writing, especially when it comes to his *Ballad of the Birds*. In Jakobsen's version, Páll was a visionary who envisioned the future of the Faroese nation as an imagined community. Moreover, he is represented as having fought for ideas and the national cause, even if there was no nation at the time.

The construction of national identity involved complex interaction between literary canons and public discourse. Hero worship became significant, especially in the field of literature. Looking at the historiography of Páll, his dramatic life and death are often understood in an excessively narrow, national context. The first Faroese literary history, *Úr bókmentasøgu okkara* (From Our Literary History)

Ills. 3—4 [Sigmund and Tróndur, modern-day monuments in the Faroe Islands. The Sigmund statue (top) is placed outside the Lutheran Vesturkirkjan in Tórshavn. The statue of Tróndur (down) was erected in 2007 in the town of Gøta. Both are by the sculptor Hans Pauli Olsen. Photo: Ole Wich.]

by Mads Andreas Jacobsen, was published in 1921. The professor Christian Matras wrote a small literary history in 1935, which, despite the book's wealth of detail, is best considered as a product of the Faroese nation-building process that was taking place in 1935. The editor Christen Holm Isaksen wrote a series of articles in 1913 about Faroese literature, in which Páll appears as a figure of fascination.[33] Árni Dahl published a Faroese literary history between 1980 and 1983, in which he does not deviate much from Matras's view. Finally, Malan Marnersdóttir and Turið Sigurðardóttir have made some adjustments to the periodisation of Faroese literature, so the first period now includes Páll. Otherwise, they do not provide a revised version of Faroese literary history, but rather confirm the historiographical patterns established by Matras.[34]

Self-Images in the Canonisation of a Cultural Saint

The *Ballad of the Birds* was supposedly written around 1806 or 1807. It is both satirical and political. It allegorises the official corruption and hardship that Páll endured as an aspiring merchant. All the persons in the ballad are pictured as birds. While the good birds are small and indigenous species, the evil and foreign birds are falcons or ravens. All of the birds in the ballad are subjugated to the eagle. The eagle was intended to represent the Danish king Frederik VI (1768–1839), and his commandant was the falcon. Through the use of allegory, Páll attacked his opponents by introducing them as birds of prey. Páll portrayed himself as a valiant oystercatcher (Faroese: *tjaldur*), who guarded the small birds (which were seen to represent the Faroese people) against the birds of prey.[35]

The ballad is written in the genre called *táttur* (the so-called 'literary ballad') which imitates the form, the language, and the spirit, of the traditional ballad, but is concerned with contemporary issues and themes. The *táttur*, which is generally satirical, is indigenous to the Faroese and, in its specific form, has never travelled outside the Islands.[36] The American anthropologist Dennis Gaffin states that the *táttur* is a form of verbal ridicule, a public spectacle, and a part of a form of verbal virtuosity embedded in the 'physical and social landscapes of the islands'.[37] This imagery signalled the creation of a discourse distinguishing between the foreign and the local or regional.

The allegorical bird images should not be seen as an early form of nationalism or the first anti-colonial discourse in the Faroe Islands, since this would be an anachronistic view of what took place at the beginning of the nineteenth century. Rather, the *Ballad of the Birds* was a criticism of the merchants in Tórshavn, who traded in international goods. The fact that the *Ballad* took on a new meaning at the end of the nineteenth century proves just how powerful the remediation of literature can be in the creation of identity.

Páll is extensively commemorated; his textual and artistic legacy has been distributed and amplified through many editions of his texts, in short stories, visual imagery, and drama.

Ill. 5 [A Faroese stamp from 1977. Because of the *Ballad of the Birds,* the *oystercatcher* has since been selected as the Faroese national bird.]

J. H. O. Djurhuus's Poem about the Death of Nólsoyar Páll

In 1917, the bohemian lawyer Jens Hendrik Oliver Djurhuus (1881–1948), the national poet of the Faroe Islands, wrote a famous commemorative poem about Páll. The poem is significant because of the way in which Djurhuus commemorates Páll's death as that of a romantic hero, as well as a martyr of the Faroese nation (in the spirit of romantic nationalism). In terms of the politics of memory, Djurhuus wrote other poems on nationally important persons and heroes, including Grímur Kamban, Magnus Heinason, Tróndur (from *The Faroe Saga*) and cultural saints such as V. U. Hammershaimb and Jóannes Patursson. In this, he contributed to the canonisation of these prominent figures and at the same time gained symbolic, cultural and even political capital as a person and a writer. Djurhuus is thus considered a cultural saint of the Faroese nation. The fact that his image was featured on the 1000 Danish kroner bank note shows that he is held in high esteem (ill. 9).

Djurhuus's poetry is a celebration of the Faroe Islands and he often wrote about his desire to return to the Viking age, when the Faroe Islands were a proud nation. As a poet he was inspired by ancient Norse literature, but he also translated contemporary European writers, as well as *The Iliad*, into Faroese.

The stamp reproduced above is a Faroese stamp from 2004 showing an illustration of the poem about Páll by Djurhuus:

TIL MINNIS UM
NÓLSOYAR PÁLL
1766~1809

EINKJA LISTAMANSINS ANNA
GAV FØROYSKU TJÓÐINI Í 1973

Ills. 6–8 [Left: a 1905 bronze and basalt memorial for Nólsoyar Páll outside the Faroese University's Department of Science, by the Icelandic sculptor Einar Jónsson (1874–1954), erected in 1973. Photo: Ole Wich. Right (down): a twentieth-century basalt memorial to Nólsoyar Páll in Suðuroy, where he built his ship *Royndin Fríða*. Photo: Ole Wich. Right (top): a model in plaster for a planned statue of Nólsoyar Páll, made by the Faroese sculptor Janus Kamban.

HER Á FLØTUNI FRÍÐU BYGDU NÓLSOYAR PÁLL, JÁKUP
BÓNDI Í TOFTUM, PER BÓNDI Í GJØRÐUM OG AÐRIR
Í 1804 FØROYA FYRSTA SKIP ROYNDINA FRÍÐU.

Ill. 9 [J. H. O. Djurhuus on the 1,000 Faroese kroner banknote issued in 1994.]

Ravnagorr yvir Beinisvørð,
skýdráttur, náttsól hálv –
Royndin hin Fríða mót heimastrond
í brotasjógvi og gjálv. . . .

Ræddist ei reysti Nólsoyar Pól,
Rán fekk frá skaldinum tøkk, –
gotrini sungu heljarljóð
og Royndin hin Fríða søkk. –
Dagur kom aftan á níðingsdáð,
– sorg var í tjaldra fjøld –
ravnar rýmdu frá Beinisvørð,
tá ið helvt var gingin av øld.

Dagur kom aftan á níðingsdáð,
Beinisvørður í sól –
frítt stóð fjallið í grønum stakki:
Rún um Nólsoyar Pól.,

. . . missa mæli og mál –
muna skal annar Nólsoyar Pól,
mikil í brynju og stál.

[The ravens croak over Beinisvørð, / storm and declining moon, / Royndin Fríða is bound for home, /over the waves in the lune . . . / Nólsoyar Poul accepted his fate, / he bowed to Ran and gave thanks, / the cannons sang their hellish tune / and Royndin Fríða sank. / But day broke after this villainy / – the oystercatchers in tears – / the ravens stayed at Beinisvørð /for more than fifty years . . . / The Faroese are cowed and suppressed / – losing their speech and appeal – / we need another Nólsoyar Poul, / dressed in armour and steel.][38]

Ill. 10 [Faroese stamps from 2004 commemorating Nólsoyar Páll, featuring an illustration of Djurhuus's poem about Nólsoyar Páll's death.]

The illustration on the stamp shows Rán (in Norse mythology, the goddess of the sea) who comes for the hero, just as it is recounted in the poem. The poem concludes with a statement to the effect that the Faroe Islanders would still be enslaved without a language or goals for the future, had it not been for Nólsoyar Páll. In Djurhuus's poem, there is no doubt that enemies of the Faroes sunk Páll's ship: 'the cannons sang their hellish tune / and Royndin Fríða sank'. While the Faroese remain suppressed, Páll is singing his *Ballad of the Birds* to Rán. The poem concludes with a plea for a new future hero, another Páll. When reconsidering Djurhuus' poem, Leerssen has pointed out what he calls the 'Janus-faced nature of nationalism between nostalgia and modernity'.[39] The poem – its celebration of the nation, its language, history, and the cultivation of a certain national self-image – is precisely the sort of 'instrumentalisation' (to use Leerssen's term) of poetry we encounter in political consciousness-raising and which made romantic nationalism particularly powerful.

In summary, many cultural texts – including hagiographies, the national bird, stamps, banknotes, and biographies of Páll – retell the story of this Faroese hero. These are texts that can be found in kindergarten and on university syllabi. Páll's image is even used in a children's menu in the restaurant Hvonn, situated next to the statue in Tórshavn. This form of modern day de-sacralisation only appears to reinstate his image and importance as a cultural saint.

The legacy and the memory of Páll are double-sided: he is both a national hero and a victim. Furthermore, responses to *Ballad of the Birds* have utilised his status as a cultural saint to express grievances and rage over real or imagined oppression. Such anger can inspire cultural revivalism, but can also easily lead to national populism and violence. To some extent, even an act of humiliation can help define national poetry as a part of a process of confronting and mastering the past.[40] In this way, Jakobsen's and Djurhuus's use of Nólsoyar Páll also come across as ambivalent.

Ill. 11 [A 1994 statue of Nólsoyar Páll in Tórshavn.
Sculptured by Hans Pauli Olsen in bronze. Photo: Ole Wich.]

The canonisation of religious saints and cultural saints shows similar patterns of dedication, martyrdom, fighting for ideas, enlightening, educating, and cultivating the memory of the nation. Though the idea of sainthood has shifted context, many traditional elements remain. Hence, poets recycle and use heroes in new ways.

Conclusion: Palimpsest Memory

The construction of national identity in the nineteenth century was a process of constant emulation. The spirit of romantic nationalism was an interlocking system of interconnected ideas, where everyone compared themselves and their nations to other nations. As the nineteenth century progressed, canons became more national, and, in so doing, tended to stress the monolingual and to protect the mono-cultural. All in all, literature played an influential role in shaping the cultural memory of nations, and canons became a part of national 'awakenings' that often started as language revivals. Once recovered, such languages (including Faroese) were given a prominent place in the national self-image.

The commemoration of heroes such as Nólsoyar Páll can be understood as an allegorical process: the memory of him connects to the notion of loss but also to the dream of a Golden Age of independence for the Faroe Islands. Consequently, the canonisation of Páll sought to combine idealism, rebellion, and nostalgia – as illustrated in Djurhuus's poem, in which the disappearance of Páll is made into something at once expressed in terms of sublime imagery (the ship sinking near the cliff) and nostalgic (the loss of a hero). In other words, Páll's *Ballad of the Birds* became a palimpsest, re-contextualised and reactivated in the creation of new images and the politics of memory.

Even if romanticism and nationalism seem to have different root systems, they were engaged within the same paradigm in early nineteenth-century Europe. The Faroese case does therefore not constitute a specific historical singularity, but is to be seen as a part of the international and interconnected currents of romantic nationalism.

Notes

1 David Aberbach, 'The Poetry of Nationalism', *Nations and Nationalism* 9, no. 2 (2003): 261.

2 Ibid.

3 Ann Rigney, 'Embodied Communities. Commemorating Robert Burns, 1859', *Representations* 115 (2011): 80.

4 Jón Karl Helgason, 'The Role of Cultural Saints in European Nation States', in *Culture Contacts and the Making of Cultures. Papers in Homage to Itamar Even-Zohar*, ed. Rakefet Sela-Sheffy and Gideon Toury (Tel Aviv: Tel Aviv University, Unit of Cultural Reserch, 2011), 245.

5 Jón Karl Helgason, 'Relics and Rituals. The Canonisation of Cultural "Saints" from a Social Perspective' *Primerjalna književnost* 34, no. 1 (2011): 245–6.

6 Marko Juvan, 'Self-Referentiality and the Formation of the Slovene Literary Canon' (paper presented at the *Amsterdam Conference on Cultural Saints*, 18–19 January, 2010), 2.

7 See also: http://vefir.hi.is/culturalsaints/, and Marijan Dović, 'The Canonization of Cultural Saints: France Prešeren and Jónas Hallgrímsson', *Slovene Studies* 33, no. 2 (2011): 153–70; Marijan Dović, 'The Canonization of Cultural Saints: An Introduction', in *Literary Dislocations*, eds. Sonja Stojmenska-Elzeser and Vladimir Martinovski (Skopje: Institute of Macedonian Literature, 2012), 557–69; Sveinn Yngvi Egilsson, 'Nation and Elevation: Some Points of Comparison Between the "National Poets" of Slovenia and Iceland', *Primerjalna književnost* 34, no. 1 (2011): 127–46; Jón Karl Helgason, 'Relics and Rituals: The Canonization of Cultural "Saints" from a Social Perspective', *Primerjalna književnost* 34, no. 1 (2011): 165–89; Jón Karl Helgason, 'A Poet's Great Return: Jónas Hallgrímsson's reburial and Milan Kundera's Ignorance', *Scandinavian-Canadian Studies* 20 (2011): 52–61; Jón Karl Helgason, 'The Role of Cultural Saints in European Nation States', in *Culture Contacts and the Making of Cultures: Papers in Homage to Itamar Even-Zohar*, eds. Rakefet Sela-Sheffy and Gideon Toury (Tel-Aviv: Unit of Culture Research, Tel Aviv University, 2011), 245–51; Marko Juvan, 'Romanticism and National Poets on the Margins of Europe: Pre'eren and Hallgrímsson', in *Literary Dislocations*, eds. Sonja Stojmenska-Elzeser and Vladimir Martinovski (Skopje: Institute of Macedonian Literature, 2012), 592–600.

8 See the study framework at http://vefir.hi.is/culturalsaints/.

9 Jón Karl Helgason, 'The Role of Cultural Saints in European Nation States', in *Culture Contacts and the Making of Cultures. Papers in Homage to Itamar Even-Zohar*, eds. Rakefet Sela-Sheffy and Gideon Toury (Tel Aviv: Tel Aviv University, Unit of Cultural Reserch, 2011), 246–50.

10 Joep Leerssen and Ann Rigney, *Commemorating Writers in Nineteenth-Century Europe – Nation-Building and Centenary Fever*, eds. Joep Leerssen and Ann Rigney (New York, NY: Palgrave Macmillan, 2014), 9.

11 Jón Karl Helgason, 'Relics and Rituals. The Canonisation of Cultural 'Saints' from a Social Perspective', *Primerjalna književnost* 34, no. 1 (2011): 246.

12 Inge Adriansen, *Erindringssteder i Danmark. Monumenter, mindesmærker og mødesteder* (Copenhagen: Museum Tusculanum, 2010); Jo Tollebeek and Tom Verschaffel, 'Group portraits with National Heroes. The Pantheon as an Historical Genre in Nineteenth-century Belgium', *National Identities* 6, no. 2 (2004): 92.

13 J. T. Leerssen, 'Notes toward a Definition of Romantic Nationalism', *Romantik: Journal for the Study of Romanticisms* 2 (2013): 9–35.

14 Anne-Marie Thiesse, 'National Identities. A Transnational Paradigm', in *Revisiting nationalism. Theories and Processes*,

eds. Alain Dieckhoff and Christophe Jaffrelot (New York, NY: Palgrave Macmillan, 2006), 122.

15 Ibid., 123.

16 Tom Shippey, 'A Revolution Reconsidered: Mythography and Mythology in the Nineteenth Century', in *The Shadow-walkers: Jacob Grimm's Mythology of the Monstrous*, ed. Tom Shippey (Tempe, AZ: MRTS and Turnhout: Brepols, 2005), 1-28.

17 Ibid., 268.

18 Leerssen, 'Notes toward a Definition of Romantic Nationalism', 9.

19 Ibid., 28.

20 Thiesse, 'National Identities. A Transnational Paradigm', 125.

21 Ibid.

22 Joep Leerssen, 'The Nation's Canon and the Book Trade', in *European Studies – An Interdisciplinary Series in European Culture, History and Politics*, eds. Dirk Van Hulle and Joep Leerssen, vol. 26, *Editing the Nation's Memory. Textual Scholarship and Nation-Building in Nineteenth-Century Europe* (Amsterdam & New York: Rodopi, 2008), 22. For Joep Leersen's definition of cultural nationalism, see the following (all by Joep Leerssen): 'Ossian and the Rise of Literary Historicism', in *The Reception of Ossian in Europe*, ed. Howard Gaskill (London & New York: Thoemmes Continuum, 2004); 'Nationalism and the Cultivation of Culture', *Nations and Nationalism* 12, no. 4 (2006): 559-78; *National Thought in Europe. A Cultural History* (Amsterdam: Amsterdam University Press, 2006); 'Viral Nationalism. Romantic Intellectuals on the Move in Nineteenth-century Europe', *Nations and Nationalism* 17, no. 2 (2011): 257-71.

23 Thiesse, 'National Identities. A transnational Paradigm', 123.

24 The inspiration for the following exploration of cultural saints came from the Study Platform on Interlocking Nationalisms (SPIN), as well as the session on cultural saints at the 4th Congress of the REELC/ENCLS: 'Literary Dislocations', Skopje and Ohrid, September 1-3, 2011. Furthermore, the papers presented at the workshop 'Commemorating Writers in Europe 1800–1914' in Utrecht December 7-9, 2011 arranged by SPIN, Joep Leerssen and Ann Rigney, Professor at Utrecht University. Also, the book Joep Leerssen and Ann Rigney, eds., *Commemorating Writers in Nineteenth-Century Europe – Nation-Building and Centenary Fever* (New York, NY: Palgrave Macmillan, 2014). The workshop Canonization of "Cultural Saints": Commemorative Cults of Artists and Nation-Building in Europe, arranged by Dr. Marijan Dović (Institute of Literature ZRC SAZU, Ljubljana) and SPIN in November 2015 was also an inspiration.

25 In 2014, a new café opened in Klaksvík's main street called 'Fríða' after Nólsoyar Páll's ship. And a project is started to recreate his farmhouse in Klaksvík. Furthermore, in 2014, a new statue of Nólsoyar Páll was erected.

26 By the beginning of the twentieth century a whole new group of persons and writers, such as the poet Mikkjal Dánjalsson á Ryggi (1879–1956), Pól F. Joensen (1898–1970), J. H. O. Djurhuus (1881–1948), Hans A. Djurhuus (1883–1951), Ricard Long (1889–1977), Rasmus Rasmussen (1871–1962), Símun av Skarði (1872–1942), M. A. Jacobsen (1891–1944), Chr. Matras (1900–1988), Jakob Jakobsen (Dr. Jakobsen), Jørgen-Frantz Jacobsen (1900–1938) and William Heinesen (1900–1991) had also become a part of the Pantheon.

27 He received his education in the Ryberg Trade Union and later obtained a partial permit to trade, but he and his ship *Royndin Fríða* were lost at sea in 1808. Jakob Jakobsen claims in

1892 that Nólsoyar Páll's ship was sunk in the article: Poul Nolsøe, 'Et Livs- og Tidsbillede fra Færøerne ved slutningen af det 18de og Begyndelsen af det 19de Aarhundrede', *Historisk Tidsskrift* 6, 1892, 587. Historian John F. West does not agree: '[T]his theory does not stand up to scrutiny . . . just as its persistence in modern times indicates the ardent and reverent affection in which most Faroemen still cherish the memory of their great compatriot'. See John F. West, *The Emergence of a Nation* (London & New York: C. Hurst & Co, 1972), 67–8.

28 The literary scholar Michael Rosenthal has studied Shakespeare's birthplace at Stratford, while another literary scholar, Harald Hendrix, also views writers' houses as media of expression and remembrance and a part of the invention of literary tourism. Michael Rosenthal, 'Shakespeare's Birthplace at Stratford: Bardolarory Reconsidered', in *Writer's Houses and the Making of Memory*, ed. Harald Hendrix (New York & Oxon: Routledge, 2007), 31–45.

29 Thiesse, 'National Identities', 131.

30 Jakobsen's 1908-1912 biography *Poul Nolsøe. Lívssøga og irkingar from 1912* transformed this eighteenth-century pioneer of free trade from a figure of popular legends to a national symbol. With his collection *Færøske Folkesagn og Æventyr* [Faroese legends and folktales] (1898–1901), Jakobsen followed in the footsteps of Asbjørnsen and Moe and the Grimm brothers. In his *Diplomatarium Færoense* (1907), Jakobsen published the few remaining Old Norse texts containing references to the Faroe Islands. Jakobsen's view on language was crucially determined by his seminal work on Norn, an early-modern Nordic language spoken on the Shetlands, the Orkneys and in Caithness until it was supplanted by Scots-English in the eighteenth century. With his work *Det norrøne sprog på Shetland* [The Norn Language on Shetland] (1897), he obtained a doctoral degree.

31 Jakob Jakobsen, 'Poul Nolsøe, et Livs- og Tidsbillede fra Færørne ved slutningen af det 18de og Begyndelsen af det 19de Aarhundrede', *Historisk Tidsskrift* 6 (1892): 518.

32 See Jakob Jakobsen's article 'Poul Nolsøe, et Livs- og Tidsbillede fra Færøerne ved slutningen af det 18de og Begyndelsen af det 19de Aarhundrede', *Historisk Tidsskrift* 6 (1892): 521–40.

33 Chr. Holm Isaksen, 'Føroyskur skaldskapur í 19. øld. Páll Nólsoy, Jóhannes Patursson, Jens Djurhuus', in *Bókmentagreinar*, ed. Árni Dahl, vol. 1 (Torshavn: Fannir, 1981), 5–28.

34 Malan Marnersdóttir and Turið Sigurðardóttir, eds., *Føroysk bókmentasøga 1* (Torshavn: Nám, 2011).

35 In the ballad collection *Corpus Carminum Faroensis*, there is an older Ballad of the Birds (Fuglakvæði I). It is known both in Norwegian and in Danish versions, but in these versions it is not known why the birds are gathering. If the ballad was an allegorical tale, the meaning of the tale has been lost. There are other Scandinavian ballads about birds, including the Danish 'Ørnevisen' [The ballad of the eagle] from 1523.

36 Dennis Gaffin, *In Place. Spatial and Social Order in a Faroe Islands Community* (Long Grove, IL: Waveland Press Inc., 1996), 194.

37 Ibid., 195.

38 J. H. O. Djurhuus, *Yrkingar* (Copenhagen: Mentunargrunnur Studentafelagsins, 1988), 105–6. The quoted version is translated by Anker Eli Petersen.

39 Joep Leerssen, 'Viral Nationalism. Romantic Intellectuals on the Move in Nineteenth-century Europe', *Nations and Nationalism* 17, no. 2 (2011): 266.

40 Aberbach, 'The Poetry of Nationalism', 263.

Spatial Memory as Place

SPATIAL MEMORY AS PLACE IN WORDSWORTH'S *THE EXCURSION* AND ROUSSEAU'S *REVERIES OF A SOLITARY WALKER*

MARTINA DOMINES VELIKI

[ABSTRACT]

This essay takes as its point of departure the idea that we usually experience ourselves in relation to place. The conception of human identity as bound up with the sense of place is not a specifically romantic phenomenon. However, in romanticism place acquires a new significance: it is linked through memory to the events experienced by the self. Thus the romantic self is constituted not only through memory understood as a temporal category but also as a spatial category. Such reading of the chosen romantic texts is contrary to the well-established readings, which prioritize the mind of the writer over the material world. However paradoxical it may seem to regard Rousseau and Wordsworth as 'bodily writers', acutely aware of the significance of place, *Reveries of a Solitary Walker* and *The Excursion* reveal writers aware of man as a physical being and of his capacity to remember through the body. Therefore, through phenomenological readings of the afore-mentioned texts (drawing on Bachelard, Casey, and Malpas) I will explore the relationship between the mind and the place through such concepts as 'body memory', localization of memory, and intersubjective memory.

.

KEYWORDS *Body Memory, Localization of Memory, Intersubjective Memory, Jean-Jacques Rousseau, William Wordsworth*

William Hazlitt, the first English critic who noticed the resemblances between Rousseau and Wordsworth, observed that:

[Rousseau] owed all his power to sentiment. The writer who most nearly resembles him in our own times is [Wordsworth]. We see no other difference between them, than that the one wrote in prose and the other in poetry; . . . and we will confidently match the Citizen of Geneva's adventures on the lake of Bienne against the Cumberland Poet's floating dreams on the lake of Grasmere. Both create an interest out of nothing, or rather out of their own feelings; both weave numberless recollections into one sentiment; both wind their own being round whatever object occurs to them.[1]

Martina Domines Veliki, PhD and associate professor at the University of Zagreb, Croatia
Aarhus University Press, *Romantik*, 04, 2015, pages 95-113

There is much more to the complex relationship between Rousseau and Wordsworth than 'that the one wrote in prose and the other in poetry', and I want to focus on the importance both ascribe to memory. Whilst both address different aspects of memory in their work (associative, affective, circumstantial, etc.), it is one aspect in particular that I want to discuss here, namely, the importance both attach to the relationship between memory and place. In this respect, two works in particular come to mind: Wordsworth's *The Excursion* (1814) and Rousseau's *Reveries of the Solitary Walker* (1776-1778). Both works form the last part of an autobiographical whole. In Wordsworth's case, *The Excursion* is the last completed portion of a larger work, *The Recluse*, which he would never finish.[2] Similarly, the *Reveries* are the last part of an autobiographical trilogy comprised of *The Confessions* and *Dialogues* (also known as *Rousseau, the Judge of Jean-Jacques*), with the final Tenth Walk of *Reveries* being left incomplete at Rousseau's death (1778).

In the Preface to *The Excursion*, Wordsworth says that he 'retired to his native mountains' in order to write a philosophical poem about 'his own mind'.[3] Already in these introductory pages the mind and place coalesce and his 'voice proclaims / How exquisitely the individual Mind . . . / to the external World / Is fitted: – and how exquisitely too – . . . / The external World is fitted to the mind'.[4] Likewise, the *Reveries* have long been regarded as another attempt by Rousseau to explore his own soul. As is the case with *The Excursion*, Rousseau's work is a kind of meditation in isolation. In a telling phrase jotted down on a playing-card whilst he was writing this book, Rousseau says: 'My whole life has been little else than a long reverie divided into chapters by my daily walks'.[5] As the human mind is the main locus of experience for both writers, and their works speak about a 'psycho-natural' parallelism (M. H. Abrams's term), it is fair to claim that their 'inward landscapes' matter more than the outward aspects of nature.[6] Therefore the question arises as to the right we have in claiming that they were both 'nature' writers, where 'nature' could preserve its materiality and be translated into a natural scene, spot of greenery or a specific locality.

In drawing a distinction between eighteenth century loco-descriptive poetry and romantic lyrics, M. H. Abrams argued that in the former:

"Composition of place" was not a specific locality, nor did it need to be present to the eyes of the speaker, but was a typical scene or object, usually called up . . . before "the eyes of the imagination" in order to set off and guide the thought by means of correspondences whose interpretation was firmly controlled by an inherited typology.[7]

Paul de Man, on the other hand, has been convinced of the persistence of unspecified locality in romanticism. In the climactic passages of *The Excursion* and the *Reveries*, the evidence of moving beyond nature in order to establish contact with time is unmistakable. Take for example the Great Dane accident in the Second Walk of the *Reveries,* when Rousseau is knocked down by a big dog and he instantaneously loses consciousness only to be 'born again' a few seconds later. The same idea of recovering the lost time rather than nature is true of Words-

worth who, in the guise of the Wanderer, hears the narratives told by the Solitary and they are 'deposited upon the silent shore of [his] memory'.[8] In such passages, one has no difficulty in seeing that the romantic consciousness holds priority over the realities of the object (both writers question the ontological primacy of the object seen).[9] Wordsworth warns us that accurate natural description, though a necessary, is an inadequate condition for poetry. When he says that 'The mind of Man is / My haunt, and the main region of my song' he expresses his anxiety at the possibility of a 'despotism of the eye'.[10] Rousseau, for his part, is also not so much concerned with accurate natural description as with the abundance of feelings that come alive in the presence of nature. On taking the second walk Rousseau laments:

The country was still green and pleasant, but it was deserted and many of the leaves had fallen; everything gave an impression of solitude and impending winter. . . . I saw myself at the close of an innocent and unhappy life, with a soul still full of intense feelings and a mind still adorned with a few flowers, even if they were already blighted by sadness and withered by care. Alone and neglected, I could feel the approach of the first frosts.[11]

A desolate scene reminds Rousseau of his own isolation and the hatred that men feel towards him. Therefore, in many passages of the *Reveries,* we are faced with Rousseau's lively inner life — he says his body was idle, but his mind remained active in producing feelings and thoughts.

However, we cannot say that nature in both *The Excursion* and the *Reveries* exists only as signified within human culture.[12] What Wordsworth manifests in his poem is his rootedness, his knowledge of a particular place, his self-conscious relation to that place. Wordsworth adopts the frame of a country walk and links all the stories, reflections, and conversations to his native ground.[13] *The Excursion* is full of topographical notes which give a sense of the poet's need to belong to a place (Hawkshead, the Esthwaite Water, Borrowdale, the Bowder Stone, Langdale Tarn, the valley of Grasmere, the summit of Snowdon). Likewise, in Rousseau's descriptions of the island of Saint-Pierre and the Lake of Bienne, he insists on the importance of localness. 'Locale', as he states in *Émile*, 'is not unimportant in the culture of men'.[14] Hence if we accept the notion of unspecified locality for the Romantic writer's view of place, we might miss the fact that the material world, the surrounding nature or landscape in which Rousseau and Wordsworth lived, could be more than just inanimate stone – it could be the place with the power to restore the mind equal to the power of time.

Recent phenomenologists of memory such as Edward S. Casey and Jeff Malpas, relying primarily on the work of Heidegger and Bachelard, have discussed the importance of place in the constitution of human identity and have pointed out that the self is to be discovered through an investigation of the places it inhabits.

The conception of human identity as bound up with the notion of place is by no means exclusively European or Western. Neither is it a specifically romantic

phenomenon. However, in romanticism the sense of place takes on a new impor-
tance: it is linked through memory to the events experienced by the romantic
self. Hence the romantic self is constituted not only through memory under-
stood as a temporal category, but also as a spatial category. The Wordsworthian
phrase 'spots of time' coined in *The Prelude* is telling in this respect, as it links the
idea of time with the idea of place.[15] The final conception of memory as a process
and a place is central to the overall character of Rousseau's and Wordsworth's
meditative art.[16]

As Edward Casey suggests: 'Place is the limit and the condition of all exist-
ing things. This means that, far from being merely locatory or situational, place
belongs to the very concept of existence. To be is to be bounded by place, limited
by it'.[17] Even the idea of 'keeping the past in mind' alludes to memory as a kind
of secondary home which represents a reconstructed version of the divine child-
hood, and can be regarded as the poet's 'dwelling place'.[18] Such representations
of memory are also found in John Locke for whom memory becomes 'the Store-
house of our Ideas' and which is therefore perceived as a place, albeit, in mecha-
nistic terms.[19] As such the conception of memory moves away from metaphors
of imprinting and impressions familiar since Plato's time. Memory functions as
a means to mental safe-keeping, 'a Repository to lay up those Ideas which at
another time the narrow Mind of Man might have use of'.[20] Memory, therefore,
cannot be thought of as completely independent from spatiality. In Jeff Malpas's
words, 'memory always stands in relation to the temporal and the spatial, which
are themselves held together in place. Memory that was disembodied, that was
therefore unplaced, would be no memory at all'.[21]

In this essay I want to argue that the sense of place in *The Excursion* and the
Reveries is acquired through both writers' physical isolation and their sense of
nostalgia, because things do not stay the same. Furthermore, they both cherish
a habitual relation to the place where body memory plays an important part.[22]

In order to remember, both writers seek secluded places and want to be left
physically alone. This is why they share their love for the life in the country. The
country differs from the city in two essential ways: it is less densely populated – it
offers the possibility of being left *physically* alone – and it is less densely circum-
scribed by objects and potential signs.[23] The solitary condition of the poet and
the secluded place thus become intricately bound up with each other. The idea of
a solitary poet is nothing new in the history of Western literature and Rousseau's
exile is no different, except that he is a self-exile. In Book IV of *The Confessions*,
Rousseau admits to being a 'solitary walker', the idea he would later expand in
his *Reveries*. Here the reader feels that there is something almost triumphant in
the way he repeats the verb 'to travel', as if he was proud of his solitariness: 'I was
travelling on foot, and travelling alone'.[24] There is no doubt that throughout his
autobiographical trilogy Rousseau is a solitary exile. He begins his *Reveries* by
saying: 'So now I am alone in the world, with no brother, neighbour or friend,
nor any company left but my own'.[25] At the beginning, the reader feels that this
condition was imposed on Rousseau from the outside; he wants to get away from

his fellow-men, as they take him for 'a monster, a poisoner, an assassin, . . . the horror of the human race, the laughing stock of the rabble'.[26] However, as his quest for his own true self unfolds (he says that the purpose of his writing is to know oneself) we realize that solitude has become a personal choice:

These hours of solitude and meditation are the only ones in the day when I am completely myself and my own master, with nothing to distract me or hinder me, the only ones when I can truly say that I am what nature meant me to be.[27]

During the eighteenth-century, the solitary is often a religious figure, ridiculed by the new philosophy of the Enlightenment. Diderot's *La Religieuse* is a fine example of the possible consequences of isolation in a convent – the message is clear: solitude is torture, man is a social being. Only the wicked person, Diderot said, is alone, but Rousseau firmly disagrees.[28] On the island of Saint-Pierre, in the *Reveries* (Fifth Walk), Rousseau opposes one of the main tenets of Enlightenment philosophy based on the necessary sociability of people: 'The idleness of society is deadly because it is obligatory; the idleness of solitude is delightful because it is free and voluntary'.[29] The society of private property is a solitary society for Rousseau. The solitariness of each and every individual becomes more prominent as the society progresses, but this solitary state differs fundamentally from the solitude felt in the company of nature.

Hence, when in Book VII of *The Confessions* we see Rousseau confined to a small cottage called the Hermitage that he acquires, thanks to the kindness of Madame d'Epinay, we immediately realize that it was a refuge absolutely made for him. In the middle of a vegetable garden, close to the forest of Montmorency, Rousseau indeed deserves to be called Mr. Bear, as Madame d'Epinay would nickname him. Rousseau's recourse to solitude and the world of fantasy 'springs from frustration in the real world' and it is bound up with his special place.[30] In the *Reveries*, this special place is the Island of Saint Pierre in the middle of the Lake of Bienne, an island scarcely known even in Switzerland, where Rousseau would spend only two months. As Eugene Stelzig correctly observes: 'The precondition of his happiness there was a kind of Wordsworthian ' "wise passiveness" . . . of a man dedicated to leisure'.[31] Rousseau would replace his small cottage with a large house belonging to the hospital of Bern and inhabited by a steward, his wife and servants. Yet, he would constantly seek solitude on the shores of the lake, 'roaming about the island, stopping to sit now in the most charming and isolated corners where [he] could dream undisturbed'.[32] His daydreaming is a sort of compensatory activity in which the fictions make him forget his real condition. Thus the books he read avidly as a boy make him forget about his master's cruelty and the imaginary worlds he would plunge himself into later in life make him forget about his friends' conspiracy against him. There is a constant need in Rousseau to build himself an alternative world as soon as he becomes dissatisfied with the world around him. It is a sort of escapism in which imagination plays the vital role: 'When alone I have never known boredom, even if absolutely

without occupation, my imagination can fill all voids, and it is in itself enough to occupy me'.[33]

This alternative world is impossible without a place of his own, where solitude becomes again a natural state, the state in which man contents himself with his own existence ('Never have I been so much myself . . . as in the journeys I have taken alone and on foot').[34] In the *Reveries* (Third Walk), Rousseau insists that the rural solitude in which he spent the best days of his youth only served to strengthen his naturally affectionate tendencies. Both nature and rural simplicity serve as a moral anchor for the adult Rousseau.

When trying to write *The Recluse* (the title itself is telling), Wordsworth had to live on his own in the mountains, and it is no wonder that the two main protagonists of his dramatic poem are the Wanderer and the Solitary. In Book I, the poet reaches a ruined cottage and meets the Wanderer resting under the shade of the trees that surround it. The Wanderer then tells the tale of his own childhood in Hawkshead, a little town at the head of Esthwaite Water (which in many ways resembles the poet's own childhood) and then relates the history of the cottage's last inhabitant – poor Margaret who died after having lost her husband and her two children. The story of Margaret and her ruined cottage in Book I of *The Excursion* was originally conceived by Wordsworth as an independent poem, and was reconstituted and published in the twentieth century by Jonathan Wordsworth. Through a number of such small tales told to the poet by different people he encounters on his way across the Lake District, the poet is faced with the harshness of life in the mountains and the perseverance of their inhabitants for whom the land is all in all. Every inhabitant of the Lake District had formed a peculiar bond with his/her native place and, as the Wanderer points out, even the senseless rocks speak:

> . . . I see around me here
> Things which you cannot see: we die my friend;
> Nor we alone, but that which each man loved
> And prized in his peculiar nook of earth
> Dies with him, or is changed; and very soon
> Even of the good is no memorial left.
> . . .
> And senseless rocks, nor idly – for they speak,
> In these their invocations, with a voice
> Obedient to the strong creative power
> Of human passion. . . .
> . . . Beside yon spring I stood,
> And eyed its waters till we seem'd to feel
> One sadness, they and I.[35]

It is a common Wordsworthian insistence on 'the fitting and the fitted' (as he points out in the Preface to *The Excursion*) – the individual mind fits the external

world and the external world reflects the mind. Yet, throughout the pages of *The Excursion*, the external world becomes a particular place – a peculiar nook of earth, a rock or a spring. Place thus becomes the limit and the condition of human existence. As phenomenologists would insist, to be is to be bounded by place and it proves to be a deeply constitutive factor in the phenomenon of time. Margaret and her family are no longer there (their time had run out) but the Wanderer's imaginative leap into what could have been, if only they were alive, the memory of the past and the place remain.

Hence, as Edward Casey insists, memory and place are the two phenomena complementary in character and they are both vitally important to Wordsworth. Despite her daily Promethean suffering, Margaret could not have parted with her place – living 'reckless and alone / Until her house by frost, and thaw and rain / Was sapped', still 'she loved this wretched spot'.[36] Later on, as the poet and the Wanderer continue their walk through the Lake District, the poet relates how they could not pass a single hamlet or a house which would not yield re-membrances to the Wanderer. Indeed, *The Excursion* thus becomes an eight-book narrative about places triggering memories.

In Book II the poet and the Wanderer meet the latter's friend, the Solitary. The Solitary lives alone in a lowly little vale, yet one high among the mountains. After his wife and two children die and he loses all faith in political action, he becomes a recluse, avoiding contact with other men. His cottage is the only one in the area and it is surrounded by little ploughed fields. The Solitary calls his cottage 'my domain, my cell, my hermitage, my cabin' and he loves it better than a snail his house.[37] In a way, just like Margaret, the Solitary becomes a part of his little, dark cottage. It is an image of his life and of his own self, but also, being a hermit's cottage, it is the centre of a legend (in Bachelard's sense of the word).[38] In other words, it thrusts us back to the beginnings of humanity and to the ex-perience of 'centralized solitude', which is hermit's own but also our own. The Solitary finds the essence of life in his solitary condition: 'You dwell alone; / You walk, you live, you speculate alone'.[39] The poet listens and registers it all upon 'the silent shores of memory' so that he may heal his own wounded spirit and renovate his mind in the years to come.[40] Like in Rousseau's case, the natural sur-roundings and the rural simplicity serve as the moral anchor for the poet.

I have already stressed the idea that both Rousseau and Wordsworth were writers with deep awareness of the sustaining power of their surroundings, and of the need to preserve the spot and the land. Nature, in that sense, is more than a linguistic construct serving as a vehicle for something else: the hegemony of im-agination over the sensory object. Furthermore, place becomes more than a mere locality, it becomes 'integral to the very structure and possibility of experience'.[41] Nature or landscape is not only 'environment', an organic-systemic totality, but rather an ontological unity. In the second half of the eighteenth century people begin to tamper with nature and places change their outward aspect. However anachronistic it may seem to call them pedestrian environmentalists, Rousseau and Wordsworth were aware of that and they could easily be mistaken for 'greens'

as their works are imbued with a sense of nostalgia, because things do not stay the same.[42] As Edward Casey explains:

nostalgia is not merely a form of regret for lost times; it is also a pining for lost places, for places we have once been in, yet can no longer re-enter (childhood places are especially dear to us and the self is vitally connected to a few square miles of land) . . . For the sense of self, personal or collective, grows out of and reflects the places from which we come and where we have been.[43]

In the *Reveries* we are often faced with Rousseau walking along the lakeside, across the mountains or through the woods with a notebook and a pencil in his hand, making plans for future works. He had never lost his taste for solitary walks and they had remained the vital prerequisite for writing. Furthermore, he sometimes seems like an ecologically conscious man:

Trees, bushes and plants are the clothing and adornment of the earth. There is no sight so sad as a bare, barren countryside that presents the eyes with nothing but stones, mud and sand. But brought to life by nature and dressed in her wedding dress amidst the running waters and the song of birds, earth in the harmony of her three kingdoms offers man a living, fascinating and enchanting spectacle, the only one of which his eyes and his heart can never grow weary.[44]

When Rousseau made a botanical expedition in the region of Môtiers in Switzerland, he believed he had found a wonderful, unspoiled and secluded spot of greenery, but was disappointed to discover a nearby mill:

I got up, pushed through a thicket of undergrowth in the direction of the noise, and in a hollow of twenty yards from the very place where I had thought to be the first person to tread, I saw a stocking mill. I cannot express the confused and contradictory emotions which this discovery stirred up in me. . . . a feeling of distress at not being able, even in the depths of the Alps, to escape from the cruel hands of men intent on persecuting me. . . . But after all, who could have anticipated finding a factory surrounded by precipices? Switzerland is the one country in the world where you can find this mixture of wild nature and human industry. The whole of Switzerland is like one great city.[45]

Apart from being an eco-conscious attack on the defilers of nature, this passage alludes to Rousseau's fear of persecution. Here the stocking mill becomes a metonym for the civilized world of men and their obsessive desire to follow him wherever he goes. The description of the walk invites us to read the entire scene as an embodiment in nature of Rousseau's darker inner world as he is haunted by the sense of persecuted isolation. The stocking factory is not only the emblem of his thwarted expectations, but also of the triumphant Enlightenment machine synonymous with the machinations of his persecutors.[46]

As has been noted earlier, Wordsworth visited the same countries as Rousseau did, and he also explored the mountain ranges and countryside of his own country. When Wordsworth composed his poetry, he mostly did it in the open air. As has been remarked by William Hazlitt, his steadiness as opposed to Coleridge's variety is also a matter of choosing some paths rather than others while composing out aloud: 'Wordsworth always wrote (if he could) walking up and down a straight gravel walk, or in some spot where the continuity of his verse met with no collateral interruption'.[47]

The Lake District and the Quantocks had been criss-crossed by Wordsworth's feet and according to De Quincey, by the 1830s, he had 'traversed a distance of 175 to 180,000 English miles' on foot, 'a mode of exertion which, to him, stood in the stead of wine, spirits, and all other stimulants'.[48] Furthermore, Wordsworth wrote two letters to the editor of the *Morning Post* on the subject of Kendal and Windermere Railway. These two letters were crucial in stopping the projected extension of the railway from Kendal to Low Wood, near the head of Windermere in the Lake District. Indeed, with the clairvoyance of a twenty-first-century green activist, Wordsworth saved the area from the intrusion of Windermere railway and people in the area still think about it as his greatest achievement. Hence the Wanderer's final words in the *Excursion* are hardly surprising:

> I grieve, when on the darker side
> Of this great change I look; and there behold
> *Such outrage done to nature* as compels
> The indignant power to justify herself; [49]

In fact, some parts of *The Excursion* exemplify Wordsworth's own fear of change through the voice of the Wanderer. The birth of a huge town causes the natural surroundings to change and ultimately, to vanish, and the Wanderer deplores this fact:

> The footpath faintly mark'd, the horse-track wild,
> And formidable length of splashy lane, . . .
> Have vanish'd – swallowed up by stately roads,
> Easy and bold, that penetrate the gloom
> Of England's farthest glens. The earth has lent
> Her waters, air her breezes; and the sail
> Of traffic glides with ceaseless interchange,
> Glistening along the low and woody dale,
> Or on the naked mountain's lofty side.
> Meanwhile, at social industry's command,
> How quick, how vast an increase![50]

What follows is a description of factory work, where men, maidens, youths, mothers and little children go to work under unnatural light of this 'illumined

pile'.[51] Their 'unceasing toil' is part of the daily routine, which is harsher than human suffering in the time of war.[52] The factory remains their only 'temple', where they offer 'perpetual sacrifice' to their capitalist master.[53]

When 'the world is too much with us', as the title of a Wordsworth's sonnet suggests, the only safe and happy shelter is to be found within the loved place. Peace is for Wordsworth the central feeling of all happiness and the ultimate peace can be experienced only in the habitual relation of the self to the place.[54] Habit is related to the body and the habitual repetition of daily work. However paradoxical it may seem to regard Wordsworth as a 'bodily poet', *The Excursion* reveals a poet acutely aware of man as a physical being and his capacity to remember through the body.

Body memory alludes to memory that is intrinsic to the body, to its own ways of remembering: how we remember *in* and *by* and *through* the body.[55] The basic borderline it occupies is traced between mind and place: it is their middle term.[56] The sense of the role of the body in the workings of memory draws on medieval sources and is still strongly felt in empiricist philosophy.[57]

Bergson was the first philosopher to have devoted attention to body memory, but he only took a part of body memory, i.e. 'habit memory' for the whole of it.[58] Bergson described the body as a continual 'centre of action' and as that 'ever advancing boundary between the future and the past'.[59] As Edward Casey explains, 'if remembering were only a temporal phenomenon it would remain largely disembodied'.[60] In that sense, memory involves more than a mere repetition of the past, as 'personal identity' and everything that pertains to an individual life is ultimately rooted in body memory. Nowhere is that assertion more true than in romantic writing, but with a different twist in Rousseau and Wordsworth. As it is clear from various passages in the *Reveries* walking is, to Rousseau, a hypnotic state, where his body forgets itself. This activity makes him utterly self-absorbed. An 'inexplicable void develops' and the mind loses its grip on reality.[61] Especially in reveries his body becomes absorbed in the rhythm of walking and conscious reflection is eliminated. The only purpose of Rousseau's 'actions' (like digging in the garden or collecting plants) is to maintain a state of dreamy passivity. The body is active, but the activity is experienced by the mind as passivity. Both, his interest in botany and his work as a copyist of music are the result of his spontaneous engagement in therapeutic activity. Mechanical motion and an almost automatic life become the sources of pleasure for the older Rousseau, where the separateness of his body makes him care more about himself than about others.

Conversely, the Wanderer's walking triggers the memory of other people and acts as a trigger for his belief in universal humanity. As Wordsworth is using him as his poetic persona, the Wanderer's self-absorption is never final, and it includes everyone around him. The Wanderer remembers other people as being bound up with a particular place and his memory of them is very 'bodily' – the intimate relationship between memory and place is realized through the lived body: his own and the bodies of his fellow men.

Likewise, he is rich in experience and wisdom, because he witnessed the pro-

gress and decay of many families, 'of their minds and bodies', as the Wanderer tells us. Even the dead bodies 'speak' as the Pastor would show us in Book V: the dead in the local churchyard are still very much alive within the local community; the stories of their lives would never be forgotten. As Geoffrey Hartman explains, at one point, 'the poem declines into a massive communion with the dead, noble raptures spoken above their graves'.[62] Thus the emphasis shifts from individual fates to a universal concern about man's mortality and human strength at the face of life's tragedies and Books V–IX register a series of 'living epitaphs' resurrected by the Pastor.[63]

As places bring with them intersubjective relations, Avishai Margalit's binary concepts of 'thick' and 'thin' relations might be of use here. While thick relations are anchored in a shared past or moored in shared memory, thin relations are backed by the attribute of being human. Thick relations are in general, Margalit explains, our relations to the near and dear, while thin relations are in general our relations to the stranger and to the remote.[64] What is of special interest to Rousseau and Wordsworth is the fact that memory is 'the cement that holds thick relations together'.[65] What distinguishes Wordsworth from Margalit's useful opposition is that his memory encompasses the lives of shepherds, the poor and distressed, i.e. his 'thin' relations.[66] Thus in Book V of *The Excursion*, when the poet and the Solitary meet the Pastor and he gives an account of poor people's lives in the area, the poet is convinced that the highest moral truth resides with the lowly class:

> And they perhaps err least, the lowly class
> Whom a benign necessity compels
> To follow reason's least ambitious course;
> Such do I mean, who, unperplexed by doubt
> And unincited by a wish to look
> Into high objects further than they may,
> Pace to and fro, form morn till eventide,
> The narrow avenue of daily toil,
> For daily bread.[67]

What follows is the Pastor's apotheosis of rural simplicity, the one that recalls Wordsworth's own words from Preface (1800) to *Lyrical Ballads* where he states that it is possible to trace the primary laws of our nature in the simple language of common people and the incidents and situations from their ordinary life.[68]

Wordsworth's 'thickening' of thin relations is best seen during the feast in *The Excursion* when the poet and the Wanderer accidentally discover a recess in the valley where the Wanderer's friend the Solitary lives. They are both attracted by the sound of singing from the vale:

> Of the broad vale casting a casual glance,
> We saw a throng of people – wherefore met?

Blithe notes of music, suddenly let loose
On the thrill'd ear, did to the question yield
Prompt answer; they proclaim the annual wake
Which the bright season favours.[69]

The merriment of a group of people is an expression of the sense of community among the people and their connection to the vale they inhabit. Everywhere in the Lake District, the poet and his companions are met with hospitality:

. . . Hospitable fare
Frank conversation, made the evening's treat;
Need a bewildered traveller wish for more?
But more was given; the eye, the mind, the heart.[70]

The same is true of a worthy couple, Jonathan and Betty Yewdale, whom Wordsworth knew (he placed his children under their care after an illness which required change of air) and who became more than mere acquaintances. The visits he paid to the couple afforded him an insight into the characters, habits and lives of these good, humble, but also wise people. The stories of the people living in the Lake District are 'written in' to the places and this explains Wordsworth's idea of poetry as 'memorial inscription' (cf. Wordsworth's poems 'Michael' and 'Poems on the Naming of Places').[71]

However, this is not the case with Rousseau's idea of place and the intersubjective relations arising from it. As I have already stated, on the island of St. Pierre Rousseau finds his self-sufficient paradise. The island is a microcosm situated in a beautiful, circular basin and it provided all the basic products necessary to life. It has fields, pastures, orchards, woods, and vineyards. As Jean Starobinski rightly claims, 'the island is an example of plenitude in a restricted area, 'bordered' and limited by nature herself'.[72] The plenitude of the place is reflected in the subjective plenitude of Rousseau himself, who claims to have found perfect happiness, 'leaving no emptiness to be filled in the soul'.[73] The place itself plays a special part in Rousseau's life – something about it gave him 'such deep, tender and lasting regrets' that even fifteen years later he was 'incapable of thinking of this beloved place without being overcome by pangs of longing'.[74] He would evoke it again in Book XII of the *Confessions* as 'the happy land of sleep' and it becomes an everlasting point of return: 'more than ever did I sigh for that delightful idleness, for that sweet repose of body and spirit' and if he was not to stay on the island, nothing could prevent him from enjoying it in imagination.[75] As Eugene Stelzig claimed, the Fifth Walk has done much 'to create the romantic image of Rousseau, the lyrical poet of the timeless moment and of the plenitude of being'.[76]

Rousseau must turn away from society and find happiness in a perfect microcosm: he must turn his gaze from the others to his own self (the Wordsworthian 'egotistical sublime' is thus more pertinently felt in Rousseau).[77] His solitariness, however, is never complete: if the reader is not aware of other persons on the

island, it is because Rousseau opens himself up only to a form of 'restrained communication' with others.[78] He remains the central figure and 'transforms' other people into non-entities. For instance, when he visits the farmers of Montmorency instead of members of the French Academia, he is disappointed at their lack of eloquence and learning as they constantly question him instead of having a meaningful conversation with him. A crippled boy incident from the Sixth Walk in the *Reveries* is also indicative of this point. As Rousseau keeps picking up the same way on his walks, he realizes the reason for it: a woman set up a stall in summer to sell fruit, rolls and tisane. She had a little boy who hobbled about on his crutches begging money from passers-by. Every time Rousseau would pass by, the boy would pay him a little compliment and would be given some money, but as soon as Rousseau's benevolence turned into habit, he no longer felt the same way about the boy:

This pleasure gradually became a habit, and thus was somehow transformed into a sort of duty which I soon began to find irksome, particularly on account of the preamble I was obliged to listen to, in which he never failed to address me as Monsieur Rousseau so as to show that he knew me well, thus making it quite clear to me on the contrary that he knew no more of me than those who had taught him.[79]

In the end, Rousseau starts avoiding this boulevard. Whenever obligation coincides with his desires, it is enough to transform them into reluctance and aversion. Unlike Wordsworth, he regards the habit of virtue as a trap to lure him into something bad (according to Rousseau, when virtue becomes duty it turns to enslavement).

To conclude, Rousseau seems to be enveloped in his imaginary worlds more often than involved with the place itself. Therefore, Rousseau's sensibility for place depends much less on his perceptive powers than on his ability to enrich the real with the imaginary. Since he often charges places with personal feelings, the place for him represents an inner space – his emotional and imaginative flights at certain places memorialize for generations events occurring there. Rousseau's enthusiasm for nature in the presence of Madame de Warens, and his passion for botany and rowing on the island of St. Pierre, managed to create a place of pilgrimage for future generations. Paradoxically enough, by praising landscape beauty and by showing respect for the traditions and the history of a certain place (all being integral to the identity of a place), this severe critic of the newly emerging consumerist society, would unknowingly attract hordes of pilgrims. In 1816, Shelley and Byron would visit Lake Leman and sail to Vevey where *La Nouvelle Héloïse* had been conceived. Their goal was to experience what Shelley called the divine beauty of Rousseau's imagination. His 'Hymn to Intellectual Beauty' composed during this trip was an act of homage to Rousseau.[80]

Wordsworth's conception of place is linked to the idea that human identity is tied to location in a reciprocal way: the characters of *The Excursion* influence their surroundings and vice versa. Their identities are therefore place-bound as the

very possibility of the appearance of the self and the other happens within the all-embracing compass of place.[81]

Wordsworth also memorialized his love for the native place and its people in his well-known *Guide to the Lakes*.[82] This book remains one of the best tourist guides to that part of England because it was written for walkers like himself and the true lovers of nature finding pleasure in natural detail. Curiously enough Wordsworth's Lake District receives today 12 million visitors each year and abounds in gift-shops, restaurants and hotels bearing Wordsworth's name or the names of his famous poems and images from the poems that have become emblematic of this part of England. So the natural beauties are sold to tourists as if they were household commodities, something Wordsworth himself was concerned about.

Both Rousseau and Wordsworth pay special attention to the importance of place, as it becomes part of their identity. The self cannot be understood as some substance that underlies mental states, but is constituted through the complex unity of actions and attitudes, and through their relation to objects and persons in the world – to have a sense of one's own identity is to be aware of one's particular place within the world.[83] These two writers return to the past in order to regain time, but they accomplish it through the 'localization' of memory: in this recovery of time in place, their lives are recovered as well.

Notes

1 William Hazlitt, 'On the Character of Rousseau', in William Hazlitt, *The Table Talk*, accessed March 15, 2010 http://www.blupete.com/Literature/Essays/Hazlitt/RoundTable/Rousseau.htm

2 In Geoffrey H. Hartman, *Wordsworth's Poetry, 1787-1814* (New Haven and London: Yale University Press, 1964), Hartman states that there had been no real body of criticism on *The Excursion*. The poem was largely neglected due to the fact that it was considered to be a second-rate work. Hartman himself says that *The Excursion* is much weaker than *The Prelude* because it offers us no vision and the reader is always brought close to some substantial drama but never allowed to see it. However, in David Simpson, *Wordsworth's Historical Imagination: The Poetry of Displacement* (New York and London: Methuen, 1987), Simpson said that it was impossible to talk about Wordsworth's poetry without taking into account this very work.

3 William Wordsworth, preface to *The Excursion* (London: Simpkin, Marshall and Co.; Windemere: J. Garnett, 1856), 1. All references to *The Excursion* are to this edition.

4 Ibid, ll. 62–8.

5 From the introduction by Peter France to Jean-Jacques Rousseau, *Reveries of the Solitary Walker*, translated and with an introduction by Peter France (New York: Penguin Books Ltd., 2004), 12. All references to *Reveries* are to this edition.

6 In M. H. Abrams, *Natural Supernaturalism – Tradition and Revolution in Romantic Poetry* (London: Oxford University Press, 1971, 28-32), the author contends that the meaning of this culminating marriage must not be underestimated, it is the solution to Wordsworth's contemporary, but also our own, 'age of anxiety'. The individual has become fragmented, dissociated, and estranged in three different ways: within himself, from other men and from his environment. The marriage of man and nature is the road to his reintegration and the final feeling of unity with himself and his community. The romantic age thus first saw and felt the predicament of a divided and alienated man. He shows on the example of Hölderlin and Novalis that Wordsworth's holy marriage was not so unique in European Romanticism. It was rather a common period-metaphor which served a number of major writers of the period to convey complex ideas about the history and destiny of man and the bardic vocation of a poet.

7 M. H. Abrams, 'Structure and Style in the Greater Romantic Lyric', in *Romanticism: Critical Concepts in Literary and Cultural Studies*, eds. Michael O'Neill and Mark Sandy (New York: Routledge, 2006), 220.

8 *The Excursion*, Book VII, ll. 28–30.

9 Cf. Paul de Man, 'Intentional Structure of the Romantic Image', in *The Rhetoric of Romanticism* (New York: Columbia University Press, 1984), 137.

10 Wordsworth, preface to *The Excursion*, ll. 40–1; Cf. M. H. Abrams, 'Structure and Style in the Greater Romantic Lyric', 198. The phrase 'despotism of the eye' comes from *The Prelude* (book XI) where the eye is 'in every stage of life / The most despotic of our senses' (ll. 171–4).

11 Rousseau, *Reveries of the Solitary Walker*, 37.

12 Laurence Coupe claims that critical theory committed a sin against Wordsworth's poetry, assuming that because mountains and waters are human at the point of delivery, they exist only as signified within human culture. See Laurence Coupe, ed., *The Green Studies Reader – from Romanticism to Ecocriticism* (London and New York: Routledge, 2004), 2.

13 Cf. Geoffrey Hartman, *Wordsworth's Poetry, 1787-1814*, 299.

14 Jean-Jacques Rousseau, *Émile*, trans. Allan Bloom (USA: Basic Books, 1979), 52.

15 In *The Prelude* 'spots of time' are recurrent illuminations issuing from the states of personal crises. As Wordsworth states in Book XII 'there are in our existence spots of time / That with distinct pre-eminence retain / A renovating virtue whence / . . . our minds / Are nourished and invisibly repaired' (208–12). Thus, 'spots of time' become symbolic of both the literal place the writer had visited and the symbolic place in his own psyche, where memory plays an important part.

16 Cf. Eugene Stelzig, *All Shades of Consciousness: Wordsworth's poetry and the self in time* (The Hague/Paris: Mouton, 1975), 58.

17 Edward S. Casey, *Getting Back Into Place – Toward a New Understanding of the Place-World* (Bloomington and Indianapolis: Indiana University Press, 1993), 15.

18 *Tintern Abbey*, l. 140.

19 'This is Memory, which is as it were the Store-house of our Ideas. For the narrow Mind of Man, not being capable of having many Ideas under View and Consideration at once, it was necessary to have a Repository, to lay up those Ideas, which at another time it might have use of. But our Ideas being nothing, but actual Perceptions in the Mind, which cease to be anything, when there is no perception of them, this laying up of our Ideas in the Repository of the Memory, signifies no more but this, that the Mind has a Power, in many cases, to revive Perceptions, which it has once had, with this additional Perception annexed to them, that it has had them before'. (John Locke, *An Essay Concerning Human Understanding* (London & Vermont: Everyman's Library, 1977, 69). Memory conceived as a container, a closed place encompassing retained ideas and pictures is also common in the Middle Ages. St. Augustine constantly refers to memory as 'fields and spacious halls of memory', 'storehouse', 'hidden recess', 'secret cell', 'the vast cave of memory with its numerous and mysterious recesses', 'that huge hall of my memory' in book X, chapter VIII of St. Augustine, *The Confessions*, trans. J. G. Pilkington (New York: Liveright Publishing Corp., 1943).

20 See John Locke, *An Essay Concerning Human Understanding*, 69.

21 J. E. Malpas, 'The Remembrance of Place', accessed July 4, 2014, http://jeffmalpas.com/wp-content/uploads/ 2013/03/The-Remembrance-of-Place.pdf.

22 For Edward S. Casey, the intimate relationship between memory and place is realized through the lived body, so body becomes an important instance of remembering. See his chapter 'Place Memory' in Edward S. Casey, *Remembering: A Phenomenological Study* (Bloomington and Indianapolis: Indiana University Press, 2000).

23 We cannot, however, say that the cityscape does not play a positive role in the works of these two writers. Wordsworth of the *Excursion* and the London sections of *The Prelude* (Book VII) feels disorientation at the multiplicity of urban sights. Seen from the outside, London appears to him like 'a monstrous ant-hill' and the visitors to the St. Bartholomew's Fair resemble a thousand-headed hydra. On the contrary in his sonnet 'Composed Upon Westminster Bridge', Wordsworth compares the city to nature and at its morning revelation feels a combination of deep excitement and calm. Rousseau, in his turn, expresses disgust at the city of Paris in book IV of the *Confessions*. Yet, we know how much he cherished the city of Geneva.

24 Jean-Jacques, *The Confessions*, translated and with an introduction by J.M. Cohen (New York: Penguin Books Ltd., 1965), Book IV, 154.

25 Rousseau, *Reveries of the Solitary Walker*, 1.

26 Ibid., 1–2.

27 Ibid., 35. The same thought is repeated by Saint-Preux in a letter he writes to Julie on his arrival
 to Paris: 'With a secret horror I enter into this vast wilderness of society. This chaos offers me
 only a frightful solitude where gloomy silence reigns. My soul in the crowd looks to expand and
 finds itself constricted from all sides' (231). Quoting from Cicero, he continues 'I am never less
 alone than when I am with myself' (231). This idea, found in Jean-Jacques Rousseau, *La Nouvelle
 Héloïse* (Hanover and London: University Press of New England, 1997), is reiterated a number of
 times in Rousseau's writing.

28 The idea comes from Diderot's work *Le fils naturel, Bastard son*, which Rousseau interpreted as a
 direct criticism of his move from Paris. The work can be read as a *roman a clef* in which the char-
 acter Clairville is Diderot, and Dorval is Rousseau, i.e. the bastard son is Rousseau so he had
 every reason to be enraged. In Rousseau's thinking self-love (*amour-propre*), the principle of all
 wickedness, is revived and thrives in society, which caused it to be born and where one is forced
 to compare oneself to others at each instant. It languishes and dies for want of nourishment in
 solitude. Whoever suffices to himself does not want to harm anyone at all.

29 Rousseau, *Confessions*, Book XII, 591. The same idea is repeated by Saint-Preux in *La Nouvelle
 Héloïse*. He would dedicate an entire letter to the critique of the society of spectacles and appear-
 ances.

30 See Peter France, *Rousseau: Confessions*. Landmarks of World Literature (Cambridge, London &
 New York: Cambridge University Press, 1987), 68.

31 See Eugene Stelzig, ' "Sur les ailes de l'imagination" – Rousseau's Mnemotherapeutic Romantic
 Prospects', *Orbis Litterarum* 69, no. 2 (2014): 82–93.

32 Rousseau, *Reveries of the Solitary Walker*, 86.

33 Ibid., *The Confessions*, Book XII, 555.

34 Ibid., *The Confessions*, Book IV, 157.

35 Wordsworth, *The Excursion*, Book I, ll. 504–9; 512–5; 518–20.

36 Ibid., *The Excursion*, Book I, ll. 946–52.

37 Ibid., *The Excursion*, Book II, 123.

38 See Gaston Bachelard, *Poetics of Space* (Boston: Beacon Press Books, 1994 [1958]), 31.

39 Wordsworth, *The Excursion,* Book IV, ll. 598–600.

40 Ibid., 602.

41 J. E. Malpas, *Place and Experience: A Philosophical Topography* (New York: Cambridge University
 Press. 1999), 31. This line of thinking also appears in the work of Martin Heidegger.

42 I am here referring to the ecological readings of Wordsworth's poetry by Jonathan Bate, Karl
 Kroeber, and Laurence Coupe.

43 Casey, *Getting Back into Place*, 37–8.

44 Rousseau, *Reveries of the Solitary Walker*, 108.

45 Ibid., 118–9.

46 Cf. E. S. Burt, 'The Topography of Memory in Rousseau's Second and Seventh Promenades',
 Yale French Studies, no. 74 (1988): 234.

47 See William Hazlitt, 'My First Acquaintance with Poets', in *Twenty-two Essays of William Hazlitt*,
 selected by Arthur Beatty (London, Bombay and Sydney: George G. Harrap & Co. Ltd., 1920), 16.

48 Thomas De Quincey, *Recollections of the Lakes and the Lake Poets*, ed. David Wright (Harmond-
 sworth and New York: Penguin, 1970), 135, as cited in Jonathan Bate, *Romantic Ecology* (London
 and New York: Routledge, 1991), 49.

49 Wordsworth, *The Excursion*, Book VIII, ll. 154-6, italics mine.

50 Ibid., ll. 109–19.

51 Ibid., 178.

52 Ibid., 176.

53 Ibid., 188.

54 See Wordsworth, *The Excursion*, Book III: 'He fled; but, compass'd round by pleasure, sigh'd / For independent happiness; craving peace, / The central feeling of all happiness' (ll. 385-7).

55 Casey, *Remembering: a Phenomenological Study*, 147.

56 Ibid., 180.

57 It is interesting that the parts of body involved in the activities of memory were always connected to digestion. The monastic custom of reading during meals has to do with the ability to consume a book as one consumes a meal. See Mary J. Carruthers, 'From the Book of Memory-A Study in Medieval Culture', in M. Rossington and Anne Whitehead, eds., *Theories of Memory, a Reader* (Edinburgh: Edinburgh University Press, 2007), 50-8. In *An Essay Concerning Human Understanding*, John Locke speaks about memory as the power depending on the body: 'The pictures drawn in our Minds, are laid in fading Colours; and if not sometimes refreshed, vanish and disappear. How much the Constitution of our Bodies, and the make of our animal Spirits, are concerned in this; and whether the Temper of the Brain make this difference, that in some it retains the Characters drawn on it like Marble, in others like Free-stone, and in others little better than Sand, I shall not here enquire, though it may seem probable, that the Constitution of the Body does sometimes influence the Memory; since we oftentimes find a Disease quite strip the Mind of all its Ideas, and the flames of a Fever, in a few days, calcine all those Images to dust and confusion, which seem'd to be as lasting, as if graved in Marble' (71).

58 Casey points out that there has been no sustained recognition of body memory from Plato to Kant. See his chapter 'Body Memory' in his own *Remembering: a Phenomenological Study*.

59 See Henri Bergson, *Matter and Memory* (New York: Dover Publications, 2004), 5 and 88.

60 See Casey, *Remembering: a Phenomenological Study*, 182.

61 Cf. Jean Starobinski, *Transparency and Obstruction*, trans. Arthur Goldhammer (Chicago and London: University of Chicago Press, 1988), 233.

62 Hartman, *Wordsworth's Poetry 1787-1814*, 296.

63 Wordsworth is also known to have written a series of *Essays Upon Epitaphs*.

64 See Avishai Margalit, *The Ethics of Memory* (Cambridge and London: Harvard University Press, 2002), 7.

65 Ibid., 8.

66 Cf. Yu Xiao, 'Habit and Moral Enhancement in "The Old Cumberland Beggar" ', in Richard Gravil, ed., *Grasmere 2008: Selected Papers from the Wordsworth Summer Conference* (Penrith: Humanities-Ebooks, 2009), 60.

67 Wordsworth, *The Excursion*, Book V, ll. 596–604.

68 'Humble and rustic life was generally chosen, because, in that condition, the essential passions of the heart find a better soil in which they can attain their maturity, are less under restraint, and speak a plainer and more emphatic language'. From Wordsworth's preface to the second edition of *Lyrical Ballads* (1800), in William Wordsworth, *Selected Poems and Prefaces*, ed. Jack Stillinger (Boston: Houghton Mifflin Company, 1965), 447.

69 Wordsworth, *The Excursion,* Book II, ll. 122–7.

70 Ibid., Book V, ll. 786–9.

71 A good article on the subject of Wordsworthian 'spots of time' as memorial inscriptions is Lis Møller's 'The Metaphor of Memory in Wordsworth's Spots of Time', *Orbis Litterarum* 69, no. 2 (2014): 94–107.

72 Jean Starobinski, 'Rousseau's Happy Days', trans. Annette Tomarken, *New Literary History* 11, no. 1 (1979): 147.

73 Rousseau, *Reveries of the Solitary Walker* (Fifth Walk), 88.

74 Ibid., 87.

75 Rousseau, *The Confessions*, 591 and 600.

76 See Eugene Stelzig, *The Romantic Subject in Autobiography – Rousseau and Goethe* (Charlottesville and London: University Press of Virginia, 2000), 106.

77 Cf. See Eugene Stelzig, ' "Sur les ailes de l'imagination" – Rousseau's Mnemotherapeutic Romantic Prospects', 84.

78 This is Tzvetan Todorov's term and he recognizes four different types of 'restrained communication' in Rousseau's oeuvre: the first one is *writing* as he remains in contact with others without having to see them or talk to them, the second one is *imagination* as it is an escape from the real world, the third one is *nature* as a substitute for human relations, and the last one is *depersonalization* of others in order to elevate himself. See Tzvetan Todorov, 'Frêle bonheur', in *Textes du XXe siècle* (Paris: Hachette, 1985), 48.

79 Rousseau, *Reveries of the Solitary Walker*, 93.

80 See Simon Schama, 'The seat of virtue', in *Landscape and Memory* (USA: Vintage Books, 1995), 481.

81 Cf. Malpas, *Place and Experience – A Philosophical Topography*, 14.

82 Jonathan Bate notes that in 1835 his *Guide* was Wordsworth's most sold out book and it went through five further editions between 1842 and 1859. Matthew Arnold's story about meeting a cleric who admired the *Guide* and asked if its author had written anything else is not entirely frivolous. He also shows that Wordsworth's book was unlike earlier guides in two respects: firstly, it was not made exclusively for tourists and as such it invited all kinds of uses and secondly, Wordsworth wanted to show what it meant to dwell there. (Jonathan Bate, *Romantic Ecology*, 44).

83 Malpas, *Place and Experience: A Philosophical Topography*, 152–3.

Acknowledgements: Research for this essay was supported by the Croatian Science Foundation funding of project 'A Cultural History of Capitalism: Britain, America, Croatia' (project leader: Professor Tatjana Jukić, English Department, Faculty of Humanities and Social Sciences, University of Zagreb, Croatia).

Moderne dannelse

Goethes Wilhelm Meister og dannelsesromanens aktualitet

[Modern Bildung. Goethe's Wilhelm Meister
and the relevance of the Bildungroman]

By Birgit Eriksson
Aarhus: Aarhus Universitetsforlag, 2013
312 pp. DKK 349.95

Johann Wolfgang Goethe's Wilhelm Meisters Lehrjahre (1795–96) plays a central, but not unproblematic role in the history of the novel. Usually construed as the origin of the typically German novelistic genre of the Bildungsroman, it is not uncommon that interpreters reduce this extremely complex narrative, which Goethe himself labelled his most 'incalculable production', to either its generic elements or its relation to the – also very German – concept of Bildung, which is almost untranslatable into any other language. Its English equivalents are formation and education, though neither of them is able to grasp the polysemy of the German concept. The multitude of themes, motives, characters, events, and techniques are in these types of readings subjugated to the ambition to understand either the genre of the Bildungsroman or the concept of Bildung.

At first sight, Birgit Eriksson's book constitutes yet another contribution to this long line of interpreta-tions, which primarily construe Goethe's novel as the origin or an exemplum of the concept of Bildung and the genre of the Bildungsroman. As the title reveals, the aim of the book is to analyze the concept of Bildung, dannelse in Danish, its relation to Goethe's novel, and its role in present-day discussions of education, canon, and tradition. Taking the point of departure in the current debate on these matters in Denmark, Eriksson's scope is a fairly wide one. Rather than accepting the 'culturally conservative and bourgeois notion of national formation' that epitomizes the Danish debate on the national canon, she acknowledges the contemporary diversity of the concept, which we find in the notion of, for instance, 'digital Bildung' and 'democratic Bildung' (p. 11; all translations from Erikson's book into English are by the reviewer).

Then again, it soon becomes apparent that Eriksson's ambition is indeed a new one and that we are in fact dealing with a highly intelligent

and fascinating reading of this super-canonized novel that has been reread so many times. Rather than offering a new interpretation of the protagonist Wilhelm Meister's education or lack of education, Eriksson effectively relocates the centre of the concept of Bildung from the novel and its characters to the reader. The first signs of this relocation and re-evaluation of the novel can be seen in Eriksson's restoration of the reputation of the founder of the concept of the Bildungsroman, Karl Morgenstern, who in a series of lectures held in the 1810s articulated the essential features of the genre. In the last of the three lectures, Eriksson argues, Morgenstern abandons all forms of essentialism as he turns his attention to the impact of the text on the reader.

However, not only Morgenstern's original conceptualization of the Bildungsroman in the early nineteenth century, but also the first reading of the novel, that is, Schiller's reading of the work in progress, documented in his correspondence with Goethe, are crucial, as Eriksson's novel interpretation of this correspondence shows. As it were, Schiller could in fact be labelled the first reductive reader, and throughout the correspondence Eriksson distinguishes a kind of resistance on Goethe's part to Schiller's insistence on a fundamental idea in the novel. Eriksson argues convincingly that Goethe, prefiguring much of what was to come in the twentieth century with regards to reader-response and reception theory, construes the process of Bildung in the novel, not primarily as something that the protagonist,

Wilhelm Meister, has to undergo and that is usually interpreted as a kind of synthesis between individual and common interests, but as something that pertains to the reader of the novel. What Goethe does in the letters to Schiller, Eriksson maintains, is to 'insist on reading as a free and positive productivity' in which the reader partakes as 'co-producer' of the work (p. 87). This, I believe, is a new and, as it turns out, extremely productive way to look at the function of Bildung in Goethe's novel and – and this is important – at the role of Bildung in today's discourses on education and individual formation.

What is at stake, then, is the Bildung of the reader. However, the reader of Eriksson's book must wait almost 200 pages before the theme reappears in the argument. If there is one thing for which one could criticize Eriksson, it is her thoroughness. The book consists of a whole string of analyses of themes, characters, and problems that are often very familiar to Goethe scholars. The opposition between the individual and society, the attempt to reconcile these two, and the contrast between the naive protagonist and the ironic narrator are merely a few of the themes that Eriksson discusses and which are well-known in Goethe scholarship. But just when you think you have Eriksson all figured out, she unexpectedly makes a quick turn and presents a dazzling insight into the novel, the processes of modernity, and our present-day endeavours.

As the reader reappears in the last chapters of the book, one understands the need for thoroughness.

Just like Wilhelm, who wanders the world, and the reader, who wanders the novel, Eriksson wanders her own interpretations. The point of this wandering is that Wilhelm Meister effectively offers 'a new form of realism in which the narrator and the other characters of the novel jointly underscore that the events have, not merely one, but many potential meanings and that also the reader has to choose between them' (p. 230). According to Eriksson, this constitutes Goethe's radical modernity, which makes time an essential factor, affecting 'all aspects of human life and simultaneously altering both individual and world' (p. 230). Everything, both man and his world, undergoes change, and it is with this ubiquitous changeability that the reader must learn to deal. This, in short, is Eriksson's concept of Bildung.

This is also why Wilhelm Meister is relevant today. As Eriksson in the last chapter turns her attention to typically contemporary issues, such as self-realization, social and technological progress, and globalization, it becomes apparent that Goethe's open, reader-oriented, and interpretative novel and the genre which it created, may still work as a point of departure for a better understanding of the world and of our selves. If we understand that 'formation at the same time means reformation', as Goethe writes in an essay ('Die Absicht eingeleitet') on morphology (!), we have the necessary skills to orient ourselves in the postmodern, postindustrial, and posthuman world of today. As a result, the Bildungsroman is still a vibrant and productive genre. Today, the tradition is continued by writers from outside the originating Western culture. These writers, who have experienced first-hand the sometimes conflicting encounters between different cultures in the globalized world, are probably better suited than writers born and bred in Europe and North America to depict the demand for education and interpretation, to depict Bildung.

Mattias Pirholt
Uppsala University and
Södertörn University

En grænsegænger mellem oplysning og romantik

Jens Baggesens tyske forfatterskab

[Crossing the frontier between Enlightenment and romanticism. Jens Baggesen's German authorship]

By Anna Sandberg
Copenhagen: Museum Tusculanum Press, 2015
350 pp. DKK 298.00

Jens Baggesen (1764–1826) is one of the most important bilingual authors in Danish literary history, but Danish critics have often neglected his German writings, deeming them of inferior quality. While Baggesen had great admirers among poets and writers (for example Heiberg, Kierkegaard, and Andersen), they, too, never acknowledged any real interest in his German texts. In the history of Danish literary criticism, Leif Ludwig Albertsen is the first important critic who, in the 1960s, began a serious study and positive revaluation of Baggesen's German verse.

The rehabilitation of Baggesen's German authorship in Danish literary criticism has now resulted in a first monograph: Anna Sandberg's impressive study, which unfolds in three parts. In part one, Sandberg studies Baggesen's epic *Parthenaïs, oder die Alpenreise* (1803) and the epic fragment *Oceania* (written 1803–1805, published 1808). In the second part, she discusses Baggesen's two satires *Der vollendete Faust oder Romanien in Jauer* (finished in 1808, published posthumously in 1836) and *Der Karfunkel oder Klingklingelalmanach* (1809). And in part three she interprets Baggesen's last work, the comical epic *Adam und Ewa* (1826).

With the exception of Baggesen's posthumously published epic on our first parents, his major German writings date from the first decade of the nineteenth century. Sandberg traces a development in these writings 'from optimism justified in Baggesen's faith in enlightenment to pessimism grounded in the post-revolutionary political development' (p. 10; all translations from Sandberg's book into English are by the reviewer). This argument seems persuasive to me, and Sandberg is very adept at relating the texts she interprets to relevant intertextual perspectives as well as to various contemporaneous European contexts, be it the importance of the French Revolution and Napoleonic Wars, Swiss alpine culture, the com-

plexities of German literature around 1806, or James Cook's naval explorations.

Sandberg's historicist approach and her lucid style make for rewarding reading. Baggesen continues in the first decade of the nineteenth century to draw on Kantian and French Enlightenment thinking, classical antiquity, modern science, and canonical literature, but, according to Sandberg, his disillusionment and anger with nationalism in both Danish and German culture increasingly turn him towards satire. As Sandberg points out, Baggesen wanted to secure his canonical place in German literary history by writing epics and at the same time to point his finger at the hollowness he found in romantic literary circles in Northern Europe.

Sandberg regards the traditional idea of Baggesen as an 'antiromantic' as simplistic, and understands Baggesen's poetical '19th century' (p. 35) as consisting of various classicist as well as romantic strains. Sandberg shows convincingly that Baggesen in his satires draws on romantic literary techniques. However this does not necessarily make those satires romantic, as Sandberg argues. Baggesen's German texts, especially the satires (one really misses critical editions of them), are very difficult, and Sandberg's readings are perfect introductions to anyone interested. I also like Sandberg's pervasive emphasis on Baggesen as a real presence in German as well as Danish literature in the first decades of the nineteenth century. Starting with the Danish romantic Adam Oehlenschläger's polemics and satire against Baggesen, the poet

has often been portrayed as a writer, whose important texts all belong to the eighteenth century. This is not true at all, as Sandberg's study ably illustrates.

Baggesen has often been construed by literary historians as an outsider, and Sandberg also refers to him in this way, although he himself chose the destinations of his travels and residences, and was part of an elitist cultural and political network in Europe. It is true that Baggesen was an antagonistic writer, which made him enemies, especially in the romantic circles. I would say his identity as an outsider is ambivalent. Baggesen did not want to belong to any group; rather, like Kierkegaard, he wanted to go it alone and also succeeded partly with many of his literary projects. On the other hand, it is true that his gamble on producing literature for both a Danish and a German audience in the first decade of the nineteenth century, whilst different forms of national romanticisms were on the rise, did make him feel less in sync with his times, particularly when he realised that the majority of readers preferred national romanticism.

One of the great joys of reading Baggesen, in Danish as well as in German, derives from his versatile tonality, as it oscillates between the lyrical, the epic, and the satirical. Baggesen did also write quite a lot of German poetry, producing the two volumes *Gedichte* (1803) and *Heideblumen* (1808), which are not studied in depth by Sandberg. This is the one major aspect I miss in this quite beautiful book, illustrated as it is with Johan Lundbye's exquisite water coloured

drawing from 1845 of the Swiss mountain Jungfrau on its cover: the same mountain climbed by Baggesen's alter ego Nordfrank in *Parthenaïs*.

Baggesen was an intelligent spectator to the complex European power play in the aftermath of the French Revolution, as well as an insider when it comes to the flowering of German philosophy and literature in his own lifetime. No Danish writer of this period had a broader outlook than Baggesen, which he was well aware of himself. The great strength of Sand-berg's study is that the reader comes away with a coherent and profound picture of Baggesen as a genuinely European writer. This is his most important legacy today, for both critics and writers, and Sandberg correctly insists that we need to study Baggesen's German authorship in order fully to understand the scope of his literary achievement.

Mads Sohl Jessen
University of Copenhagen

Mellem ånd og tryksværte

Studier i trykkekulturen og den romantiske litteratur

[Between spirit and ink.
Studies in print culture and romantic literature]

Ed. by Robert W. Rix
Copenhagen: Museum Tusculanum Press, 2015
201 pp. DKK 198.00

Mellem ånd og tryksværte [Between spirit and print] is a collection of six essays, each examining its subject from the dual perspectives of book history and literary criticism. Despite a growing interest during the past three decades in material studies, print culture, and textual scholarship, the area remains underdeveloped and much published scholarship and teaching still fails to take sufficient account of the fundamental, material conditions from which literature arises. The literary work always manifests itself to its reader in a material form – often a book – and this materialisation always affects reading and interpretation.

With this collection, six important case studies are added to this area of research. And we need excellent case studies like these, which demonstrate the value of the material perspective. The editor's excellent introduction lets us know that this is particularly important in studies of romantic cultural texts. The myth of the inspired artist working alone at his masterpiece so deeply informs the research clouding the mundane business of literary production that all authors must deal with. But the problem goes beyond romanticism. We are dealing here with a core issue in the human sciences. Any empirical analysis of literature must take into account the mediating documents. This is what Rix's collection demonstrates, covering areas such as reception history, the book as an expressive form, publishing history, translation practises, cultural studies, and textual instability.

Jens Bjerring-Hansen's contribution offers an important reminder of the value of shifting the focus in literary history from who wrote what and when (authors, schools, influences) to what was actually bought and read. The essay covers the reception and publication history of Ludvig Holberg's mock-heroic epos *Peder Paars* (1719–1720). Through a detailed analysis of editions (though not the two

latest from 2015), Bjerring-Hansen performs what could be called a bibliometric literary history and unveils that the success of *Peder Paars* contributed to making Holberg the most published Danish author of the nineteenth century.

Bjerring-Hansen investigates three bibliographic factors that contribute to making *Peder Paars* a bestseller. First, Holberg's works were cheap to reprint, since copyright laws had not yet been implemented effectively. Second, consumers preferred a good bargain, making it easier to sell voluminous books at low cost. And finally, technological advances during the second revolution in book printing – the industrial revolution – meant that *Peder Paars* could be more easily and inexpensively illustrated, thus catering to a new reading audience which had not previously been in the market for book buying.

Klaus Müller-Wille further pursues the focus on book trade and materiality in his investigation of J. L. Heiberg and Søren Kierkegaard in the first half of the nineteenth century. Both had a highly developed sense of the emerging book trade, which they evoked as a thematic and aesthetic point of reference. Both authors (more or less willingly) embraced this material condition of the intellectual enterprise.

As his two main examples, Müller-Wille looks at Kierkegaard's *Forord* (1844) and Heiberg's *Ny A-B-C-Bog* (1817), disclosing a range of intertextual references in both. Kierkegaard's polemic satire is aimed at the book trade in general and at Heiberg in particular. Müller-Wille demonstrates how Kierkegaard's highly critical viewpoint – in this and other works – is supplemented by a finely-tuned employment of the very same features he criticises in Heiberg and others.

In Heiberg's *ABC*, typography and other bibliographic codes are used more expressively in a polemic discussion with N. F. S. Grundtvig. The *ABC* is a highly graphical publication and the link to book aesthetics is therefore evident. But Müller-Wille goes on to disclose more hidden references to the book trade in other works by Heiberg. Thus the essay very effectively demonstrates the central doctrine of book history: intellectual content and material form must always be viewed as a whole. Without the material perspective, the two controversies discussed would make little sense.

Petra Söderlund demonstrates how the history of a publishing house – A. F. Palmblad & Co., based in Uppsala in the early nineteenth century – is also a literary history. Swedish romanticism and, in particular, the so-called *phosphorism*, was closely linked to Palmblad. Söderlund's contribution is a fine example of the Uppsala school where an investigation of the sociology of texts is the main methodological approach. The essay focuses on the importance of the (social) network, the strong ties and co-operation between publishers and writers, and the influence of readership and financial considerations on aesthetic production. Söderlund makes the interesting point that the development of romanticism in Sweden was particularly influenced by the limitations of the commercial book trade during the early nineteenth century. As romantic publications

did not sell well, Palmblad had to rely on other genres in order to raise the financial capital needed, while accumulating *cultural* capital. According to Söderlund, this was a conscious strategy by Palmblad. Here one discovers an interesting clash between the idealised view of the Swedish romantic movement with its (divinely) inspired artists conjuring up the work of art in solitude and the practical, financial influence of the book trade.

Simon Frost examines the publication history of *Robinson Crusoe* and shows how various editions have prompted different interpretations of the work. His essay demonstrates the importance of distinguishing between the work *per se* and its various editions, copies, and versions.

Defoe's three-volume novel was first published in 1719–1720 and quickly became a commercial success. Frost's essay relates how the translation practices of the romantic era ('transediting', to borrow a term from book history) transformed the story. Translations would often abbreviate and focus on the Island episode that resonated better with romantic ideologies of man and nature than did the rest of the work. Also, translations would often discard the author's name and become in fact rewritten versions. Thus began the wave of Robinsonades that rushed over the eighteenth and early-nineteenth centuries. However, as Frost shows, deviations from the original were not seen as untruthful to the original, but as an imaginative recreation with the aim of delivering the unreleased potential of the work.

Robert W. Rix focuses on how the cultural, political, and religious climate of England in the 1790s prompted the publisher Joseph Johnson to terminate the publication of a poem *The French Revolution* by William Blake, a work that now only exists in a single incomplete proof copy.

Johnson was a central figure in both the reformist movement and in early English romanticism. Like many others, he was supportive of the revolution in France and had published in support of it. Blake's work therefore seemed conducive. However, the difference in perspective between Blake and Johnson was too great. Rix traces in detail how Blake's poem was too visionary and prophetic, bordering on the fanatic, whereas Johnson's publications of the Unitarian Joseph Priestly and others would stay within a scholarly exegetical approach. Blake was in a sense too romantic.

In Johnson's view, releasing a work of this kind would jeopardise his position as publisher in the intensified political climate of the time. Rix's essay beautifully demonstrates how cultural, historical, material, and literary studies come together and effectively enrich our understanding of the work, the author, and the cultural dynamics of the early romantic era in England.

In Peter Simonsen's essay, romantic ideas of the sublime are coupled with the notion of textual instability. The latter is a fundamental concept in textual criticism and modern book history, stating that works of literature often exist in different versions and that no *one* version can be said to be authoritative. Simonsen takes as his example a poem by Samuel

Taylor Coleridge and claims that the poet deliberately employs revision as a means of poetic expression. The poem – 'Frost at Midnight' – was written and first published in 1798. By 1834 it had been published in ten substantially different versions although the essay only discusses the two versions extant by 1807.

Simonsen not only considers the different versions of Coleridge's poem. More importantly, he examines the tension between the two. In a discussion of how the versions have previously been valorised by Coleridge scholars, he asserts that it is not a question of which is better, but of what each version means in relation to the other.

Whether the case really represents a chaos of variants as is stated, is difficult to say. The article does not provide sufficient information on the textual transmission of the poem, but using the theories of Jerome McGann, it does assert that textual differences matter – whatever the scholarly approach might be. This conclusion cannot be overstated.

The essays in this volume are well-written and well-edited. The combination of Scandinavian and English case studies works well, even though is it not made to bear any particular, comparative argument. The essays also maintain a fine balance between the material and the literary perspective, and equal emphasis is important in cross-disciplinary studies. In charting selected blank areas of the literary map, this book is highly recommendable and should be employed in university curricula.

Klaus Nielsen
Aarhus University

REVIEW

Der lebensphilosophische Frühromantiker

Zur Rekonstruktion der frühromantischen Ethik Friederich Schlegels. Schlegel-Studien, vol. 9

[Philosophy-of-life-aspects of an early romantic:
a reconstruction of Friedrich Schlegel's early romantic ethics]

By Andreas Hjort Møller
Paderborn: Ferdinand Schöningh, 2014
288 pp. €38.00

Andreas Hjort Møller argues for the unity of Friedrich Schlegel's thought. Apparent differences between the author's early and later writings are identified as a change of expression rather than intention. Møller emphasises the permanent presence of what he calls an early-romantic ethics in Schlegel, which remains unaltered in Schlegel's later works. Ethics is here understood in the vague sense of a 'normative theory of how to live' (p. 18; all translations from Møller's book are due to the reviewer). Morality and life are connected in a sort of early romantic existentialism (p. 258). Møller finds the ethical meaning sufficiently determined to free Schlegel from the charge of having been an 'anarchist [Chaot], fragment-maker, hedonist or ironist' (p. 18). What Schlegel discarded was a priggish moralism which only allowed for the articulation of the virtuous side of human nature. In addition, Møller attacks an understanding of the young Schlegel as an adorer of the French Revolution and of democracy, and as such opposed to the later Schlegel, often depicted as a Metternich-loyal reactionary thinker. Indeed, Møller presents the young Schlegel as a conscious and conscientious, moral, Protestant Christian, as a non-revolutionary author, who, without greater disruption, developed into a moral, Catholic Christian spiritualist, and a moderate conservative. Within this analysis, early romanticism is considered not as a *political*, but rather as a purely *spiritual* phenomenon (p. 112).

Møller refers extensively to modern critical debates about the uniformity of Schlegel's thought, with scholars like Ernst Behler arguing for continuity whilst others, like Hans Eichner and Arnim Erlinghagen, argue for discontinuity. But the interpretation which Møller wishes to challenge is the late nineteenth-century, ideologically-motivated interpretation of Schlegel's development formulated by authors like Rudolf Haym (1870) and Georg Brandes (1873). Møller

also confronts poststructuralist revisions of the same negative picture into a positive, 'ironic nihilism', as defended by Paul de Man and many others. Haym and Brandes continued an influential tradition of ridiculing Schlegel as an egotistical and immoral author and as an incompetent philosopher, a tradition going back to Hegel's personal impressions of Schlegel in Jena 1801. They favoured the Schlegel of the *Athenäum* (1797–1800) and the scandalous *Lucinde* (1799) rather than the later Schlegel. In fact, *Lucinde* had a few contemporary defenders. One of them, Schlegel's close friend Friedrich Schleiermacher, praised in the anonymous *Vertraute Briefe* über *Friedrich Schlegels Lucinde* (1800) the book's unity of sensuality and spirituality and its artistic rigour and strength. Schleiermacher held *Liebe* [love] to be its *Mitte* [centre] and the appearance of love the developing motor in the life of the main character, Julius, both in his relation to other persons and as an artist (he is a painter). The book is held by Schleiermacher to be a *complete* exposition of love, unrivalled by any other novel. As a standard of *morality* for a work of art, Schleiermacher's first person narrator, *Friedrich*, only accepted *artistic quality*. Møller, however, in his analysis, abstains from referring to Schleiermacher's interpretation, which could have supplemented his own – apparently because he suspects some disturbing theological bias (p. 99, n. 2), although the reasons for this are not altogether clear to me.

Opposing *deconstructive* interpretations (i.e. de Man et al.), Møller points to the demands made by Schlegel and other early romantics for veracity. Both the *subjectivist* interpretation of Schlegel's work and the poststructuralist critique of it are answered by a conception that does not embrace *irony* as an isolated, negativistic peak in Schlegel's poetics. Instead, Møller presents irony as a constructive means to come nearer to a truth that defies an adequate communication because it is infinite and unreachable, and thus demands paradoxical strategies, e.g. a hermeneutics of fragments. The *moralist* objection is met by an ethical reading of *Lucinde*. The larger task of harmonising Schlegel's early and later authorship exhibits how important terms from the early romantic vocabulary in Schlegel's use of language can have double meanings. Terms like purposelessness, liberty, wit, chaos, capriciousness, fantasy, and ludicrousness, for example, have negative penumbras, or anti-theses.

Møller approaches his subject with care. In four studies, he attempts to bridge the gap between a central, early text and a later text by Schlegel. To do so, he invokes a multitude of lesser-known early, later or very late texts, mainly with the aim of tracing the connotations of the *words* used by Schlegel. This scheme is the basis for some fine observations in support of the idea of the coherence of Schlegel's thought.

Although Møller rejects poststructuralist and deconstructive readings of Schlegel, he seems to accept the notion that Schlegel was a sort of anti-philosopher, being against systems and *-isms*. For an attempt to 'reconstruct' Schlegel's ethics, this might be an unfortunate assumption. The

task of reconstruction, mentioned in the book's subtitle, is never in fact fulfilled, at least not in the systematic sense usually indicated by the term 'reconstruction'. In the end it seems abandoned by Møller, although the interpretation of *Lucinde* does present the outlines of an ethics.

An objection to Møller's method could be that the permanent focus on what he calls 'intratextuality' (p. 36) confines the scope of his references too much to Schlegel himself. An in-depth investigation of the intellectual context, and most importantly Kant's *Toward Perpetual Peace*, would have turned the discussion of Schlegel's ethics and politics in a less 'spiritual' direction. Furthermore, the difference between comparing the meaning of *entire* texts comparing similar *elements* of different texts seems to be vital. In the last two studies, the hunt for connotations seems to overrule a holistic focus on the selected texts.

The *first* study examines the essay *Vom aesthetischen Werth der Griechischen Komödie* [On the aesthetic value of the Greek comedy] (1794) and a minor newspaper article, Über *die neue Wiener Preßfreiheit* [On the new Viennese freedom of the press] (1809). Møller exposes the many (minor) moral and political reservations against Aristophanes' comedies already present in the comedy-essay of 1794 that can be read as general warnings against political misuse of poetic autonomy. This anticipates Schlegel's defence, in 1809, of censorship as a protection against rationalistic, Enlightenment authors and immoralists like Voltaire and Aloys J. Blumauer, both propagated in Austria by Napoleonic 'free-

dom of the press'. In the apology for Aristophanes, Schlegel uses a vitalistic terminology [*Leben, Lebenskraft*] that anticipates the 'Philosophy of life', developed in depth after 1810.

In the *second* study, the novel *Lucinde* (1799) is read alongside Schlegel's second Lecture on the *'Lebensphilosophie'* [Philosophy of life] (1827). The publication of *Lucinde* was seen as a provocation because of the very direct sexual dialogue and the alleged indecency. Conversely, according to Møller, *Lucinde* is a highly moral work. Schlegel underlines the existential and educational necessity for a young man to develop from chaotic, liberal experiences into the mature ethical order of matrimony. Real morality – in a work of art – is namely to be faithful towards the wide totality of human life and not to withdraw from what is against conventional decorum (p. 186). Another highly important issue for Møller (here, and throughout his book) is to argue against the die-hard view of Schlegel's conception of love as subjectivist and egotistical. Møller argues the opposite: in *love*, the *'thou'* and the *'we'* are primary to the *'I'*. His aim is to read *Lucinde* as a 'tractatum Christianum', not as a 'tractatum eroticum' (p. 99). Thus, he traces references to Madonna (Julius, the principal character, calls his beloved Lucinde 'Madonna') and allusions to Christian imagery in the novel back to Christian paintings known by Schlegel. In addition, some (early) hints about a religious interpretation and a Christian continuation of the book in Schlegel's manuscripts are investigated.

The *third* study concerns Schlegel's

praxis of re-editing his own texts. The original edition (1800) of *Gespräch über die Poesie* [Conversation on poetry] is compared with the second edition, of 1823. Schlegel's praxis of reediting is shown to contain some significant, recurrent elements. Expressions such as 'the highest holy' are revised as 'the life of the soul', the 'revolution' to the 'great intellectual rebirth', the 'certainty of the holiest mysteries' to 'certainty of this wonderful apparition'. The connotations of terms like 'republic' and 'mythology' are restricted by adding 'state and republic' or 'mythology and the symbolic world of ideas' (pp. 204ff.). Religious issues are abandoned. According to Møller, Schlegel seems loyal to his earlier intentions. Møller does not attempt an overall interpretation of the *Conversation*, with its conception of a general history of canonical literature, of mythology as the stuff of ancient and new literature, of the modern romantic novel, and of Goethe's work as exemplary for future 'romantic' literature. However, he finds that Schlegel at the end of the revision of the *Conversation* presents a new understanding of poetics based on Christian Trinity, without making any sense – 'grundsätzlich sinnlos' – for literature (p. 233).

Møller's *fourth* study concerns the political conceptions of the younger and the older Schlegel. Central to this discussion is *Versuch über den Begriff des Republikanismus* [Essay on the concept of republicanism] (1796), specifically the young Schlegel's discussion of some elements of Kant's treatise *Toward Perpetual Peace* from 1795. In the essay from 1796, Schlegel points

to the various different incarnations of republicanism, and to moral and political formation ('politische Bildung'), an aspect neglected by Kant although immensely important, in Schlegel's view, for the development of mankind, as a condition for development of full republicanism. Again, Møller does not aim at an interpretation of the Essay as a whole. Instead, some of its salient features are brought into constellation with the third part of *Signatur des Zeitalters* [Signature of the age] (1823).

Møller quotes the passage in the essay of 1796 where Schlegel asserts that Kant's book 'contains an abundant wealth of fertile ideas and new views on politics, morality, and the history of mankind' (p. 235). Astonishingly, Møller understands Schlegel's assessment of *Kant's* text as an indication of non-political aims in his own. With reference to Nikolas Immer (p. 239), Schlegel's central modification of Kant's understanding of republicanism, *viz.* that republics in real life have to be ruled by a majority attempting to be in accordance with general will, is turned into a sort of utopianism, making Møller doubt 'whether Schlegel's republicanism is ever to be understood as "republican" in the strict sense' (p. 241), and to conclude that 'Schlegel's Republic is not Jacobin or democratic' (p. 245).

Møller considers Schlegel's very thoroughly-argued essay of 1796 immature and full of inept phrases (p. 238), seemingly because Schlegel uses the language developed by political philosophers such as Kant and Fichte. In my view, Schlegel's Essay also draws heavily on Rousseau's *Du*

Contrat Social. What is Schlegel's essay then about, in Møller's view? Møller reads the principles of the essay as analogous to an aesthetic theory of progression, similar to 'the hermeneutical theory of fragment' (p. 239). Møller concludes that Schlegel's essay subordinates politics to morality, which might be a misreading of the essay. Further, Møller claims that words like 'constitution', 'republican', or 'despotism' in Schlegel might have other meanings than the political: 'The political sense of such terms as "republic" and "revolution" can hardly be distinguished from the aesthetical' (p. 244). Hence, according to Møller, Schlegel was never a revolutionary in any political sense. Here, however, Møller ought to have considered Schlegel's use of the language of Rousseau's and Kant's political philosophy. Be that as it may, to conclude with Møller (who draws here on Peter D. Krause) that Schlegel's essay of 1796 is not democratic-minded at all, but that it contains, conversely, undemocratic aspects, is to strain the evidence. In fact, against Kant, Schlegel argued in 1796 that 'Republicanism is necessarily democratic': The *general will* as an *a priori* normative principle cannot be an empirical phenomenon. Being *the* warranty for republican freedom and equality, it needs the *fiction* of an empirical will that acts according to general will in order to perform the political imperative. Therefore, the *will of the majority* has to be considered as a surrogate for the general will.

Møller presents Kant and Schlegel's essay of 1796 as standing in the service of *peace* in a rather unspecific way. The version of 1823 firmly demands the peace and the inner stability of a Christian state with multiple centres. Admittedly, the *Signatur des Zeitalters* has some *elements* reminiscent of the young Schlegel, as suggested by Møller (pp. 248–56). Nevertheless, it seems difficult to vindicate the essay of 1796 on republicanism for Schlegel's – in comparison with the '*Ultras*' (de Maistre & co.) allegedly more moderate – Christian monarchism. The legitimacy of this Christian community does not depend on the normative *a priori* general will or on the empirical will of the many, i.e. the majority, but on its Christian spirit and foundation.

Møller's main thesis in the book is the continuity of Schlegel's thinking. In many respects the book succeeds in corroborating this. Møller argues for Schlegel's early awareness of the interaction between the freedom of literature and its political environment. He gives good reasons for reading *Lucinde* as a novel based on ethical intentions pointing to a broad conception of what matters in human life, although the insistence that it is a Christian book is less convincing. He shows the emphasis laid in *Lucinde* on an interpersonal point of view. In this context, Møller offers good counter-arguments to an interpretation of Schlegel as a subjectivist, although a more general discussion of the issue of subjectivism might turn out to be a challenge to his view. Møller argues plausibly against the view of Schlegel as an admirer of the French Revolution. He shows that Schlegel in many of his early-romantic fragments where he mentions 'revolution' is pleading

for an aesthetic and not a political revolution. However, it does not seem convincing that Schlegel in his essay of 1796 should not be a republican or a democrat at all, or that a political understanding of his authorship can be discarded. With his first study, Møller himself has elucidated the relations between aesthetics and politics in the very early Schlegel. The fourth study confirms that Schlegel remained highly political in his orientation, even in 1823, although he was now discussing from (what I consider to be) quite another political point of view. Why then interpret the authorship as unilateral 'spiritual', translating political conceptions into aesthetical stances?

Schlegel wrote recurrently about the *Zeitalter* [the age] in which he lived. In *Athenäum Fr.* 426, he called it 'chemical' (1798); in his *Reise nach Frankreich* (1803), he called it an age of 'separation' (Trennung). His early reflections meditate the potential of the lost past for a better future and for an art that can be a remedy against the rationalism that ruins imagination. Perhaps Schlegel gradually and without great disruption, as Møller argues in his four studies, gave up central elements of this historico-philosophical structure and asked for a more fundamental 'Philosophy of life', for a political order that was not based on the achievements of humans, and for an aesthetical theory based on Trinity. Møller has not inquired into what *made* Schlegel develop his thought on these issues. Hopefully, he will do so in a future study.

Jørgen Huggler
Aarhus University

Peder Balke

Visjon og revolusjon

[Peder Balke. Vision and revolution]

Eds. by Marit Ingeborg Lange, Knut Ljøgodt,
and Christopher Riopelle
Tromsø: Nordnorsk Kunstmuseum i samarbejde med
The National Gallery, London, 2014.
141 pp. NOK 300.00

Paintings by Peder Balke

Eds. by Marit Ingeborg Lange, Knut Ljøgodt,
and Christopher Riopelle
London: The National Gallery,
distributed by Yale University Press, 2014.
127 pp. £16.95

The artistic reputation of Peder Balke (1804–1887) depends almost entirely upon a single journey. In 1832, he was the first Norwegian artist to travel to northern Norway. His masterpieces, *From Nordkapp* (c. 1840), *Lighthouse at the Norwegian coast*, and the *North Cape* (1845), are based on the sketches and impressions he made there, when he was 28 years of age. He was also a student of the Norwegian artist Johan Christian Dahl, in Dresden.

However, when Balke died in 1887 he was more or less unknown. Since then there have been several attempts to 'relaunch' his career, the most famous being in 1914 during the Norwegian Jubilee exhibition. During the last couple of years, the most enthusiastic advocates for Balke have been

the director of Northern Norway Art Museum, Knut Ljøgodt, and Marit Lange. Ljøgodt curated a major exhibition at The Northern Norwegian Art Museum in June 2014, a version of which was later shown at the National Gallery in London (international catalogue: *Paintings by Peder Balke*).

The book *Peder Balke: Visjon og revolusjon* serves as a Norwegian catalogue for the exhibition at The Northern Norwegian Art Museum. It contains four essays. One biographical essay by Lange; one essay by Ljøgodt about Balke's relationship with the sublime and the North; and two shorter essays by Guro Braathen and Christopher Riopelle, the curator from the National Gallery, who reflect on how Balke was rediscovered, including a

discussion, by Braathen of all earlier exhibtions of Balke's. The book is richly illustrated and offers a generous selection of quotations.

The main thesis of *Peder Balke* is that although Balke was an outstanding Norwegian romantic, he died in relative obscurity in 1887 and has only recently been recovered. However, the book never really addresses the question of Balke's significance as an artist. In fact, each of the editors takes for granted that Balke is interesting, that he deserves to be rediscovered. I tend to agree, but I would still like to hear the argument for why Balke is important: is his artwork better than that of his peers, is he relevant for our time, and was he influential on the continent?

The book does however describe Peder Balke as an artist who was on the wrong side of virtually all the major disputes of his time. His mentor Jens Rathke did not have the influence to define the art establishment in Norway and he was not a popular man; from the 1860s there was a growing antipathy towards the government in Stockholm, where his other mentor Frederick Due was prime minister.

The recovery of Balke was driven in no small part by one of Ljøgodt's co-editors, Dr. phil. Marit Lange, whose interest in Balke dates back to 1974. She describes the origins of that interest as follows:

In 1974, I moved into an apartment in Schultz gate. I sat and looked out the window while I was working on my master's degree on Antonio Gherardi. There were some small houses with narrow streets, that accounted for a block that differed markedly from everything around it. I wondered what the reason could be, and began investigating. It turned out that the houses were built after the great fire of the working district Balkeby, named after the painter Peder Balke. (Excerpt from interview in *KUNSTforum* 3, 2014).

Six years later, in 1980, she assembled her first exhibition of Balke's work at Oslo Kunstforening [the Art Association of Oslo], showing 94 paintings. 40 years later, her contribution to *Peder Balke* is a lengthy discussion of Balke's biography, drawing on his letters and the known facts about his life. This is an interesting read, especially for readers with an interest in Norwegian history: Lange portrays an artist whose career did not fit with the usual patterns of his time, and hence her essay also offers the reader an alternative cultural history of Norway in Balke's day.

Balke's name was Peder Andersen. His father disappeared when he was young and his mother was part of the landless rural proletariat. Balke began by learning house painting and fine decorative painting with his cousin Anders Skrædderstuen. In 1823, when he was 19, Andersen was helping to restore Balke Church on Toten. Two years later he was in charge of the restoration of the interior of Kolbu church at Toten. He became a renowned artisan and lived for a while with the wealthy farmer Andreas Balke at the farm Vestre Balke. It was during this time that Peder Andersen took the name Balke, following a tradition amongst servants of taking the name of the farm where they lived. The future was promising for the

budding artisan, until he was drafted into military service. To escape conscription, Balke left Toten in 1826.

In Christiania, Balke started to study at the Royal Drawing School. It is interesting that the major trigger to start Balke's career as an artist was the urge to escape conscription. His mentor in Christiania was not one of the directors of Christiana Kunstforening or at The Royal Drawing School, but professor of biology Jens Rathke.

Rathke had in his youth travelled extensively along the Norwegian coast, including northern Norway. He had studied the fisheries and their socio-economic conditions. On these journeys, he made a series of fine watercolours of the wildlife on the coast. He was, nevertheless, not an easy man to get on with and emerges from the history of the university as a bitter and difficult man. However, Lange paints him in a more sympathetic light and it is Rathke who advises Balke to study at the art academy in Stockholm.

In Stockholm, Balke found another unlikely mentor. Frederick Due, a junior minister, and later Prime Minister, helped Balke to get in touch with the leading Swedish painter Carl Johan Fahlcrantz (1774–1861). Later he would help Balke to sell his work to the royal family. In 1831, Balke was in a position to choose whether to travel to Dresden to study with Johan Christian Dahl or to northern Norway. Had he asked Oslo Kunstforening, the members would have answered: Dresden. But Balke listened to Rahtke, and Due supported him in his decision to visit northern Norway. Balke's subse-quent journey is well documented in this book.

In short, Lange describes a painter who finds his own paths and isn't at ease with his peers in Christiania. Nor were they especially enthusiastic about him. Balke received a state travel grant for artists in 1842, on the condition that he studied in Düsseldorf, where both Norwegian artists such as Adolph Tidemand and Hans Gude had also studied. However, the award was disputed. The Royal School of Drawing opposed it: the director, the Danish-Norwegian artist Johannes Flintoe, despised Balke, whom he believed to be a dilettante. The architects HDF Linstow and Johan Sebastian Welhaven supported Balke, but they stated their belief that he should receive an academic education. In 1844, when Oslo Kunstforening bought more of Balke's work, the critic Emil Tidemand was unimpressed: the images, he thought, were 'devoid of all, that might have an artistic Interest'.

These reactions by Tidemand and Flintoe were due, in part, to Balke's use of a marbling technique, where the paint was heavily diluted and added over with a priming. Balke could certainly use rags, a sponge – or even his fingers while painting. According to Lange, several members of Christiania Kunstforening viewed these as dilettante techniques.

Knut Ljøgodt's essay sets out to explain why Peder Balke travelled to northern Norway, the journey on which much of his status as an artist depends. He points out that in 1832, northern Norway was not unknown to civilised society. Indeed, Ljøgodt

gives several examples, including the Danish poet Adam Oehlenschläger and English novelist Charlotte Brontë, illustrating that northern Norway may have been the true definition for the European public of a frightening and terrifying place. It is not for nothing that Mary Shelley has Dr. Frankenstein appear for the first time just inside the Arctic Circle.

Ljøgodt argues that a fascination with the sublime is an important context for Balke's career. Edmund Burke's *Philosophical Enquiry into the Origin of Our Ideas of the Sublime and Beautiful* (1757) offered one of the most influential contemporary descriptions of the sublime, linking it to, amongst other things, the 'dark, uncertain, and confused'. To outsiders, northern Norway was nothing if not 'dark, uncertain, and confusing'.

As a reader it is easy to ask: Did Peder Balke travel to northern Norway in order to discover what scares the civilized European man? Such an enquiry was no doubt a familiar part of the romantic project, witness the *Nigthmare* (1781) of Henry Fuseli, which represents the animal subconscious that threatens always to disturb our balance. If it is true that Balke portrays the wild nature that threatens our existence even, then this alone secures his relevance in our age of anxiety about climate change.

The reader is never told whether Balke knew Edmund Burke's *Enquiry*, (but since he had little schooling he probably did not) or whether he was driven by intellectual desire to venture out in the unknown. Ljøgodt points out that Balke must have known about travel writing such as Anders

Fredrik Skjöldebrand's *Voyage Pittoresque au Cap Nord* (1801–1802) and that he was fascinated by the German painter Christian Ezdorf's paintings of Northern Sweden and Norway. But Balke does not seem like an intellectual. Of course he might have heard of the sublime, but Lange's article describes an artist who is driven by chance, an artist who puts faith in his mentors, rather than one on an intellectual mission. As a result, Ljøgodt's article gives an interesting impression of the intellectual climate at the time and of the growing fascination with the north. It explains why people were curious about Balke's paintings of northern scenes, but does not really tell us much about Balke.

In 1848 Europe was shaken by revolutions. These riots were a political awakening for Balke, and again show him as a maverick, who followed his own path. This irritated his teacher Johan Christian Dahl who wrote in a letter: 'Balke is now Communist'.

The bourgeois in Christiania lost interest in Balke at around the same time: Christiania Kunstforening bought its last painting *Nordkapp i måneskinn* [The North Cape in Moon Shine] in 1849. Balke returned to Norway, engaged in politics, and lost the battle of his time. Lange points out that Balke's politics played a significant role in his fall from favour with the establishment. That was undoubtedly so, but his lack of powerful mentors in the art world certainly also explains why he remained out of favour with the art world – until recently.

The exhibitions of Balke's work at the Northern Norway Art Museum and The National Gallery in London

aim to give him a shot at the posthumous reputation denied him by his contemporaries. Unfortunately *Peder Balke* does not really tell us why he deserves it.

Nicolai Strøm-Olsen
Editor of *KUNSTforum*

ABOUT THE AUTHORS

Sine Krogh is an art historian at The Royal Collection of Graphic Art at Statens Museum for Kunst (National Gallery of Denmark). Her research focuses on various aspects of Danish nineteenth-century art such as portraits and the shaping of artist identity in the romantic era, gender and friendships, and the travelling artist's strategies of networking abroad. She has contributed to *100 Years of Danish Art* (Den Hirschsprungske Samling, 2011) and has recently written an article on contemporary and nineteenth-century Danish artists in Olevano Romano, Italy (2015). Since 2014, she has been writing on Elisabeth Jerichau Baumann's stays in London and the Victorian art world.

National Gallery of Denmark
Sølvgade 48-50, 1307 København K, Denmark
sinekrogh@hotmail.com

Kate Scarth is SSHRC Postdoctoral Research Fellow at Dalhousie University and has a PhD in English from the University of Warwick, UK. She has a monograph *Romantic Suburbs: Fashion, Sensibility, and Greater London* under contract with the University of Toronto Press, and has published on a variety of eighteenth- and nineteenth-century writers, including Alexander Pope, Charlotte Smith, and Jane Austen.

Dalhousie University Faculty of Arts and Social Sciences
Marion McCain Arts and Social Sciences Building
Halifax, Nova Scotia, Canada B3H 4R2
kscarth@dal.ca

Prof. Dr. Christoph Bode is Professor of English Literature at Fakultät für Sprach- und Literaturwissenschaft, at the Ludwig-Maximilians-Universität, Munich. He is the author of the monographs *Future Narratives: Theory, Poetics, and Media-Historical Moment* (to which Rainer Dietrich has contributed) (Berlin/New York: De Gruyter, 2013), *The Novel: An Introduction* (Oxford/Malden, MA: Wiley-Blackwell, 2011), *Fremd-Erfahrungen: Diskursive Konstruktion von Identität in der britischen Romantik 2: Identität auf Reisen* (Trier: Wissenschaftlicher Verlag Trier, 2009), and *Selbst-Begründungen: Diskursive Konstruktion von Identität in der britischen*

Romantik 1: Subjektive Identität (Trier: Wissenschaftlicher Verlag Trier, 2008). His research focuses on modern English literature, English Romanticism, travel literature, and English and American Literature of the twentieth century. Among his research projects are 'Konstruktion von Alterität und Identität in der britischen Entdecker- und Reiseliteratur der Neuzeit' and 'Narrating Futures' (European Research Council Advanced Investigator Grant Research Project).

Department III, Anglistik und Amerikanistik
Schellingstrasse 3, 80799 München, Germany
Email: christoph.bode@anglistik.uni-muenchen.de

Kim Simonsen is a PhD, MA and a postdoctoral researcher at the Study Platform of Interlocking Nationalisms (SPIN) at the University of Amsterdam. He is the author of the forthcoming *Literature, Imagining and Memory in the Formation of a Nation – Travel Writing, Canonisation and the Formation of a National Self-image in the Faroe Islands* (Rodopi) and *The Cultivation of the Pan-Scandinavian Nation – Pan-Scandinavism and the Use of Literature in C.C. Rafn's and Rasmus Rask's early Philological Work*, the latter to be published in *Mythology and the Image of the North*, ed. Simon Halinck (Rodopi). Among his other fortcoming works are 'Paper Monuments of the North. The Royal Society of Northern Antiquties. C.C. Rafn's Letters and the Case of creating a Literature of the Faroe Islands' in *Building the North with words. Geographies of scientific knowledge in European philologies 1850–1950*. FRIAS – USIAS, Freiburg.

Faculty of Humanities, Capaciteitsgroep Europese studies
Spuistraat 134, 1012 VB Amsterdam, the Netherlands
Email: K.Simonsen@uva.nl

Martina Domines Veliki works as a teaching assistant in the English Department of the Faculty of Humanities and Social Sciences, University of Zagreb. She teaches courses in British romanticism (poetry and prose) to undergraduate students. She has published papers in both Croatian and international journals (*Grasmere Journal, Studien Zur Englischen Romantik, Central European Journal of Canadian Studies*). For her first romantic conference she was granted the Jonathan Wordsworth Scholarship and has won two bursaries for doing her doctoral research (from the University of Bergen and the University of Newcastle). In 2011 she defended her doctoral thesis entitled 'Constructions of the Romantic Subject: Rousseau and Wordsworth'. In 2013 she became the president of the Croatian Association for Anglophone Studies (HDAS), which is a member of ESSE (European Society for the Study of English).

Odsjek za anglistiku, Filozofski fakultet
Ivana Lučića 3, 10000 Zagreb, Croatia
Email: mdomines@ffzg.hr

Romantik. Journal for the Study of Romanticisms
Issue 04, 2015
© The authors and Aarhus University Press
Cover, book design and typesetting by Jørgen Sparre
Cover illustration: Peder Andersen Balke,
Lighthouse on the Norwegian Coast, 1855
Oil on canvas, 70.5 x 58.5 cm
Photographer: Jaques Lathion
© Nasjonalmuseet for kunst, arkitektur og design/
The National Museum of Art, Architecture and Design, Norway
Printed by Narayana Press, Denmark
Printed in Denmark 2015
ISBN 978 87 7124 919 4
ISSN 2245-599x

Aarhus University Press
Langelandsgade 177
DK – 8200 Aarhus N

INTERNATIONAL DISTRIBUTORS:
Gazelle Book Services Ltd.
White Cross Mills
Hightown, Lancaster, LA1 4XS
United Kingdom
www.gazellebookservices.co.uk

ISD
70 Enterprise Drive
Bristol, CT 06010
USA
www.isdistribution.com

PEER REVIEWED

/ In accordance with requirements of the Danish Ministry of Higher Education and Science, the certification means that a ph.d.-level peer has made a written assessment which justifies this book's scientific quality.

MIX
Paper from responsible sources
FSC® C010651
www.fsc.org

Colophone